OLD MISTRESSES

The Authors

■ Rozsika Parker studied European Art History at the Courtauld Institute, London. She formed the Women's Art History Collective with Griselda Pollock and others in 1973-5 and was one of the original members of the editorial collective of the British feminist monthly *Spare Rib*, working with them from 1972 to 1980. She has since trained as a psychotherapist and is currently in practice in London. She is the author of *The Subversive Stitch: Embroidery and the Making of the Feminine* (The Women's Press, 1984).

■ Griselda Pollock studied History and Art History at Lady Margaret Hall, Oxford, and the Courtauld Institute, London. She is now Senior Lecturer in the History of Art and Film at the University of Leeds. She was a member of the Women's Art History Collective 1973-5, and is the author of *Millet* (Oresko, 1977), *Van Gogh* (with Fred Orton, Phaidon, 1978), *Mary Cassatt* (Jupiter Books, 1980), *Van Gogh: His Dutch Years* (Huig, Amsterdam, 1980) and *Vision and Difference: Femininity, Feminism and Histories of Art* (Routledge, 1988).

■ Rozsika Parker and Griselda Pollock are the editors of *The Journal of Marie Bashkirtsef* (Virago, 1985) and *Framing Feminism: Art and the Women's Movement 1970-1985* (Pandora, 1987).

OLD MISTRESSES

Women, Art and Ideology

Rozsika Parker and Griselda Pollock

PANDORA

London Sydney Wellington

First published in 1981
Reprinted in 1987
by Pandora Press
an imprint of the Trade Division of Unwin Hyman Limited
Reprinted in 1989

Pandora Press
Unwin Hyman Limited
15/17 Broadwick Street, London W1V 1FP

Allen & Unwin Pty. Ltd.
8 Napier Street, North Sydney, NSW 2060, Australia

Allen & Unwin N.Z. in association with the Port Nicholson Press
75 Ghuznee Street, Wellington, New Zealand

British Library Cataloguing in Publication Data

Parker, Rozsika
Old mistresses: women, art and ideology.
1. Women artists
I. Title II. Pollock, Griselda
709'.2' 2 N8354

ISBN 0-86358-185-4

Printed and bound in Great Britain
by BAS Printers Limited
Over Wallop, Hampshire

In memory of Gay Fischer and Kathleen Pollock

Contents

Illustrations

New York, Metropolitan Museum of Art (gift of William Church Osborn), 1899, oil on canvas, 94 by 72.4cm *120*

72 Paula Modersohn-Becker, *Old Peasant Woman Praying*, Detroit, Detroit Institute of Arts (gift of Robert H. Tannahill), *c.* 1905, oil on canvas, 75.2 by 57.7cm *120*

73 Suzanne Valadon (French: 1865–1938), *Self-portrait*, Paris, Musée Nationale d'Art Moderne, 1883, pastel on paper, 45 by 32cm *122*

74 Pierre-Auguste Renoir (French: 1841–1919), *The Bathers*, Philadelphia, Philadelphia Museum of Art (Mr and Mrs Carroll S. Tyson collection), 1887, oil on canvas, 115.5 by 167.6cm *122*

75 Suzanne Valadon, *Nu à la Palette*, Paris, Musée Nationale d'Art Moderne, 1927, pencil on paper, 63 by 42cm *122*

76 Henri Matisse (French: 1869–1954), *The Painter and his Model*, Paris, Musée Nationale d'Art Moderne, 1917, oil on canvas, 146 by 97.1cm *125*

77 Sylvia Sleigh (American b. 19—), *Philip Golub Reclining*, New York, Lerner Misrachi Gallery, 1971, oil on canvas, 42 by 60cm (photo Geoffrey Clements) *125*

78 Diego Velásquez (Spanish: 1599–1660), *The Toilet of Venus* ('The Rokeby Venus'), London, National Gallery, *c.* 1650, oil on canvas, 122.5 by 177cm *125*

79/80 Suzanne Santoro (American: b. 1946), two double pages from *Towards New Expression*, published by Rivolta Feminile, Rome, 1974, original double-page spread 15.7 by 21.7 cm *128*

81 Judy Chicago (American b. 1939), *The Rejection Quintet: Female Rejection Drawing*, collection of the artist, 1974, prismacolour on rag paper, 101 by 76.2cm *129*

82 *Penthouse*, vol. 12, no. 3, July 1977 (photo Richard Romero) *129*

83 Leonor Fini (French: b. 19—), *Chthonian Deity Watching a Young Man Asleep*, Paris, private collection, 1947, oil on canvas, 28 by 41 cm *141*

84 Anne-Louis Girodet de Roucy-Trioson (French: 1767–1824), *The Sleep of Endymion*, Paris, Musée du Louvre, 1791, oil on canvas, 197 by 260cm *141*

85 Leonor Fini, *The White Train*, Geneva, private collection, 1966, oil on canvas, 64.8 by 76.4cm *142*

86 Augustus Egg (British: 1816–63), *The Travelling Companions*, Birmingham, City Art Gallery and Museum, 1859, oil on canvas, 64.8 by 76.4cm *142*

87 Meret Oppenheim (German-Swiss: b. 1913), *Déjeuner en fourrure*, New York, Museum of Modern Art, 1936, fur on china, cup 11.1cm diameter, overall height 7.3cm *147*

Preface

With the rise of the modern women's movement, feminist artists, critics and art historians have begun to redress the neglect of women artists and to undermine the stereotyped views of women's art. Many books have been published in the last few years which have once again made accessible the names and works of hundreds of women artists from all periods of the history of art. We can build on that solid foundation of research and documentation and begin to produce a more searching analysis of women's position in culture. It is no longer necessary to assert that there have been women artists. The evidence is overwhelming. In this book, therefore, we are not just presenting information about them or even offering new interpretations of their work. Our intention is to explore women's place in the history of art. Recognising that it is only in the twentieth century that women artists have been systematically effaced from the history of art, we pose what we think is the more important and fundamental question: 'Why has this happened?'

In trying to find answers to this question we are not concerned to prove that women have been great artists or to provide yet another indictment of art history's neglect of women artists. Instead we want to know how, and more significantly, why women's art has been misrepresented and what this treatment of women in art reveals about the ideological basis of the writing and teaching of art history.

Throughout the book we distinguish between the history of art by which we define the field of study, the historical material, and art history which is the professional academic discipline which studies the history of art. We make the distinction clear in order to emphasize that the way the history of art has been studied and evaluated is not the exercise of neutral 'objective' scholarship, but an ideological practice. It is a particular way of seeing and interpreting in which the beliefs and assumptions of art historians, unconsciously reproducing the ideologies of our society, shape and limit the very picture of the history of

art presented to us by art history. This is not simply to accuse art historians themselves of bias or prejudice, but concerns the significance of the typical forms of art history, the survey history of art's evolution independent of social forces, the *catalogue raisonné* and the monograph on a single artist's work. These forms, on the one hand the basic tools of art history, also embody values which privilege the named creative individual and certain forms of art over all other expressions of creativity. Art history's methods and categories constitute a particular and ideological reconstitution of the history of art.

In the first two chapters we analyse the stereotyped categorizations imposed upon women's art, in order to expose the cluster of particular meanings attributed to their art since the Renaissance. We need to understand the significance of that process by which art by women has been separated from the dominant definitions of what constitutes art, consigned to a special category, seen simply as homogeneous expressions of 'femininity'. Such interpretations have petrified into a stereotype by their repetition, automatically asserted and rarely questioned, now carrying the force of natural, obvious truth.

Some feminists have criticized the stereotype imposed on women's art but have not recognized what it means, nor questioned why it has been so insistently and anxiously reasserted. Why has it been necessary to negate so large a part of the history of art, to dismiss so many artists, to denigrate so many works of art simply because the artists were women? What does this reveal about the structures and ideologies of art history, how it defines what is and what is not art, to whom it accords the status of artist and what that status means?

Although the 'feminine' stereotype seems merely to be a way of excluding women from cultural history, it is in fact a crucial element in the construction of the current view of the history of art. Women's place in art history, we argue, has been misrecognized; exposing the feminine stereotype allows us to realize the true significance of women in art history as a structuring category in its ideology.

Women's relation to artistic and social structures has been different to that of male artists. We analyse women's practice as artists to discover how they negotiated their particular position. And we show that they were able to make art as much because of as despite that difference. We purposely avoid presenting the history of women in art as merely a fight against exclusion from and discrimination by institutions such as academies of art. To see women's history only as a progressive struggle against great odds is to fall into the trap of unwittingly reasserting the established male standards as the appropriate norm. If women's history is simply judged against the norms of male history, women are once again set apart, outside the historical processes of which both

men and women are indissolubly part. Such an approach fails to convey the specific ways that women have made art under different constraints at different periods, affected as much by factors of class as by their sex.

Another tendency in feminist art history to date, which exposes once again the force of the ideologies of art history, has been the over-emphasis on individual biographies of women to the detriment of serious consideration of works of art by them. We have tried to show how women have participated in the development of the language and codes of art, contributing to and at times opposing the meanings conveyed by the dominant styles and images. In other words, we stress women's relation to art practice not just to the institutions of art. The main issue concerns the tensions that have existed for women between the possibilities for becoming artists and the possibilities for making paintings in which they can produce meanings of their own. In the final section we therefore consider the constraints placed on women's art by the very language and codes of art with which they had to work, and we conclude with an analysis of the work of a few women in twentieth-century avant-garde movements, with special reference to those who have been involved in radical art practices which confront the ideologies of art institutions, writings on art and the meanings produced in art itself.

Our book is therefore not a history of women artists, but an analysis of the relations between women, art and ideology. We hope that the map we have drawn up, the developments we have charted and the analyses we offer will provide a new theoretical framework for the understanding of the significance of sexual difference in our culture.

Griselda Pollock
Rozsika Parker
Leeds and London 1980

Acknowledgments

This book is the product of the Women's Liberation Movement, and many people have, in diverse ways, contributed to it. We wish to thank particularly the Women's Art History Collective, especially Denise Cale, Pat Kahn, Tina Keane and Alene Straussberg; the *Spare Rib* Magazine Collective; Adrian Forty, Susan Hiller, Kim Parker, Ruth Pavey, Ruthie Petrie and Nanette Salomon; and Ann Scott, who helped us enormously by commenting on and correcting the original manuscript.

I

Critical stereotypes: the 'essential feminine' or how essential is femininity?

When Virginia Woolf was asked to lecture on 'Women and Fiction' in 1928 she commented ironically:

> A thousand questions at once suggested themselves. But one needed answers, not questions; and an answer was only to be had by consulting the learnèd and unprejudiced, who have removed themselves above the strife of tongue and confusion of body and issued the result of their reasoning and research in books which are to be found in the British Museum. If truth is not to be found in the British Museum, where, I asked myself, picking up a notebook and a pencil, is truth? (*A Room of One's Own* (1928), 1974 edn, p. 27)

Hundreds of questions can equally be posed about women in the history of art. Have there been female artists? If so, what have they created? Why did they produce what they did? What factors conditioned their lives and works? What difficulties have women encountered and how did they overcome discrimination, denigration, devaluation, dismissal, in attempting to be an artist in a society which since the Book of Genesis has associated the divine right of creativity with men alone (figs 1 and 2)?

But what answers are to be found on the shelves of the British Museum, that repository of received knowledge? Virginia Woolf was surprised to discover the sheer number of books to consult about women, though written from the assured heights of masculine authority. 'Are you aware that you are perhaps the most discussed animal in the universe?', she asked her women readers drily. There is indeed a great wealth of information on women artists in the British Museum. But are the learnèd unprejudiced?

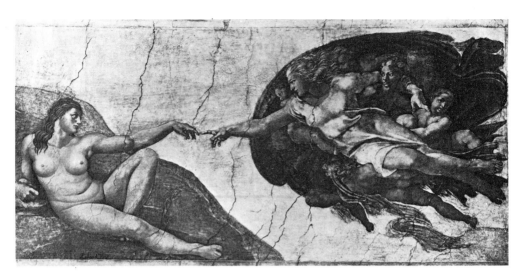

1 *And God created Woman in Her own Image,* an advertisement for Eiseman Clothing via Michelangelo and Ann Grifalconi (1970) (derived from an original design by Ann Grifalconi)

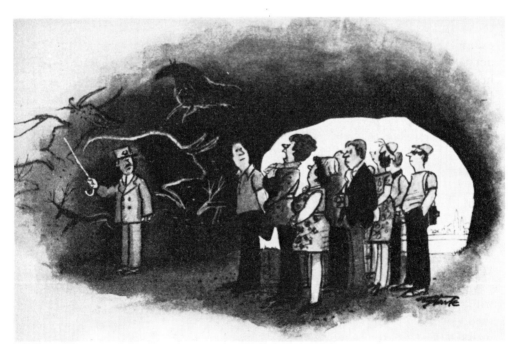

2 'It's never occurred to you, I suppose, that they could have been created by a cave-*woman*?' Cartoon by Leslie Starke, *New Yorker*, 23 July 1973
The cartoon is a mocking response to feminist art history, which has shown that there have been women artists. We are clearly not meant to take the idea very seriously since the cartoonist has drawn the woman who raises the issue in such a way as to alienate all sympathy or respect.

Even a cursory glance at the substantial literature of art history makes us distrust the objectivity with which the past is represented. Closer reading alerts us to the existence of powerful myths about the artist, and the frequent blindness to economic and social factors in the way art is produced, artists are taught, and works of art are received. In the literature of art from the sixteenth century to the present two striking things emerge. The existence of women artists was fully acknowledged until the nineteenth century, but it has only been virtually denied by modern writers. Related to this inconsistent pattern of recognition is the construction and constant reiteration of a fixed categorization—a 'stereotype'—for all that women artists have done.

To discover the history of women and art is in part to account for the way art history is written. To expose its underlying values, its assumptions, its silences and its prejudices is also to understand that the way women artists are recorded and described is crucial to the definition of art and the artist in our society.

A brief survey of the literature of art up to the nineteenth century shows that the existence of women artists was consistently acknowledged. The sixteenth-century artist and critic Giorgio Vasari was one of the earliest writers of art history as we know it. His lengthy study of artists of the Renaissance was a forerunner of the most common genre of modern art history, the monograph, a study of the life and work of an individual artist. In this sixteenth-century text the women artists of the period are both documented and assessed. There is, for example, a chapter on the sculptor Properzia de' Rossi (1490–1530) (fig. 3), detailed information about Sofonisba Anguissola (1532/5–1625) (fig. 4) and her five sisters, and a description of an ambitious fresco of *The Last Supper* in the Florentine church of Santa Maria Novella by Plautilla Nelli.

The trickle of references to women artists in the sixteenth century grows by the eighteenth century to become a flood in the nineteenth century. Lengthy surveys of women in art from Greece to the modern day were published throughout Europe. There was, for example, Ernst Guhl, *Die Frauen in der Kunstgeschichte* (1858), Elizabeth Ellet, *Women Artists in All Ages and Countries* (1859), Ellen Clayton, *English Female Artists* (1876), Marius Vachon, *La Femme dans l'art* (1893), Walter Sparrow, *Women Painters of the World* (1905) and the massive compilation of more than one thousand entries on women by Clara Clement in her encyclopedia, *Women in the Fine Arts from the 7th Century BC to the 20th Century* (1904).

Curiously the works on women artists dwindle away precisely at the moment when women's social emancipation and increasing education should, in theory, have prompted a greater awareness of women's participation in all walks of life. With the twentieth century there has been a virtual silence on the subject of the artistic activities of women in the past, broken only by a few works which repeated the findings of the nineteenth century. A glance at the

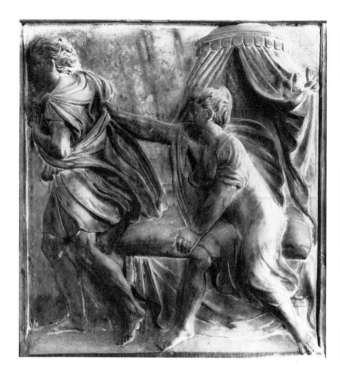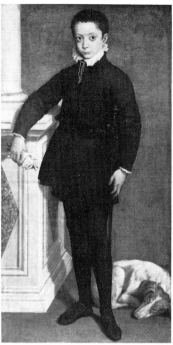

3 Properzia de' Rossi, *Joseph and Potiphar's Wife*, c. 1520
Properzia de' Rossi was born in Bologna, a city which has a consistent history of progressive attitudes and produced a significant number of women who participated as professionals in many branches of the arts and sciences during the Renaissance (see Laura Ragg, *Women Artists of Bologna*, 1907).

4 Sofonisba Anguissola, *Portrait of a Young Nobleman*, early 1560s
Anguissola was one of five daughters of a noble family of Cremona. With her second sister Elena she studied under Bernadino Campi and Bernadino Gatti and through her father's agency was advised by Michelangelo (C. de Tolnay, 'Sofonisba Anguissola and her Relations with Michelangelo', *Journal of the Walters Art Gallery*, vol. V, 1941, pp. 15–18). In 1560 she was invited to Spain by Philip II as a court painter and lady-in-waiting to the Queen. During the twenty years she spent in Spain Anguissola also painted portraits commissioned by the Pope. In 1580 she moved with her new husband to Palermo where she died at an advanced age. In 1624, shortly before her death, she was visited by the Flemish painter, Anthony van Dyck (1599–1641), who drew a sketch of Anguissola and wrote in his notebook:

> Portrait of Signora Sophonisba, painter. Copied from life in Palermo on 12th day of July of the year 1624, when she was 96 years of age, still a good memory, clear sense and kind. . . . While I painted her portrait, she gave me advice as to the light . . . and many more good speeches, as well as telling me parts of her life story, in which one could see that she was a wonderful painter after nature. (Cited in Tufts (1974), p. 20)

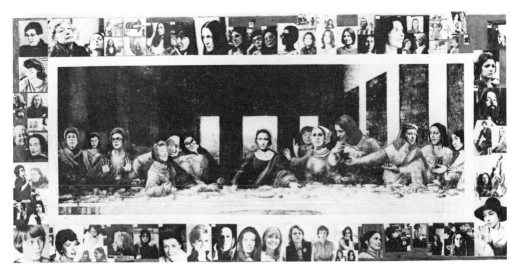

5 Mary Beth Edelson, *Some Living American Women Artists*, 1972
Dramatis personae at this 'Last Supper' (l. to r.): Lynda Benglis, Helen Frankenthaler, June Wayne, Alma Thomas, Lee Krasner, Nancy Graves, Georgia O'Keeffe, Elaine DeKooning, Louise Nevelson, M. C. Richards, Louise Bourgeois, Lila Katzen, Yoko Ono; Guests: (clockwise) Agnes Martin, Joan Mitchell, Grace Hartigan, Yayoi Kusama, Marisol, Alice Neel, Jane Wilson, Judy Chicago, Gladys Nilsson, Betty Parsons, Miriam Schapiro, Lee Bontecou, Sylvia Stone, Chryssa, Suellen Rocca, Carolee Schneeman, Lisette Model, Audrey Flack, Buffie Johnson, Vera Simmons, Helen Pashgian, Susan Lewis Williams, Racelle Strick, Ann McCoy, J. L. Knight, Enid Sanford, Joan Balou, Marta Minujin, Rosemary Wright, Cynthia Bickley, Lawra Gregory, Agnes Denes, Mary Beth Edelson, Irene Siegel, Nancy Grossman, Hannah Wilke, Jennifer Bartlett, Mary Corse, Eleanor Antin, Jane Kaufman, Muriel Castanis, Susan Crile, Anne Ryan, Sue Ann Childress, Patricia Mainardi, Dindga McCannon, Alice Shaddle, Arden Scott, Faith Ringgold, Sharon Brant, Daria Dorsch, Nina Yankowitz, Rachel bas-Cohain, Loretta Dunkelman, Kay Brown, CeRoser, Norma Copley, Martha Edelheit, Jackie Skyles, Barbara Zuker, Susan Williams, Judith Bernstein, Rosemary Mayer, Maud Boltz, Patsy Norvell, Joan Danziger, Minna Citron.

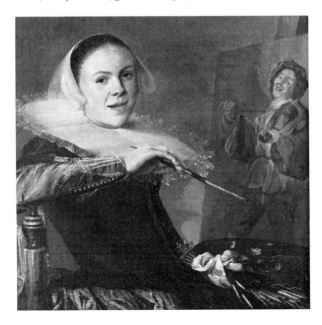

6 Judith Leyster, *Self Portrait*, 1635

index of any standard contemporary art history text book gives the fallacious impression that women have always been absent from the cultural scene.

Twentieth-century art historians have sources enough to show that women artists have always existed, yet they ignore them. The silence is absolute in such popular works surveying the history of western art as E. H. Gombrich's *Story of Art* (1961) or H. W. Janson's *History of Art* (1962). Neither mentions women artists at all. The organizers of a 1972 exhibition of the work of women painters, *Old Mistresses: Women Artists of the Past*, revealed the full implications of that silence:

> The title of this exhibition alludes to the unspoken assumption in our language that art is created by men. The reverential term 'Old Master' has no meaningful equivalent; when cast in its feminine form, 'Old Mistress', the connotation is altogether different, to say the least. (A. Gabhart and E. Broun, *Walters Art Gallery Bulletin*, vol. 24, no. 7, 1972)

Despite the enormous increase in numbers of women artists during the twentieth century (fig. 5), the assumption persists in our language that art is created by men, an attitude which is perpetuated in contemporary criticism.* In the *Feminist Art Journal* (April, 1972), the Tamarind Lithography Workshop published the results of its survey of criticism of contemporary art in major American art magazines. From August 1970 to August 1971, 87.8 per cent of the reviews in *Art Forum*, a leading art journal, discussed men's work; only 12.2 per cent reported women's work; 92 per cent of *Art in America*'s reviews were devoted to men's work, 8.0 per cent to women's work, while men took 95 per cent of the lines allotted to writing on art and 93 per cent of the reproductions. Particular ideological assumptions about women's relation to art sustain this silence. When one feminist art critic questioned a colleague about his attitude to a woman artist and asked why he had never visited her studio, 'he said in perfect frankness that she was such a good looking girl that he thought that if he went to the studio it might not be because of her work.' Another typical example comes from the chairman of an art department who said to a female student 'You'll never be an artist, you'll just have babies' (*The Rip Off File*, 1972).

At a lecture at the Slade School of Art in 1962, the sculptor Reg Butler proposed a similar identification of women with procreativity and men with cultural creativity:

I am quite sure that the vitality of many female students derives from

*For a massive dictionary of women artists, see *Female Artists Past and Present*, published by the Women's History Research Center Inc., Berkeley, California, 1974.

frustrated maternity, and most of these, on finding the opportunity to settle down and produce children, will no longer experience the passionate discontent sufficient to drive them constantly towards the labours of creation in other ways. Can a woman become a vital creative artist without ceasing to be a woman except for the purposes of a census? (Reg Butler (1962), reprinted in *New Society*, 31 August 1978, p. 443)

In reviewing an exhibition in 1978 at the Arts Council's Hayward Gallery in London, organized by women and showing predominantly work by contemporary women artists, John McEwan employed another but related strategy. He identified women not with art, but domestic craft. Only one artist escaped his general censure, but for revealing reasons. She

at least exhibits none of *the needle-threading eye and taste for detail* that is so peculiarly the bug bear of women artists when left to their own devices; a preoccupation that invariably favours presentation at the expense of content. (John McEwan, 'Beleaguered', *Spectator*, 9 September 1978, our italics)

Such stereotypes and assumptions infect writing on art both past and present. But the denigration of women by historians is concealed behind a rigidly constructed view of art history. Some rationalize their dismissal of women by claiming that they are derivative and therefore insignificant. R. H. Wilenski, for instance, stated categorically, 'Women painters as everyone knows always imitate the work of some men' (*Introduction to Dutch Art*, 1929, p. 93).

But dependence on another is seen as a fault only if stylistic or formal innovation is the exclusive standard of evaluation in art. Lucy Lippard usefully challenges this notion which has so often been used to justify the exclusion of women from serious consideration:

Within the old, 'progressive', or 'evolutionary' contexts, much women's art is 'not innovative', or 'retrograde' (or so I have been told by men since I started writing about women . . .). Some women artists are consciously reacting against avant-gardism and retrenching in aesthetic areas neglected or ignored in the past; others are unaffected by such rebellious motivations but continue to work in personal modes that outwardly resemble varied art styles of the recent past. One of the major questions facing feminist criticism has to be whether stylistic innovation is indeed the only innovation, or whether other aspects of originality have yet to be investigated: 'Maybe the existing forms of art for the ideas men have had are inadequate for the ideas women have.' Susana Torre suggests that

perhaps women, unable to identify with historical styles, are really more interested in *art itself*, in self expression and its collective history and communication, differing from the traditional notion of the avant-garde by opposing not styles and forms, but ideologies. (*From the Centre: Feminist Essays on Women's Art*, 1976, p. 6)

Most consistent, however, is the pejorative attribution of a certain notion of femininity to all women artists. James Laver wrote on women artists of the seventeenth century:

Some women artists tried to emulate Frans Hals but the vigorous brush strokes of the master were beyond their capability, one has only to look at the works of a painter like Judith Leyster (1609–1661) to detect the weakness of the feminine hand. ('Women Painters', *Saturday Book*, 1964, p. 19)

But if the 'weakness of femininity' is so clear in contrast to the 'masculine' vigour of Frans Hals, why where so many works by Judith Leyster (fig. 6) attributed to Frans Hals in the past? (Leyster's existence was rediscovered in 1892 when a painting thought to be by Hals was found to have Judith Leyster's signature.*)

This 'feminine' stereotype is a 'catch-all' for a wide range of ideas, and it has a long history. As Mary Ellmann showed in her study of phallic criticism and sexual analogy in literary criticism, *Thinking About Women* (1968), the stereotype is a product of a patriarchal culture which constructs male dominance through the significance it attaches to sexual difference. Women and all their activities are characterized as the antithesis of cultural creativity, making the notion of a woman artist a contradiction in terms. A nineteenth-century writer stated it clearly: 'So long as a woman refrains from *unsexing* herself by acquiring genius let her dabble in anything. The woman of genius does not exist but when she does she is a man' (cited in Octave Uzanne, *The Modern Parisienne*, 1912, our italics). Often the only way critics can praise a woman artist is to say that 'she paints like a man', as Charles Baudelaire commented on Eugénie Gautier in 1846.

None the less, writers have been forced to confront the fact that women have consistently painted and sculpted, but their use of a feminine stereotype for all that women have done serves to separate women's art from Art (male) and to

*For a full discussion of Leyster and the attribution of her work see Juliane Harms, 'Judith Leyster, Ihr Leben und Ihr Werk', *Oud Holland*, vol. XLIV (1927), and T. Hess, 'Great Women Artists', *Art and Sexual Politics* (1973), pp. 44–8, with many other examples of women's work being attributed to male artists.

accommodate the internal contradiction between the reality of women's activities and the myths of male cultural creativity. One example of this is Vasari's chapter on Properzia de' Rossi (*c.* 1490–1530), who started as a carver of curios but turned professional sculptor, producing bas-relief carvings such as *Joseph and Potiphar's Wife, c.* 1520 (fig. 3). Vasari tells us, in this order, that she was accomplished in household management, beautiful in body, a better singer than any woman in her city and, finally, a skilled carver. All he could see in her work was subtlety, smoothness and a delicate manner. *Joseph and Potiphar's Wife* is praised for being 'A lovely picture, sculptured with womanly grace and more than admirable.' His readers are reassured that Properzia de' Rossi conformed to the social expectations and duties of a noblewoman of the era.

Almost a hundred years later Count Bernsdorff reviewed the works of Angelica Kauffman (1741–1807), (fig. 50), a founder member of the Royal Academy, praising her for propriety and conformity to social norms:

> Her figures have the quiet dignity of Greek models. . . . Her women are most womanly and modest. She conveys with much art the proper relations between the sexes; the dependence of the weaker on the stronger which so much appeals to her male critics.

The hey-day of this special characterization of women's art as biologically determined or as an extension of their domestic and refining role in society, quintessentially feminine, graceful, delicate and decorative, is without doubt the nineteenth century. Bourgeois ideology attributed an important but ancillary role to women (see L. Davidoff, *The Best Circles,* 1973). They were the defenders of civilization, guardians of the home and social order. John Ruskin's book *Sesame and Lilies* (1867) is a clear statement of Victorian ideals and the rigid division of roles for men and women; men work in the outside world and women adorn the home, where they protect traditional, moral and spiritual values in a new industrial society. As his title of the section on women's roles, 'Of Queen's Gardens', implies, women are to fulfil themselves in a kind of aristocratic, untainted Garden of Eden, and he finally declares:

> Now their separate characters are these. The man's power is active, progressive and defensive. He is eminently the doer, the creator, the discoverer. His intellect is for invention and speculation. But the woman's intellect is not for invention or creation but sweet ordering, arrangement and decision. Her great function is praise. (*Works of John Ruskin,* Library Edition, vol. XVIII, 1905, p. 122)

Not surprisingly, similar views are evident in nineteenth-century writers on

women artists. Women artists shared the great social responsibility the Victorians placed on their sex. The work of a group of expatriate American sculptors (figs 57, 58) in Rome in the 1850s and 1860s could be endorsed by critics because they viewed it entirely in the light of social ideology. In 1866 an anonymous reviewer wrote:

> One or two lady artists in Rome of distinguished talent have made themselves a name yet [in addition] we have a fair constellation here of twelve stars of greater or lesser magnitude who shed their soft humanizing influence on a profession that has done so much for the refinement and civilization of man. (H. W., 'Lady Artists in Rome', *Art Journal*, vol. V, March 1866, p. 177)

But the most important feature of Victorian writing on women was that it attributed natural explanations to what were in fact the result of ideological attitudes. It prescribed social roles and social behaviour while pretending to describe natural characteristics. Thus John Jackson Jarves analysed the same group of sculptors in the following terms:

> Few women as yet are predisposed to intellectual pursuits which demand wearisome years of preparation and deferred hopes. *Naturally* they turn to those fields of art which seem to yield the quickest returns for the least expenditure of mental capital. Having in general a nice feeling for form, quick perceptions and a mobile fancy with not infrequently a lively imagination it is not strange that modelling in clay is tempting to their fair fingers Women by *nature* are likewise prompted in the treatment of sculpture to motives of fancy and sentiment rather than realistic portraiture or absolute creative imagination. ('Progress of American Sculpture in Europe', *Art Journal*, vol. X, 1871, p. 7, our italics)

Such language endlessly reinforces the notion of the 'fair' femininity of women's art and its supposed source in their gender, although we can locate the reasons for women's concentration on certain subjects and their more limited achievements in the sphere of nude sculpture or public commissions of heroic portraits, in the social structure of education, training, public policy and Victorian propriety (fig. 7).

At least one Victorian writer, Elizabeth Ellet, fully recognized that social, not biological factors account for women's choice of art forms:

> The kind of painting in which the object is prominent has been most practised by female artists. Portraits, landscapes and flowers, and pictures

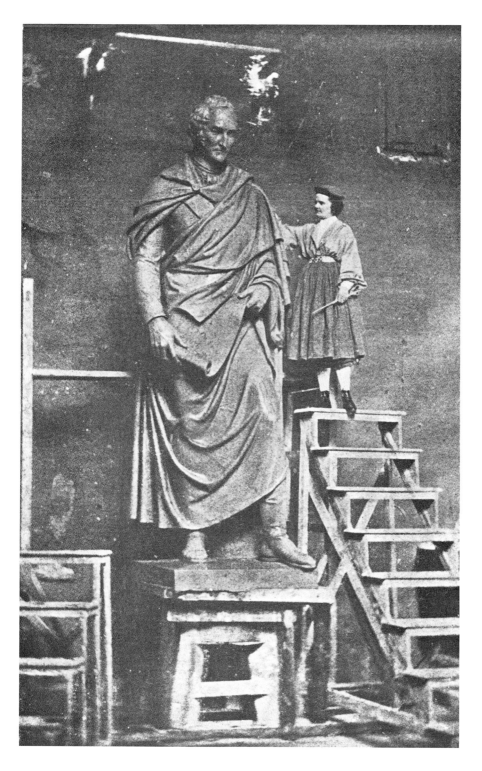

7 *Harriet Hosmer on a Scaffold with the Statue of Senator Thomas Hart Benton*, 1863 (anonymous photograph from Cornelia Carr, *Harriet Hosmer: Letters and Memoir*, 1912)

of animals are in favour among them. Historical or allegorical subjects they have comparatively neglected; and perhaps, a significant reason for this has been that they could not demand the years of study necessary for the attainment of eminence in these. More have been engaged in engraving on copper than in any other branch of art, and many have been miniature painters.

Such occupation might be pursued in the strict seclusion of the home to which custom and public sentiment consigned the fair student. Nor were they inharmonious with the ties of friendship and love, to which her tender nature clung. In most instances women have been led to the cultivation of art through the choice of parents or brothers. While nothing has been more common than to see young men embrace the profession against the wishes of their families and in the face of difficulties, the example of a woman thus deciding for herself is extremely rare. (*Women Artists in All Ages and Countries*, 1859, p. 3)

Victorian writers found a way of recognizing women's art compatible with their bourgeois patriarchal ideology. They contained women's activities, imposing their own limiting definitions and notions of a separate sphere. Yet it was actually these rigid prescriptions which insidiously prepared the ground for twentieth-century dismissal and devaluation of all women artists. It was the Victorians' insistence on essentially different spheres for men and women that precipitated women artists into historical oblivion once Victorian chivalrous sentimentality gave way to a more disguised but potent sexism.

The contradictory character of Victorian attitudes to women's art can best be illustrated by two quotations. The positive value they attributed to women as refined spirits is expressed in an article in the *Art Journal* of 1874, a review of an exhibition of the Society of Lady Painters* founded in 1857:

Nevertheless the refinement which characterises the painting of Lady Artists cannot be passed over without remark. We cannot say that English art does not stand in need of its influence and there is good reason to believe that Englishmen might take a lesson from Englishwomen in this. . . . There is scarcely a trace of vulgarity and we may even go so far as

*The Society of Lady Painters was first known as the Society of Female Artists, but later it acquired its more genteel title. It represents another aspect of the notion of separate spheres resulting from the structure of Victorian society. Since women were excluded from the most important institutions of art education, they founded their own schools and institutions, thus perpetuating one of the main forces in their exclusion from an accepted place in the official history of art. The history of women's institutions is a further example of the structural factors in the neglect of women artists.

to say that the pictures here collected suggest a more cultured spirit than can be claimed for the average art product.

This piece of criticism, coloured by Victorian attitudes, none the less attributes some significance to the specificity of women's art. His comments are addressed to the state of English painting in 1874. However, a more extended essay on the place of women in art by a French critic, Léon Legrange, declaims universal absolutes, in themselves conditioned by nineteenth-century ideology, which concern both the quality of women's art and the specializations, flower painting for example, or graphic art, within which women artists were confined by the social structure:

> Male genius has nothing to fear from female taste. Let men of genius conceive of great architectural projects, monumental sculpture, and elevated forms of painting. In a word, let men busy themselves with all that has to do with great art. Let women occupy themselves with those types of art they have always preferred, such as pastels, portraits or miniatures. Or the painting of flowers, those prodigies of grace and freshness which alone can compete with the grace and freshness of women themselves. To women above all falls the practice of the graphic art, those painstaking arts which correspond so well to the role of abnegation and devotion which the honest woman happily fills here on earth, and which is her religion. ('Du rang des femmes dans l'art', *Gazette des Beaux-Arts*, 1860)

In a few brief lines Legrange illustrates all the destructive stereotyping we have discussed. Men are the true artists, they have genius; women have only taste. Men are busy with serious works of the imagination on a grand scale but women are occupied in minor, delicate, personal pastimes. The flower analogy places both women and their work in the sphere of nature. Woman's socially appointed 'duty' becomes divinely ordained and her historical restriction to certain practices an inevitable result of Nature and God.

The legacy of the Victorians' views on women and art has been the collapse of history into nature and sociology into biology. They prepared the way for current beliefs about women's innate lack of talent and 'natural' predisposition for 'feminine' subjects. On the other hand, some late Victorian 'compilers of short memoirs' on women artists, for instance, Elizabeth Ellet, showed more historical sense. Clayton (1876), Clement (1904) and Sparrow (1905) record the consistent presence of women in the fine arts, recognizing difficulties they had as women to negotiate in the form of both institutional and social factors. Such texts enable us to see that women in art *do* have a history, but a different one from the accepted norm, because of their particular relation to official

structures and male-dominated modes of art production. For women artists have not acted outside cultural history, as many commentators seem to believe, but rather have been compelled to act within it from a place other than that occupied by men.

II

Names of women artists have been recorded since antiquity, for instance, Lala, Aristarte, Timarete, Olympia, Helen, Kalypso, Kora, Marcia, Eirene, Thamyris. Using the Roman historian Pliny as a source, the fourteenth-century Italian poet Boccaccio produced an inspirational text on *Famous Women of Antiquity* (*De Claris Mulieribus*, 1370), which included short accounts of three classical artists, Eirene, Marcia and Thamyris, who is shown on a page from a fifteenth-century French translation of Boccaccio's treatise (fig. 8). Boccaccio's essays on women artists contain contradictory messages. On the one hand, classical achievements are proposed as models for contemporary artists, and the presentation of women artists from the classical period served to validate and encourage women artists in the fourteenth century. Yet the poet's commentary undercuts this by asserting that these women were exceptional, forswearing their womanly duties to pursue a masculine profession: 'I thought these achievements worthy of some praise, for art is much alien to the mind of women, and these things cannot be accomplished without a great deal of talent, which in women is usually very scarce.' The text and representations of women artists in treatises such as Boccaccio's make us aware of the contradictions in the way women's art practice has been presented to us. Boccaccio's early Renaissance text is an example of the tendency to impose a rigid and anti-historical categorization on women's art.[1]

Research on women artists in the Middle Ages, when art production and theories of art were significantly different to those that emerged during and after the Renaissance, shows how necessary it is to pay close attention to the specific and differing conditions of women's practice in art. Women's participation in the varied forms of medieval art has to be related to particular historical factors, to the uneven development of religious and secular centres of art production, to amateur and professional work and to attitudes to women's membership of professional bodies such as the guilds which varied from guild to guild and from country to country. Moreover women's economic participation in such productive units as the household workshop has to be distinguished from the social and the sexual roles preached at them by Christian theology. In a published lecture, *Anastaise and Her Sisters: Women Artists of the Middle Ages* (Walters Art Gallery, Baltimore, 1974), Dorothy

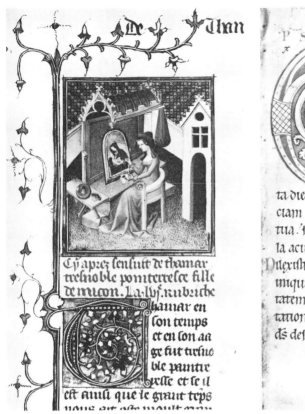

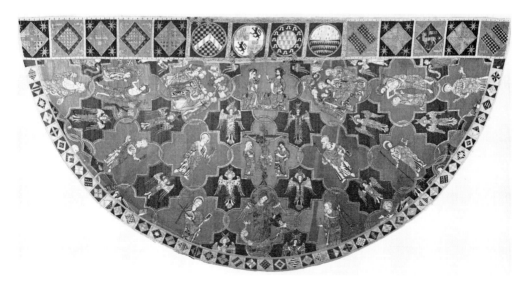

8 Anonymous, *Thamyris Painting*, early fifteenth century manuscript

9 Claricia, *Initial Q*, c. 1200

10 Anonymous (British), *The Syon Cope*, 1300–20

Miner discusses many women illuminators, including Claricia whose student work in a South German, thirteenth-century manuscript is illustrated here (fig. 9). In the Middle Ages illumination was carried out in convents and monasteries by their female and male members, and names of many such nuns have survived, for example, Ende, whose name appears on a Spanish manuscript dated 975, Guta of Schwartzenthan, a twelfth- or thirteenth-century scribe, and Donella, recorded in Bologna in 1271. However, as Miner points out, Claricia, who incorporates her self-portrait into the initial 'Q', is not a nun. Her long, plaited hair and dress are secular. She was probably therefore a student at a professional scriptorium in Augsburg.

In the later Middle Ages women's activities are more substantively documented in guild and parish records which specify women sculptors and illuminators working as members of a family production unit—wives, daughters—as well as working alone or as the heads of households. In the painters' Guild of St John the Evangelist in Bruges some women attained full membership; Miner states that in the year 1461–2 dues by eighteen women were received. Douglas Farquar has calculated that female membership of this guild increased from 12 per cent in 1454 to 25 per cent in the 1480s. Although the names of women renowned for their illuminations have been recorded, it is difficult to attribute any particular manuscript firmly to one of them, because signatures are rare in medieval art. For instance, no work is known by the hand of Anastaise whom Christine de Pisan praised so highly:

> With regard to painting at the present time, I know a woman called Anastaise, who is so skilful and experienced in painting borders and miniatures of manuscripts, no one can cite an artist in the city of Paris, the centre of the best illuminators on earth, who in these endeavours surpasses her in any way. (*Cité des Dames*, quoted in Henry Martin, *Les Miniatures Français*, 1906, p. 164)

As opposed to rigid modern divisions between art made with paint or stone and art made with thread and fabric, in medieval art practice a variety of forms and media were linked by their ritual functions. On the rich and precious copes worn by ecclesiastics, devotional scenes in medallions were embroidered in arrangements comparable to those in manuscript illumination or stained glass windows. What was admired was the skill with which prescribed theological content and common formal arrangements were adapted to the particular medium employed. In the ecclesiastical embroidery that culminated in the style known as 'Opus Anglicanum' ('English Work') of which *The Syon Cope* (fig. 10) is a superb example, a particular method of laying gold and silver gilt threads onto the fabric was developed to ensure that the

cope flowed and glittered when worn in procession. Subtle effects of features, modelling and expression could also be created through the ways silk threads were worked over the hands and faces. The figures and scenes are organized in the then popular arrangement of linked medallions. Patricia Wardle comments in *Guide to English Embroidery* (1970) on the typically English features of the cope which were shared by the East Anglian school of illuminators, particularly the way in which the participants reveal emotions through forceful gesture and facial expressions. And like illumination, embroidery was neither an exclusively female practice nor executed only by those in religious orders.

These few examples of work by women from the Middle Ages only touch this rich period superficially, but can serve none the less as an introduction to the problematic of women's art practice in modern times. What changed with the Renaissance was the whole condition of art practice, with a new identity and social position for the artist, ways of training, functions of art, patrons and documentation. These changes in the later Middle Ages and early Renaissance had far-reaching implications for women, usefully summarized by Annemarie Weyl Carr in the *Feminist Art Journal* (1976). She writes:

> the professional women painters of the fifteenth century were essentially craftspeople working within the conventions of an established style. But they have become not merely unnamed, but anonymous, without the individual immediacy of their earlier medieval counterparts. The miniature was ceasing to be the major art it had been in the Middle Ages. The amateur monastic workshop was giving way to the highly trained professional one; the medieval illuminator was giving way to the miniature painter in the modern sense. Art itself was changing. And with it, not surprisingly, the context of medieval women's art was being swept away. (*Feminist Art Journal*, vol. 5, no. 1, 1976, p. 9)

With the gradual redefinition of art and artist and the restructuring of the conditions of artistic production during the period we call the Renaissance, women's practice in the fine arts was affected by new factors. Increasingly they ceased to have access to conventional forms of training. Some were excluded from the newly organized artists' workshops. We find instead that women became artists by taking advantage of their different circumstances. While male artists tended to come from an artisan or petit-bourgeois background, and rarely from the aristocracy, the significant women artists in the Renaissance were born into the nobility. Caterina Vigri (b. 1413) came from the Ferrarese nobility, and Properzia de' Rossi was the daughter of a nobleman and her talents were those of a cultured lady of her class. She had a taste for music and carved elaborate designs on nuts and peach stones before

developing her skills on a large scale and in a public sphere. Sofonisba Anguissola (1532/35–1625) belonged to a family of five sisters who were encouraged by an enlightened father to play music and to learn Latin, as well as to paint.* The circumstances of her birth may have enabled her to pass by the normal channels of training. But more importantly, she transcended the more obvious constraints of her class and sex. She was no mere 'lady painter', and in addition to her employment as a painter at the Spanish court, she received papal commissions in Italy. Although Anguissola's background as an Italian noblewoman was atypical for a Renaissance artist, both her gender and her class had as much positive as negative effect upon the direction of her work. Without training in anatomy and years of study she was not equipped to paint religious or historical works with many half-draped or nude figures. Instead she concentrated on those scenes or models available to her, authentically portraying her immediate environment. In painting her sisters and their chaperone, *Three Sisters Playing Chess* (fig. 11) she explored a new form of genre portraiture which placed her sitters in intimate, domestic settings rather than among formal or allegorical props.† In his survey of Renaissance artists, Vasari discusses Anguissola and specifically mentioned this early example of a new kind of portraiture known as the 'conversation piece', praising it for such liveliness that the figures only seem to lack speech. To twentieth-century eyes Vasari's enthusiasm seems misplaced, for, at first sight, the painting appears awkward and clumsy: the perspective of the table and the chessboard is faulty and the hieratic stiffness of the girl on the left does not seem life-like. However, on closer examination, the beautifully individualized and characterful faces of the other figures are quite remarkable and carefully document the age and stage of womanhood of each of the three sisters. The presentation of their relations to each other is daringly informal and casual. Even the difficult and problematic parts of the painting are not without interest. The inconsistencies between the composition as a whole and the detailed, successful treatment of individuals point to the experimental nature of the painting, moving from formalized portraiture, as in the *Portrait of a Young Nobleman* (fig. 4), to a new genre based on her own family environment.

Moreover, she painted many self-portraits (fig. 48) at a date when it was relatively rare for artists to use themselves as the subjects of paintings. It is not surprising that Anguissola so consistently advertised herself as an artist to a society that considered women artists as notable exceptions. Yet in doing so she substantially contributed to the development of the self-portrait.

*See L. Nochlin and A. Sutherland Harris, *Women Artists: 1550–1950* (1977), pp. 23–4, for an important discussion of Castiglione's *Il Cortegiano* on Renaissance attitudes to the education of noblewomen.
†R. Longhi, 'Indicazione per Sofonisba Anguissola', *Paragone*, no. 157, 1963, pp. 50–2.

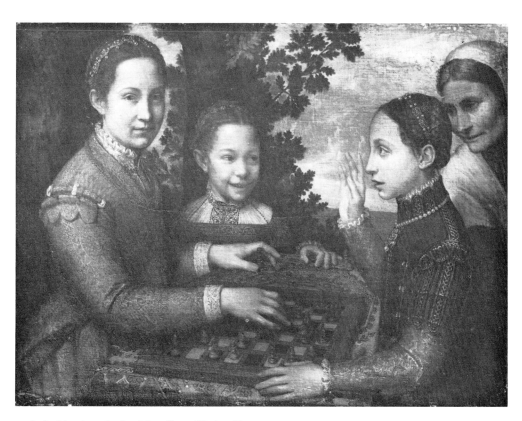

11 Sofonisba Anguissola, *Three Sisters Playing Chess*, 1555

Although Anguissola was obliged to work in specialized areas of genre and portraiture, her career illustrates a significant feature of the history of women's art practice. Certain types of painting, initially practised notably by women in response to the social conventions affecting them as artists, frequently became, at a later date, important spheres of art activity for men. It was, therefore, as much because of the particular restrictions which narrowed the range of options for women artists in the Renaissance that Anguissola was impelled to explore thoroughly the modes open to her and thus, to produce a singular contribution to the development of Renaissance portraiture and genre painting.

However, amongst most women artists of the period, Anguissola was unusual in that her father was not an artist. The great majority of women artists in the sixteenth and seventeenth centuries came from families of painters in which the absence of sons or the availability of materials and free teaching gave daughters an entry to an artistic career that would otherwise have been far less accessible to them. The careers of Fede Galizia (1578–1630) (fig. 28), Catharina van Hemessen (1528–post 1587), Lavinia Fontana (1552–1614) and Clara Peeters (1594–post 1657) (fig. 29) followed this pattern. Among women in this category Artemisia Gentileschi (1593–1652/3), the daughter and pupil of Orazio Gentileschi (1563–1639), a follower of Caravaggio, was one of the most important. Her works conform to the dominant stylistic mode of Caravaggist realism and dramatic subject matter and are a distinctive contribution to that tradition.

The career and work of Artemisia Gentileschi has been well documented in recent years. Her father Orazio Gentileschi taught her himself and also sent her to fellow artists to complete her training. She worked with her father, assisting him in the late 1630s with the decorations at the Queen's House in Greenwich, London. Most of her working life, however, was spent in Italy, first in Florence and later in Naples, where she finally settled. Several letters from Artemisia Gentileschi have survived which show that by the seventeenth century a woman artist was encountering particular forms of prejudice from patrons. She repeatedly had to allay her patrons' doubts about a woman's capacities, reassuring one patron that she invented her own subjects and did not merely repeat the successful formulae of other artists. We find her offering a defence understandable for a woman in a male-dominated world: 'You will find the spirit of Caesar in the soul of this woman.'

Gentileschi's invocation of the spirit of Caesar may have had a great deal to do with seventeenth-century notions of the heroic and with her characteristic subject matter, the actions of heroines of the biblical and classical epochs. Such themes belonged to a tradition of depicting famous women of the past whose deeds were recorded in the Bible and in texts such as that of Boccaccio (fig. 8);

the story of Judith and Holofernes was one of the most popular and was portrayed by male and female artists throughout the Renaissance.

Historians are clearly discomforted by the dramatic and characterful images of women in Gentileschi's canvases of *Susanna and the Elders* (Pommersfelden, collection of the Graf von Schönborn-Wiesentheid), *Cleopatra* (Genoa, Antichità Rubinacci), *Lucretia* (formerly Genoa, Palazzo Cattaneo-Adorno), *Mary Magdalene* (Florence, Palazzo Pitti) and *Judith*. As Amanda Sebestyen and Caroline Dees have pointed out in an article on Gentileschi (*Shrew*, 1973), the women in Gentileschi's paintings have frequently been described as 'gory', 'animalistic', 'buxom', 'sullen'. Her celebration of great women is charact-erized as 'irreligious', and the Judith subjects were described by the nineteenth-century writer, Mrs Jameson, as 'proof of her genius, and, let me add, of its atrocious misdirection'. Confronted by the expressive, powerful or victimized images of Gentileschi's women, writers have been unable to fit her paintings into the usual feminine stereotype: they cannot trace the expected signs of femininity, weakness, gracefulness or delicateness. Thus, unable to put her work into a stereotype, they turn instead to the dramatic events of her life, resurrecting the opposite category, that of the whore, thus suggesting that she was an unnatural woman. This in turn is used to explain the problematic character of such violent images painted by a woman. Her repeated rape by her teacher, Agostino Tassi, and her torture at the trial to ascertain the truth of her allegations are frequently cited in sensationalized accounts of her life, and she is stigmatized, in the words of Margot and Rudolf Wittkower, as a 'lascivious and precocious girl'.

It is impossible to assess from this distance in time the impact of these early experiences on Gentileschi, but many have been tempted to read her paintings as evidence of dislike of men, a notion contradicted by the same writers' gleeful accounts of her 'amours' which produced four daughters, also painters. It is only when we escape this disturbing fascination with her life and return her work to its context within a specific time, place and school of painting that we can fully appreciate her activities as a painter.

A popular subject in the Caravaggist circle was the story of the Jewish heroine Judith, who decapitated the enemy general Holofernes after gaining access to his tent by being offered as a hostage. Artemisia Gentileschi painted this subject many times. Her interest in the theme was not unusual, nor indeed was her emphasis in some versions (fig. 12) on its violence (fig. 13). What is particular is the prominence Gentileschi gave to the figure of Judith, portraying her as a powerful and decisive woman bravely defending herself, liberating her people, fully capable of an act of carefully planned violence (fig. 15). This later, less melodramatic, version of the Judith subject illustrating that moment of suspense after the murder concentrates on the

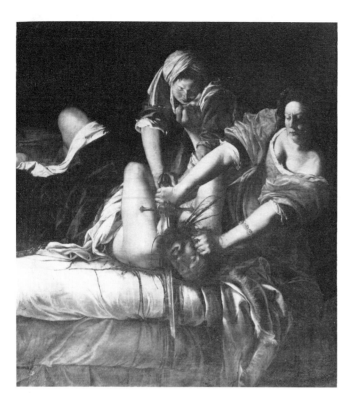

12 Artemisia Gentileschi, *Judith Decapitating Holofernes, c.* 1620

13 (*below*) Michelangelo Caravaggio, *Judith Decapitating Holofernes, c.* 1599
Caravaggio's version of the subject dates from early in his career, but is typical for its choice of the most violent moment of the story which can be usefully contrasted to Gentileschi's treatment.

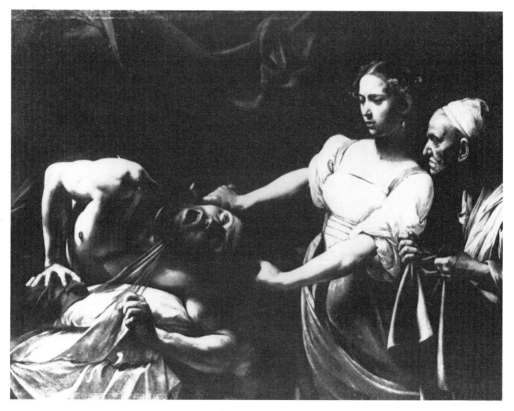

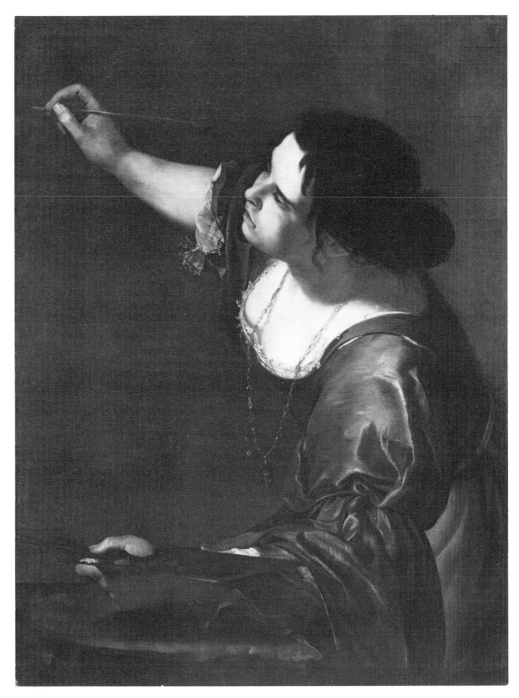

14 Artemisia Gentileschi, *Self-portrait as La Pittura*, n.d.

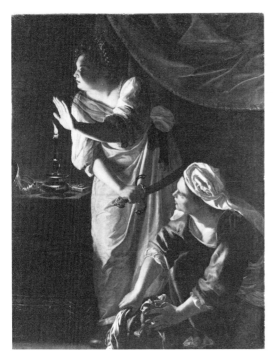

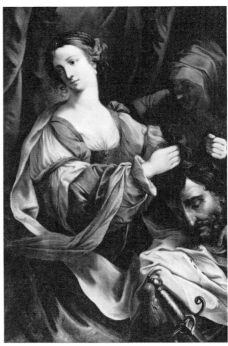

15 (*above, left*) Artemisia Gentileschi, *Judith and her Maidservant with the Head of Holofernes, c.* 1625
16 (*above, right*) Elisabetta Sirani, *Judith with the Head of Holofernes,* n.d.
17 (*below*) Elisabetta Sirani, *Portia Wounding her Thigh,* 1664

two women who have carried out the courageous and dangerous plan. The anxious moments after the actual execution, which were equally important to the success of the scheme, leading to an undetected escape from the enemy camp, are here represented by the Caravaggist use of dramatic chiaroscuro. The light of the single candle plays over the features and figures and casts a golden glow throughout the picture, reflecting the dull golden tone of Judith's dress and picking out the complementary violet of her companion's. The lighting serves to unify the composition and also suggests the eerie silence of the night, the conspiratorial tension of the scene, while drawing the spectator into the shallow enclosed space of the enemy general's tent.

Gentileschi's manipulation of this Caravaggist mode of representation suggests that there have been particular historical styles which women have most effectively used to introduce their own different nuances and meanings. Gentileschi's paintings of celebrated heroines should not be seen as evidence of an individual woman's proto-feminist consciousness reflected in art, but rather as her intervention in an established and popular genre of female subjects through a contemporary and influential style. It is only against this specific background, this prevailing climate, that the particular character of Gentileschi's work can be distinguished. It is by relating the contradictions inherent in the seventeenth-century's fascination with confrontations between male and female protagonists to this woman's treatment of those stories and styles that we can begin to produce useful insights for a theory of how women have fully participated in and altered dominant forms of art practice.

But it would seem that Gentileschi was at least partially aware of some of the contradictions in her position as a professional painter and the current representations of women's supposed relationship to art. In an allegorical self-portrait (fig. 14) she represents a woman artist painting. In addition to the representation of a painter at work, which conformed to Gentileschi's allegiance to the dramatic realism of Caravaggio, the concept of this picture plays on the contradiction between woman as painter's muse, symbolic embodiment of the art, and woman as professional practitioner of the art. There is at least one precedent for this image of a woman artist dishevelled and absorbed in work, an anonymous portrait medallion of the Bolognese painter, Lavinia Fontana (Imola, Biblioteca). But this medallion shows a woman seated at her easel, seized by some strange form of lunacy and ecstasy, her hair on end, eyes enlarged and staring upwards. Such an image suggests that to be an artist and female does not bring the inspiration of divine madness, but the total disordering of the reason and the senses. In striking contrast, Gentileschi's quiet, serious and dignified realism simply asserts that she paints, that she is absorbed by it, that painting is the profession of this woman. Gentileschi's *Self-portrait*, now in the Royal Collection at Hampton Court, furthermore sheds

light on women artists and their fate at the hands of posterity. For generations it languished in storerooms, believed to be merely an allegory of painting by an unknown artist. Its authorship and thus its particular meaning were obscured by a cloak of anonymity, probably because a female figure is commonly used as the symbol of those arts which actual women are presumed not to practise but inspire. In the first article (*Burlington Magazine*, 1962) which reattributed this work to Artemisia Gentileschi, Michael Levey revealingly commented, 'Perhaps the picture's real intention would have been earlier recognised had it been painted by a man' (p. 80). Elisabetta Sirani (1638–65), another painter's daughter, offers an interesting contrast to Gentileschi. Her father, Gian Andrea Sirani (1610–70), a follower of the most influential Bolognese painter of his day, Guido Reni (1575–1692), did not initially encourage his daughter to paint. She none the less learned from him the elements of the idealized and elegant Bolognese style in which she was so successful that even during her brief lifetime a cult grew up around her as the female reincarnation of Guido Reni. She overshadowed both her father and her two sisters, who were also painters.

Sirani was both precocious and prolific. Her own listed works and those recorded by a contemporary biographer, Malvasia, number over 170 in a career which ended with her premature death at the age of twenty-six. She became a legend in her lifetime. The stories of her enormous success that circulated in the seventeenth century have been repeated with some incredulity by later writers. Such stories have served to ensure Sirani's reputation, but, once again, as a strange phenomenon, an exception. The successful woman artist is often transformed into a legend, and the implications are obvious. Her intervention into the male preserve of art is retrieved for the stereotype, adumbrated by Boccaccio, of the exceptional woman, atypical of her sex by virtue of artistic ability. Indeed as Laura Ragg (1907) points out, the oration delivered at Sirani's public funeral was more a eulogy to the city that gave birth to so popular a painter than it was a requiem for the 'Lamented Paintbrush', as Sirani was described by a poet.

Sirani's version of the Judith and Holofernes subject (fig. 16) contrasts with Gentileschi's stylistically, with its cooler colours and more mannered composition, and, perhaps more importantly, in the treatment of the female figure. Sirani's Judith is as cool and detached as Gentileschi's is decisive and involved. Sirani offers Judith to the spectator as a beautiful woman to be contemplated and appraised. Gentileschi evokes the moment of action and draws the spectator into the scene by the tense pose of the main protagonist. This comparison brings to light no qualities shared by the two artists merely because they happened to be female, no essential femininity. It underlines the heterogeneous ways women artists have manipulated dominant modes of

representation, according to their particular situations in relation to the styles of the period and their different experiences.

Sirani's subjects included historical and religious themes—the Holy Family, the Penitent Magdalen, as well as the popular Judith and Holofernes. However, her painting of Portia, wife of Brutus, one of the Roman conspirators who murdered Julius Caesar, *Portia Wounding her Thigh* (fig. 17), is unusual even though it can be placed in the genre of representations of famous women of the past. Some have been tempted to see this painting as a feminist work, for they read it as an image of a strong-willed woman. According to Plutarch, the painting's apparent source, Portia inflicted on herself a cruel wound in order to test her own strength of will so that she might convince her husband, Brutus, that a woman had sufficient strength to share his burdens and his secrets.

But elements in the painting seriously question such an interpretation. For a start the necessity for self-mutilation to prove a woman's ability to be privy to her husband's thoughts strikes a rather curious note. On another level, the picture has overtones of perverse titillation and sado-masochistic sexuality— the exposed thigh, the loosened robe, the knife poised ambiguously, the coiled, almost Medusa-like, head-dress. The picture was listed by Sirani with a description of its subject, Portia, its intended hanging place, over a door, and its commissioner, Signore Simone Tassi. Sirani's female figures, luscious, voluptuous women, painted for her male patrons' more private apartments are stamped by the mode of representing women developed by Guido Reni. Women caught in moments of penitential contemplation or private suffering, in acts of heroism or courage, are shown to the viewer for the enjoyment of the sight of woman and not for the psychological or dramatic impact of the events. The seventeenth-century fascination with dark, violent, sexually disturbing subjects marks Sirani's *Portia*, which has a heavy, close atmosphere produced by the sombre lighting and rich colours. We, the spectators, are closer to Portia than are her maids, withdrawn into a distant room. We are privy to this secret act. In contrast to Gentileschi, Sirani's participation in the dominant stylistic and iconographic modes of her period and city led her to represent female figures in a way which confirmed rather than disrupted the sexual ideology which the Reni mode of representation served.

By the late seventeenth and the eighteenth century both the structure of art training and the status of the artist were changing. The founding of official academies of art as places of art education and public exhibition was an important shift in the organization of art practice away from the craft-based training offered in artists' workshops, and also in the social and intellectual position of the artist. Women were not initially excluded from these influential and prestigious bodies. The Paris Académie admitted a handful of women in the late seventeenth century. But then, in 1706, it barred them altogether. The

English Royal Academy had two female founder members in 1768 (fig. 49), but systematically excluded women from its schools and privileges for the next hundred years. This ambiguous situation had two results. Those women who did break into these male preserves at least offered visible examples of female success to others, but equally further progress could be contained within a policy of tokenism, with a quota system.[2]

The means by which women like Rosalba Carriera (1674–1757) and Adelaide Labille-Guyard (1749–1803) received their training serve to emphasize once again the positive and negative features of women's place in cultural history women were denied access to the training offered in the academy schools, and their election to membership of the academies often represented only a belated recognition of a reputation won outside the academies.

Carriera's fame and skill as a portraitist in pastel (fig. 18), the medium she revolutionised, won her honorary membership of the Accademia di San Luca in Rome (1705), of the Accademia di Santa Clementina in Bologna (1720) and the Académie Royale in Paris (1720). She had not followed a characteristic route to these honours. She came from a craft tradition, probably pursuing her mother's trade as a lace-maker, turning to the decoration of the lids of ivory snuff boxes when the lace market collapsed. Encouraged by appreciative buyers, she began to study drawing and anatomy but only applied her skills to the genres and materials commonly associated with women, miniature portraits and pastel chalks. But she transformed the medium of pastel, which since the sixteenth century had been only a preliminary sketching material, by using it as a vehicle for serious portraiture, which significantly influenced the development of the rococo style in the mid-eighteenth century.

Moreover, she shared her skills as a painter with other women, instructing her two sisters Giovanna (1683–1738) and Angela (1677–1757), who married a painter, Pellegrini, with whom Carriera collaborated in England. Two female pupils are also documented, Margherita Terzi and Angioletta Sartori, whose own sister was also an artist. Carriera had female rivals in the field of pastel portraiture, notably Giovanna Fratellini (1666–1731).

The significance of her introduction into eighteenth-century portraiture of the medium of pastel chalks and her contemporary fame are hard to gauge from modern studies of eighteenth-century art in which she is briefly mentioned as 'Rosalba', casually patronized as women artists so often are by the use of the Christian name alone. When mentioned at all, Carriera is usually treated as an exception, a rarity as a woman artist, an unexplained celebrity. Her work itself and the reasons for her renown are rarely considered. Despite the significance attached by art history to an artist who has pupils and thus propagates a particular style or kind of painting, Carriera's role as teacher and

centre of an artistic circle is ignored. The network of women's studios and rival practices, like the one we can discover around Carriera, is easily obscured once its most prominent member is consigned to the margins of art history. Since excellence in art is usually the product of an extensive system which may include the average as well as the exceptional artist, it is important that in the pursuit of a history of women artists we search out these networks. Carriera's relations with the influence on other women artists were initially obscured by the evolving eighteenth-century discourse on woman artist as celebrity, beautiful object and adornment. (Fuller analysis of this development will be undertaken in chapter 3.) In the later eighteenth and in the nineteenth centuries both male and female writers were puzzled by Carriera's success since it was not accompanied by that beauty of person and feminine charm which had come to be the dubious passport to acceptance as a woman artist. By eighteenth-century standards, the artist Carriera was exceptional because she was not a beautiful woman; in the twentieth century because she was a woman she is hardly worthy of mention. And the existence of the larger community of women artists to which she belonged is obliterated by the mystifying notion of individual genius. Within such an ideology artists become exceptional beings and women artists exceptions.

Far from being extraordinary as woman or artist, Carriera's specialization in pastel and portraits was the product of a particular aesthetic shift in the eighteenth century to the style known as rococo. Her subsequent reputation is a telling example of the fate of women artists precisely because they belong so clearly to their period and its art, for when the rococo mode went out of critical favour Carriera was devalued and dismissed because her work was indelibly marked by that eighteenth-century movement. However, in later reassessments of the eighteenth century, the fact that Carriera was a woman has led to her contribution being minimised. Many texts, while fully discussing the work of other eighteenth-century pastellists such as Liotard, Quentin de la Tour and Perroneau, pass over Carriera with a mere mention of her name, 'Rosalba'. In his comprehensive study, *Art and Architecture in Italy: 1600–1750* (1965), Rudolf Wittkower discounts the significance of her work and has to account for her undeniable contemporary success by implying that she was merely the natural product of a decadent society:

> On a lesser level portraiture flourished during the period, particularly in Venice and the *terra ferma*. Rosalba Carriera's (1675–1758) charming Rococo pastels come to mind; in her time they made her one of the most celebrated artists in Europe. Her visits to Paris (1721) and Vienna (1730) were phenomenal successes; in Venice all the nobles of Europe flocked to her studio. But her work, mellow, fragrant, and sweet, typically female

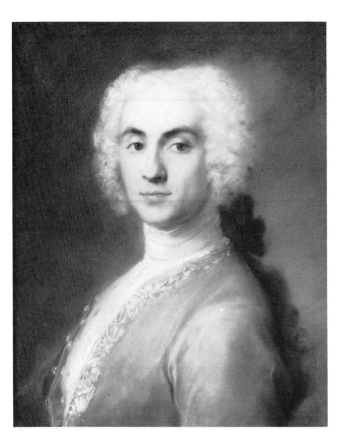

18 Rosalba Carriera, *Portrait of a Man in Grey*, n.d.

19 (*below*) Claude [?] Bornet, *Exhibition at the Salon of 1787*, eighteenth-century print

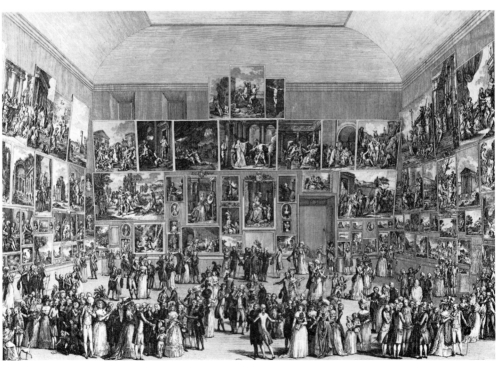

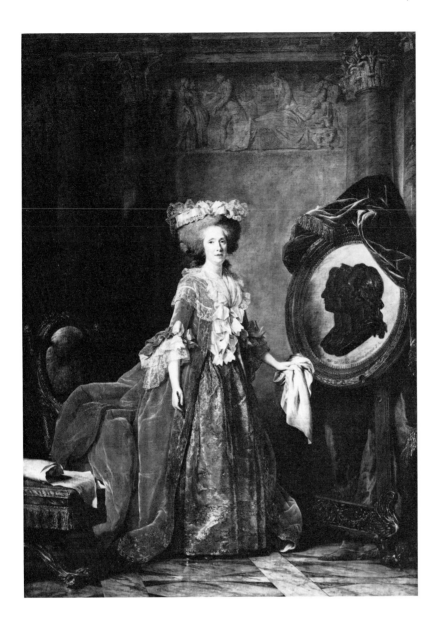

20 Adélaïde Labille-Guyard, *Madame Adélaïde*, 1787
This portrait of Madame Adélaïde, one of Louis XVI's aunts, is, as Bornet's engraving (fig. 19) shows, a large-scale work, and it was hung at the Salon of 1787 in a complementary position to Vigée-Lebrun's *Marie Antoinette surrounded by her Children* (Versailles), further evidence of the way in which work by women artists was hung to encourage comparison between them. Both the women's paintings were placed on the second row, a respectable but not the most prestigious position. It was Jacques-Louis David's *Death of Socrates* that was hung centrally 'on the line', that is at eye level, below the two portraits, as befitted a history picture, and below the work of the two most famous women painters of the period, as befitted a canvas by the leading artist of the day. Bornet's engraving provides visual evidence of the particular position occupied by these women, an intermediate one. Their work was prominent at this Salon, and although the two paintings were compared directly, they also stood in close relation to the painting by David. They were not 'skied', that is, hung too high to be visible, nor were they right 'on the line'. Their position was respectable.

and a perfect scion of the elegant Rococo civilization of Venice, is interesting (in spite of a recent tendency to boost it) as an episode in the history of taste rather than for its intrinsic quality. (p. 322)

Carriera's innovatory use of pastel had become widespread by the mid-eighteenth century. Adélaïde Labille-Guyard took to the medium in 1769, learning from its most famous French exponent, Maurice Quentin de la Tour (1704–88). Labille-Guyard was the youngest surviving daughter of a haberdasher. Her first professional instruction in art was provided by the painter François-Elie Vincent (1708–90), who had a shop close to that of her father. She had ambitions to be an oil painter and member of the Académie Royale. She exhibited publicly from 1774 onwards, first at the less prestigious rival to the Académie Royale, the Académie de Saint-Luc. When it closed, she exhibited in 1782 at the Salon de la Correspondance, founded in 1779. By the time she applied for membership of the Académie Royale in 1783, Labille-Guyard had had years of training and experience and had built a notable reputation as a portraitist of considerable skill. Despite the 1706 ruling against female membership, a few women had recently been admitted, at least providing a precedent. Moreover, Labille-Guyard was not alone in her success and ambitions; Elisabeth Vigée-Lebrun (1755–1842) applied at the same time (1783) for the status of an Academician. The concentrated assault by two women whose reputations and whose access to royal patronage made them impossible to ignore marked a new phase in the discriminatory treatment of women by the male authorities. The threat they represented to existing stereotypes of male creativity was contained by consistently comparing women artists with each other rather than with other artists working in their field (figs 19 and 20). That they posed a threat is confirmed by the subsequent decision, after heated debate in the Académie, to limit to four the number of women who could enter the Académie at any one time.

Both Labille-Guyard and Vigée-Lebrun painted royal portraits. It is known, however, that, unlike Vigée-Lebrun who was a royalist, Labille-Guyard supported the Revolution. Given this attitude, it is difficult to understand why Labille-Guyard painted portraits of the royal family and, in this case (fig. 20), one of its most conservative members. The links between the patronage of women artists and their political allegiances in the years immediately before the Revolution remain obscure, not only as a result of the general uncertainty that still surrounds relations between art and patrons in this period, but because women's different and often difficult situation as regards patronage has never been fully explored. Labille-Guyard and Vigée-Lebrun were in an ambiguous position as professional artists because they were often seen as members of the court entourage. Their skill as artists had

32

provided them entry to the patronage of the circle around the queen. Women artists such as Labille-Guyard perhaps experienced the contradictions that customarily forced women in all professions into conservative positions. In the struggle to gain access to institutions and to acquire reputations women tend to focus on the status quo, on participating in the existing establishment from which they want and need recognition. One particular incident in Labille-Guyard's career exemplifies this. In pursuit of her ambitions, Labille-Guyard undertook a commission for a huge canvas of an historical subject on which she worked for two and a half years, *The Reception of a Knight of St Lazare by Monsieur, Grand Master of the Order*. However, after the Revolution, with which she sided and of whose leaders she painted many portraits, her great project was considered unacceptably royalist in tendency and she was ordered to destroy the canvas on which she had pinned her hopes for achieving recognition and status.

Before the Revolution, women had reacted to their exclusion from the best of art education in many ways. They found alternative means to learn their craft, and those who were successful instituted classes for less privileged women. Labille-Guyard not only accepted female pupils, the names of nine of whom are known, but also used the opportunity of the first Salon after her admission to the Académie to exhibit a representation of herself at work, observed by her two most famous followers. The inclusion of the artist's two pupils in the portrait of *The Artist with Two Female Pupils* of 1785 (fig. 21) both makes visible the particular circumstances of women's training in the eighteenth century and establishes that women artists had followings and exercised influence. This point is crucially important because one of the most constant criteria within art history for assessing an artist's significance in the history of art is the extent of their influence on others. Yet women are so often isolated in a separate critical category and cut off thereby from this notion of importance in the history of art. The iconography of Labille-Guyard's painting of 1785 directly challenges the basis of the dismissive categorisation of women on its own ground.

After the French Revolution, despite abolition of the royal academy in the 1790s, the situation of French women artists deteriorated drastically. They were absolutely excluded from the Académie when it was refounded and, for most of the nineteenth century, were kept outside the major art institution, the Institut des Arts. In her memoirs, published in 1835, Vigée-Lebrun regretted the outbreak of the Revolution from which she had herself fled. Her nostalgia is obviously personal but her comments are quite perceptive: 'It is difficult to convey today an idea of the urbanity, the graceful ease, in a word, the affability of manner which made the charm of Parisian society forty years ago. Women reigned then; the Revolution dethroned them.'

Feminist art historians have misunderstood the nature and results of the

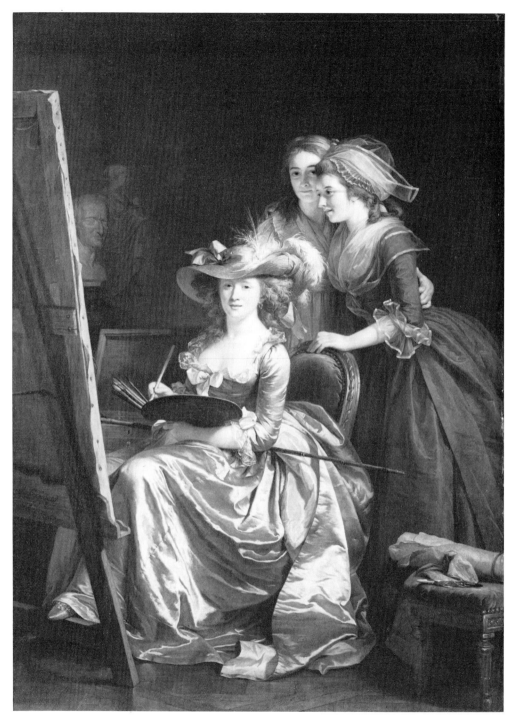

21 Adélaïde Labille-Guyard, *The Artist with Two Female Pupils*, 1785

constraints placed upon women artists in the later eighteenth and nineteenth centuries. The restricted access to academic art education has been frequently represented as an effective form of discrimination which prevented women from being able to make a contribution to all genres of art. Admittedly a far-reaching effect of women's exclusion from the life class of the academy schools, which persisted into the nineteenth century, was that they were not permitted officially to study human anatomy from the live, nude model (which for almost three hundred years, from the renaissance to the hey day of the Academy in the nineteenth century, was the most highly regarded form of painting). The simple fact of women's exclusion from studying the nude constrained many of them to practice exclusively in the genres of still-life and portraiture. These genres were considered less significant than history painting. Artists who practiced in the so-called 'lesser' genres were regarded as artists of 'lesser' talent. Yet in cases where men, Reynold and Chardin, for instance, specialised in these genres, their abilities as artists were never questioned. This institutionally constructed segregation was then represented as evidence of an innate inequality of talent.

Throughout the nineteenth century women artists campaigned consistently against this exclusion from the nude. But it is arguable that this struggle served to divert their energies. It is not without irony that their final victory and entry into the full academic curriculum occurred precisely at the moment when the hegemony of the academic tradition was successfully challenged and finally eroded by the emergence of avant-garde practices and theories. Moreover, when avant-garde artists rejected academic theories and hierarchies, they took up the hitherto less prestigious field of portraiture, landscape and still-life. Women could and did take full part in avant-garde movements based in these, for them, familiar, areas of art.

The phenomenal success of Rosa Bonheur (1822–99), for example, occurred in landscape and animal painting, genres which became more important during the nineteenth century under the impact of romantic landscape painting and the revaluation and influence of Dutch seventeenth-century art. Once again shifts of artistic ideology touched and transformed areas of predominantly female practice.

Bonheur came from a painter's family: her father was a painter, her mother had been his pupil, and both her brother and sister pursued their parents' career. Bonheur was initially trained as a *couturière* before her father agreed to oversee her instruction as a painter. In 1849 she took over his post as the director of a drawing school. In addition to her father's profession, she adopted his politics. He was a Utopian socialist of the school of Saint-Simon whose doctrines not only espoused equal rights for women but placed a special social

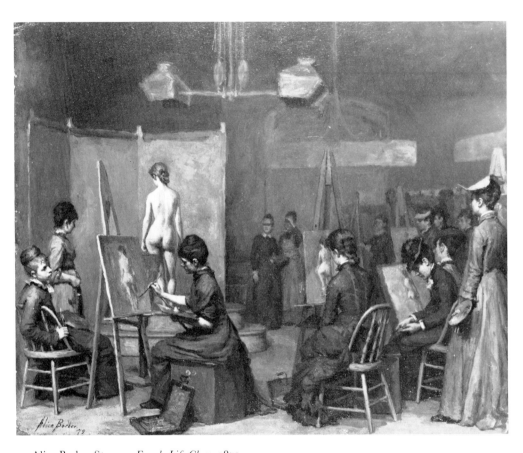

22 Alice Barber Stevens, *Female Life Class*, 1879
The painting was commissioned by the Academy in order to be reproduced in a popular magazine article which described the advanced and progressive courses available in this art school. In the centre of the studio we can identify Susan Macdowell at work on her canvas. Macdowell later married Thomas Eakins who was largely responsible for initiating life studies for women students.

responsibility upon the artist as part of the élite that would lead society through to a new world. Saint-Simonism thus provided Bonheur with a model of activity both as a woman and as an artist. Bonheur won considerable success as a professional artist—she was made a member of the coveted Légion d'Honneur. The award was given for her paintings, drawings and sculptures of animals, whose anatomy, unlike that of the human figure, she was able to study. She dissected carcasses in slaughterhouses and observed animals at work in the fields and in her own private menagerie.

Bonheur's work as an animal and landscape painter was part of a development in French painting in the first half of the nineteenth century—the establishment of a romantic-naturalist landscape and genre painting movement known as the Barbizon School. Within this group the other major animal painter was Constant Troyon (fig. 23). His paintings of watering cattle and woodlands bathed in subtle atmospheric effects of light observed at different times of the day represent a lyrical and idyllic tendency within the Barbizon School. Bonheur's treatment of animals was, however, more energetic. She represented animals at work, as in the painting which was her first major public success, *Ploughing in the Niverne* (1848, Fontainebleau, Musée Nationale du Chateau de Fontainebleau). *The Horse Fair* (fig. 24), completed for the Paris Salon of 1853, was the largest canvas an animal painter had produced. (Size was still a matter of prestige and was usually reserved for history paintings—though this had been questioned by Courbet's paintings in the Salon of 1850–1.) *The Horse Fair* combines the heroic mode of earlier Romantic treatments of horses by such artists as Théodore Gericault (1791–1824), for whom the horse was the embodiment of energy, power and virility, with the more contemporary naturalist concerns for atmospheres and effects of light.

However, despite the growing public for this kind of painting, and the relatively easier access an artist such as Bonheur had to the study of her animal models, her practice was constrained by other factors—by notions of propriety and the confinement of women to the private and domestic sphere. In order to make the preliminary studies for *The Horse Fair* Bonheur had to visit the Paris horse market. To do this without harrassment or danger on account of being a woman in such a public place, she dressed in men's clothing—for which she had to get legal authorisation. Thus in order to paint scenes outside the domestic sphere she had to disguise her sex. For as a member of the female sex, an artist was subject to the constraints bourgeois society was increasingly placing on women's activities and movements.

The practice of women artists was increasingly determined in the nineteenth century by the consolidation of bourgeois society and its ideologies of femininity—the natural essence of womanhood sustained and reproduced

through the location of women in the home and identification of women with domesticity. Later in the nineteenth century the Impressionist movement turned away from bourgeois classicism and history painting to genre scenes of contemporary modern life which included scenes of bourgeois leisure and family life. Moreover they rejected official institutions and established their own exhibition society to which a number of women artists were drawn. With the Impressionist group, Berthe Morisot (1841–95) and Mary Cassatt (1844–1926) not only found a more congenial environment for their radical art politics, but, because of the Impressionist ethos of 'modernity', they were able to draw upon their direct experiences of the circumscribed lives of bourgeois women in the family as subject matter for their artistic practice. However, the contradictions they experienced as women and artists, though comparable in some ways to those experienced by earlier generations of women artists, were magnified by the rigid social roles and definitions of femininity constructed within bourgeois society.

The passage from girlhood to womanhood fascinated both male and female writers and artists in the nineteenth century but with significant differences. For women the onset of puberty was the onset of their bondage; for male writers it was the moment of the mystery of femininity. Morisot frequently painted adolescent girls, often with great poignancy, as in the numerous portraits of her daughter. In *Psyche* (fig. 25), a young girl dresses in front of a mirror, also known in French as *psyché*, but pauses in private reverie, for which the title provides some clues. Psyche was the mortal who fell in love with Cupid and aroused the jealousy of Venus. Her unhappy state finally won the compassion of Venus and she was reunited with Cupid. The theme of awakening sexuality and young love had attracted Romantic artists to the story. Morisot's painting, however, strips the story of its classical garb and offers a contemporary Psyche, half-dressed, in brilliant whites, in a boudoir, looking at herself, her adolescent sexuality subdued, turned in on itself, private, dreamy.

Cassatt was far more radical in her examination of the phases of women's lives and the social and ideological constraints within which they lived. (For a full-length study of this artist, see G. Pollock, *Mary Cassatt*, London, 1980.) Cassatt was an American, an expatriate who had chosen to live in France for her working life because she felt that Europe offered more opportunities than her native country for a woman to do serious work, in her own words, 'to be someone not something'. She was not only a supporter of women's campaigns for political emancipation, but she herself stated in letters that her involvement with the struggle of independent artists against the Salon and its jury system was a political commitment to the causes of freedom. This radicalism is apparent, moreover, both in the subjects she chose to paint and

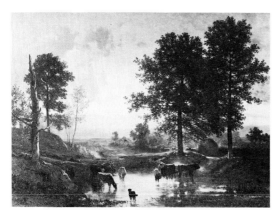

23 Constant Troyon, *Watering Cattle*, 1857[?]

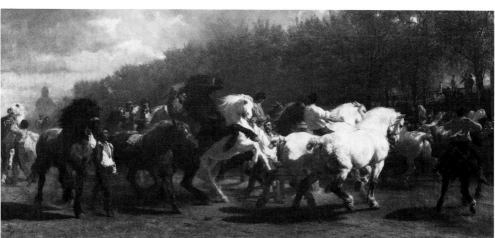

24 (*above*) Rosa Bonheur, *The Horse Fair*, 1853

25 Berthe Morisot, *Psyche*, 1876

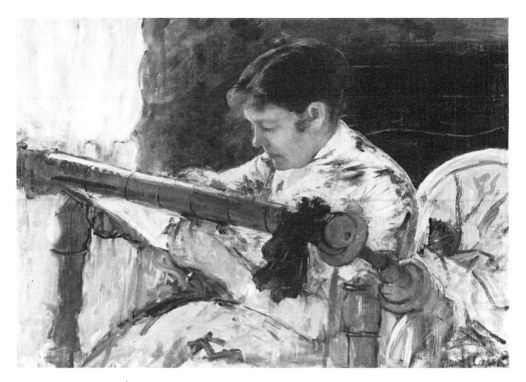

26 Mary Cassatt, *Lydia at a Tapestry Frame, c.* 1881

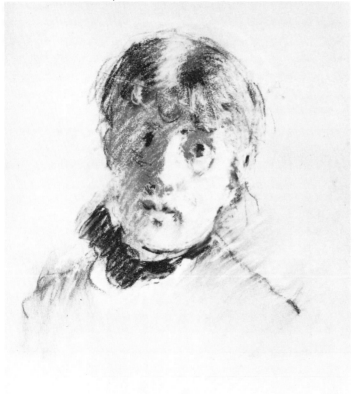

27 Berthe Morisot, *Self-portrait*, 1885

the way in which she painted them. In her works Cassatt critically analysed the life of bourgeois women from infancy to old age in such a way that their acquisition of 'femininity' is exposed as a social process, not as the essence of womanliness, ideologically imputed to women as their nature, but a result of their introduction into place in the social order. The way in which she represented these processes is crucial. Her bold and decisive style effectively subverted traditional images of women, the mother and female child, for instance.

Because her subject matter was drawn—of social necessity—from the world of women in which she lived as an unmarried daughter of a bourgeois family, because she addressed herself to the stages of women's lives—as young girls, mothers, matrons, in families, in the domestic sphere—her paintings are easily mis-recognized. Instead of being seen as a radical critique of dominant ideologies, they are used as confirmation of them. Yet even in those works depicting a woman engaged in what was in the nineteenth century *the* feminine domestic activity, 'woman's work', embroidery, Cassatt's treatment undermines that ideology. In *Lydia at a Tapestry Frame* (fig. 26) the composition is boldly painted and presents a picture of a woman absorbed in work. But the woman and her work are placed in a confined space, enclosed. That containment is almost brutally broken and aggressively thrown at the spectator by the way in which the wooden embroidery frame threatens to break out of the flat plane of the painting. This is but one example of the way in which Cassatt manipulated space and compositional structure to endow what women did in the home with respect and seriousness, while at the same time being able to make us recognize the limitations resulting from the confinement of bourgeois women in the domestic sphere alone.

Morisot had participated in the first group exhibition of those artists who were collectively dubbed 'Impressionists' in 1874. Manet and her old teacher, Guichard, advised her strongly against joining forces with 'those madmen' and risking general derision by withdrawing from the official institutions of art such as the Salon. At first Morisot shared the critical abuse poured by some on the independents, but once the group established its own circle of dealers, patrons and critics, Morisot was spoken of stereotypically as a 'women Impressionist', or, with the other women in the group, Mary Cassatt, Eva Gonzales and Marie Bracquemond, as an exponent of 'feminine Impressionism'. However, various writers on Impressionism placed Morisot in a central position within that movement. Some even hailed her as the only true Impressionist. But their praise of Morisot depended on the constant association of Impressionism with a certain notion of femininity based on intimations of subtle sensibility, nuance and suggestiveness. This is interesting for, in so far as femininity was used as a critical category to some extent independent of the gender of the

41

practitioner—men's work too could share these qualities—we can perceive more clearly of what qualities the category 'feminine' is composed. However, the critics still tried to detect some biological connection between the presence of certain qualities in Morisot's work and the artist's sex. But just as important is another aspect of this critical response to Morisot which elided her sex, her 'eternal feminine', with her social class. Roger-Marx wrote of a talent developed 'in complete quietude, according to the logic of sex, temperament and social class' (*Gazette des Beaux-Arts*, 1907, p. 508) and he supported this with reference to the novel *Chérie* (1884) by the de Goncourt brothers in which a fascination with the artifice and elegance of the life of the haute bourgeoisie is represented by the study of a female child in that milieu.

These contemporary critics were attempting to find something to say for women's art. But, more often than not, they lost sight of the individual artist in their overriding notion of femininity. In an appreciative essay on Berthe Morisot, *Sex in Art* (1890), George Moore exposed all the contradictions and uneasy manoeuvres of a thoroughly bourgeois Victorian struggling to come to terms with paintings that genuinely moved him:

Madame Lebrun painted well, but she invented nothing, she failed to make her own of any special manner of seeing and rendering things; she failed to create a style. Only one woman did this, and that woman is Madame Morisot, and her pictures are the only pictures painted by a woman that could not be destroyed without creating a blank, a hiatus in the history of art. True that hiatus would be slight—insignificant if you will—but the insignificant is sometimes dear to us; and though nightingales, thrushes and skylarks were to sing in King's Bench Walk, I should miss the individual chirp of the pretty sparrow.

Madame Morisot's note is perhaps as insignificant as a sparrow's, but it is an unique and individual note. She has created a style, and has done so by investing her art with all her femininity; her art is no dull parody of ours; it is all womanhood—sweet and gracious, tender and wistful womanhood. (pp. 228–9)

We may be tempted to smile at Moore's evident confusion. However, we should not minimize the destructive effects of such condescension and its assertion of a categorical difference between masculine and feminine. The *Correspondence* (ed. Rouart, 1957) of Berthe Morisot provides the necessary and saddening corrective. It underlines the potency of Victorian ideology which denied women a belief in themselves more powerfully than had mere institutional discrimination or exclusion from academic education.

Morisot came from an haut-bourgeois family with three daughters all of

whom wanted to study art. Initially their parents complied with their wishes for it was thoroughly acceptable for a lady to be 'accomplished' as a sketcher or watercolourist. Their first drawing master, Guichard, disturbed by the obviously serious ambitions of his three pupils, wrote to their mother:

> Your daughters have such inclinations that my teaching will not give them merely the talent of pleasing; they will become painters. Do you know what this means? In your environment . . . this will be a revolution, if not a catastrophe. (A. Mongan, *Berthe Morisot*, 1961, p. 12)

Undeterred, the Morisot sisters demanded more and better instruction and became for a short time the pupils of Camille Corot, one of the leading landscape painters of the Barbizon School. However, the haut-bourgeois environment soon claimed the eldest, Yves, whose marriage denied her further access to art practice. Though Edme was considered the most gifted by her teachers, her career was also cut short. What Guichard's warning had failed to check, marriage soon halted, for on her marriage in 1869 Edme Morisot was obliged by social convention to abandon all painting but pastiches of her younger sister's work. Shortly afterwards she wrote sadly to Berthe, revealing her sense of loss:

> I am often with you in my thoughts; I follow you everywhere in your studio and I wish that I could escape, were it only for one quarter of an hour to breathe again that air in which we lived. (B. Morisot, *Correspondence*, 1957, p. 27)

Berthe Morisot's reply to her unhappy sister is yet more depressing. It reveals how difficult it was for a woman of their class to believe in herself as an artist, despite her continuing professional practice and evident determination. Her response is witness to the way women internalized Victorian definitions of the nature of Woman. A kind of psychological indoctrination replaced the clumsy weapons of institutional discrimination:

> This painting, this work you mourn for, is the cause of many griefs and troubles. . . . Come now, the lot you have chosen is not the worst one. You have a serious attachment and a man's heart totally devoted to you. Do not revile your fate. Remember it is sad to be alone and despite anything that may be said or done, a woman has an immense need of affection. For her to withdraw within herself is to attempt the impossible. (*Ibid.*, p. 28)

The appalling poignancy of such language is paralleled pictorially in Morisot's *Self-portrait* of 1885 (Fig. 27). Morisot depicted herself at the age of

forty-four, after more than eleven years of professional, respected work. Yet this self-portrait is a supremely defensive image: the expression is tentative through the veil of light pastel, and the face hovers uncertainly on the paper, partially obscured by dark shadow. The drawing's physical delicacy, the immaterial dust of coloured chalks, inscribe into the language of art itself the confusions a nineteenth-century woman artist experienced. While using the excellence of her own skill as a painter, she presented her conflicted sense of identity as woman and artist.

III

By the late nineteenth century, Victorian historians of art could rightly record the persistent presence of women in the history of art and note their growing numbers and gradual progress in the face of problems such as institutional exclusion and lack of recognition. In 1876 Clayton talked confidently of these 'latter pleasant days' when more women than ever worked in the fine arts, had won access to Academy schools or set up their own places of art education and were able to participate in avant-garde circles. Yet these practical developments were in fact Pyrrhic victories. The consolidation of the bourgeois social system and its ideologies increasingly isolated women from both participation in and recognition as part of the mainstream of social and cultural production. Victorian writings on 'Women Artists' simultaneously recorded the existence of women artists and laid the foundations for their obliteration. Because women artists were treated, as were all women, collectively as a homogeneous group by virtue of their shared gender, and separately from artists of a different gender, women were effectively placed in an absolutely different sphere from men. Thus art by women was subsumed into bourgeois notions of femininity and furthermore, art historically, relegated to a special category which was presented as distinct from mainstream cultural activity and public professionalism—the preserve of masculinity. Thus at the very moment of a numerical increase in the numbers of women artists working professionally, women artists were represented as different, distinct and separate on account of their sex alone.

In the twentieth century women artists have to struggle against these dominant bourgeois notions of sexual difference which emerged in the nineteenth century. However, a new and significant factor is the discipline of art history itself with its related critical and curatorial practices. For modern art history has not only inherited and perpetuated Victorian ideologies of femininity and notions of women's art as categorically different from men's. These positions have solidified and in place of Victorian notions of separate but

(un)equal, however contradictory those were, modern art history produces a picture of the history of art from which women are not only absent, but identifies women artists as inevitably and *naturally* artists of lesser talent and no historical significance.

IV

With the rise of the modern women's movement, feminist artists, critics and art historians have begun to question the neglect of women artists and the stereotyped dismissal of women's art. Important work has been done in the past few years. Hundreds of women artists have been documented and the art historical establishment's limited vision of the entire history of art has been exposed. Two major trends in feminist thought can be identified, neither very satisfactory. We have been caught too often in reacting against the dominant notions about women's art and have tended only to exchange one set of stereotypes for another. And, in the attempt to make art history take notice of women artists, we have submerged them once again in a slightly reformed but still traditional notion of history.

Myths about creativity and the limiting, distorting way art historians write about the past have deep roots in our social structure and ideologies. They are powerful and pervasive and the feminist attempt to challenge them is rendered difficult precisely because we have been produced within the dominant social order. Some of the very real traps and contradictions can be illustrated by analysing the main tendencies in feminist literature, not simply to criticise but rather to suggest some of the dead-ends which many feminists, ourselves included, have come up against in trying to challenge existing ideologies and practices.

Confronted with the complacent ignorance of the art historical establishment, feminist art historians are obliged to prove the very existence of women artists. Reacting to this provocation, feminists rummage in dusty basements and return to ancient sources in search of 'Old Mistresses' to rescue them from undeserved neglect and re-establish their reputations, justifying their research, however, according to the establishment's criteria. Eleanor Tufts's *Our Hidden Heritage: Five Centuries of Women Artists* (1974) is representative of this reformist trend. She writes in her introduction:

> I hope this book, by presenting a selection of outstanding women artists over five centuries will constitute the beginning of a redress of balance
> As our hidden heritage of women artists becomes more apparent and solidly annexed to the main stream of history, we might look forward to

monographs on the artists perused here and a closer scrutiny of all artists throughout the centuries. (pp. xv and xvii)

Tufts's book aimed to redress the neglect and omission of women artists from the sixteenth century onwards by providing twenty-two mini-monographs. She anticipated that her initial researches would inspire more extended monographs on these and other women painters and sculptors. However, on the evidence and model provided by her book such studies would only serve to reproduce, with the slight difference of women in the place of men, the concentration on the isolated individual artist and an exclusively stylistic account typical of current art historical practices represented in the monographic format, and its emphases and limitations. Moreover, Tufts's text suggests that women artists, thus partially retrieved, are to be *annexed* to the mainstream of art history. Women will thus on the one hand be integrated and absorbed into existing fields of historical knowledge through the established channels and formats. On the other, they are to be absorbed simply as additions. In her haste to insert women into the current patterns and curricula of the discipline, the specific factors affecting women's work and its varying differences from men's, as well as other perspectives from which one has to analyse the historical process in order to comprehend women's activities within their particular contexts, are avoided or overlooked.

This determination to relocate women in art history on the discipline's own terms culminated in the United States during 1976 with a huge exhibition and a scholarly book *Women Artists 1550–1950* by Linda Nochlin and Ann Sutherland Harris. Sutherland Harris concludes her introductory essay with this statement:

> Slowly these artists must be integrated into their art historical context. For too long they have either been omitted altogether, or isolated and discussed only as women, not simply as artists as if in some strange way they were not part of their culture at all. This exhibition will be a success if it helps remove once and for all the justification of any future exhibitions with this theme. (p. 44)

The intention is thus to bring to an end the separate categorisation of women artists. However, it is clear that the authors subscribe to a slightly modified, but none the less conventional notion of art history, its system of values and criteria of significance. So perhaps inevitably their initially admirable intentions are ultimately betrayed by academic conservatism and defensiveness. For instance, in so far as Nochlin and Sutherland Harris feel obliged to offer justification for women's inclusion in art history books and courses, they not

only acknowledge, but also reinforce, existing systems of values established from men's work against which women artists have to be measured. But, more significantly, because they cannot accept the fact that the existence and activity of women in art throughout history is of itself a sufficient justification for historical enquiry, they offer reasons for women's inclusion in existing forms of art history on grounds that are spurious in terms of the discipline itself. A comment on Anguissola, for instance, is revealing:

> And *even if* Sofonisba Anguissola's contribution to Renaissance portraiture does not earn her a place in the Renaissance chapter, her historical impact as the first women artist to become a celebrity and thereby open up the profession to women surely does. (p. 44, our italics)

By treating Anguissola only as an interesting novelty, the really interesting questions are ignored. To what extent must our understanding of the Renaissance be altered in view of the fact that such a painter as Anguissola was considered worthy of note by her contemporaries? What different kinds of portraits did she produce because she was a woman and of noble birth as opposed to those painted by her male contemporaries? Anguissola the artist is not allowed to expand our understanding of her period. The woman artist is merely to be added as an interesting celebrity whose importance lies only in her pioneering role for a sub-group, women.

Such a process loses sight of the particularity of women's participation in a given period in an attempt to make them acceptable to current art history. Some feminists do recognize that art history needs to be modified in order to understand women's different circumstances. Linda Nochlin herself wrote in an earlier article:

> A feminist critique of the discipline of art history is needed which can pierce cultural-ideological limitations to reveal biases and inadequacies *not only in regard to the question of women artists, but the formulation of crucial questions of the discipline as a whole.* Thus the so-called woman question, far from being a peripheral sub-issue, can become a catalyst, a potent intellectual instrument probing the most basic and 'natural' assumptions, providing a paradigm for other kinds of internal questioning, and providing links with paradigms in other fields. ('Why Have There Been No Great Women Artists?', *Art and Sexual Politics*, ed. E. Baker and T. Hess, 1973, p. 2)

According to Nochlin's statement the feminist critique is validated *because* it sets off long-needed reforms. But as we shall argue, a radical reform, if not a

total deconstruction of the present structure of the discipline is needed *in order to* arrive at a real understanding of the history of women and art.

While many feminists are caught in the trap of merely reacting against the monolithic art historical dismissal of women, attempting to justify their reconsideration without seriously questioning the basis of art history's practice and values, others over-react and reject any form of art historical analysis. They do not look at women's precise place in history, nor do they undertake pictorial analysis of works by women in relation to their historical period. This tendency can be seen in *Women Artists: Recognition and Re-Appraisal from the Early Middle Ages to the Twentieth Century*, by K. Petersen and J. J. Wilson, who make a fair criticism: 'The danger of having a fixed, or unexamined, art history perspective is that it all too frequently predisposes us to look only at certain kinds of art, to see only superstars, chosen by biased criteria' (pp. 6–7). But in so far as Petersen and Wilson then compile an amplified dictionary of women artists, the art produced by women is still effectively left in the separate category the Victorians constructed, a tendency their title, *Women Artists*, reinforces. Of course, the authors would not accept a Victorian notion of an essential 'femininity' but, because women artists are lumped together in one book without sufficient attention to their diverse and particular historical contexts, the book gives the impression that there is a fundamental link between women artists down the ages simply because they are of the same gender.

In order to avoid that particular trap some feminists are tempted to discount the possibility of any distinctive feature resulting from their gender in women's art at all. Thus women's work is offered merely as a few more examples of mainstream styles, 'Impressionist', 'Realist', 'Surrealist' or 'Abstract'. However, any argument that proposes 'art has no sex' ignores the difference of men's and women's experience of the social structures of class and the sexual divisions within our society, and its historically varied effects on the art men and women produce.

The strategies adopted by feminists have been enormously important. Most significantly the conventional biologistic accounts of women's art or 'natural' explanations for women's supposed absence from the history of art have been shown to be fallacious. Feminist art history to date has redressed twentieth-century neglect and omission. Some have accomplished this only by refusing to acknowledge the specific conditions of women's artistic practice. Others, admittedly with slight shifts of emphasis, have merely returned us to the position bequeathed by the Victorians. Women artists remain an entirely separate category.

The more radical attempts to avoid Victorianism often turn to sociologically based accounts of the obstacles and institutional forms of discrimination

women artists have encountered. They are ultimately handicapped by the unaltered perspectives and unquestioned value systems within which their work is constituted. Such a sociologically oriented approach is the product of the equal rights movement in feminist politics in the early 1970s which attacked forms of social and economic discrimination against women. While these struggles for equal opportunities have produced some reforms, they leave intact and unexamined the social and ideological structures of which discrimination is but a symptom.

In 1972 Linda Nochlin published an essay entitled 'Why Have There Been No Great Women Artists?'. Leaving aside for the moment the troubled question of 'true greatness', defined by whom and with what criteria, the very question itself is revealing, for it implies a negative. As Nochlin rightly points out, it can only be answered by defensive explanations. However, she herself stated that there have not been great women artists. And she concentrated on explanations for this absence based on institutional exclusion, restrictions on training and conflicting attitudes to women's professional activity. But if these social or institutional restraints had indeed been effective, or, more importantly, were the central cause of women's 'problems' in art practice, the only logical conclusions one could draw would be that there should have been no women artists at all. However, since there have always been women artists, the issue is rather how they worked despite these restraints. Furthermore, in many cases women have produced really interesting work as much because of as despite their different relation to the structures that officially excluded them.

The issues have thus to be reformulated. Women artists have always existed. They worked consistently and in growing numbers despite discrimination. Each woman's work is different, determined by the specific factors of sex, class and place in particular historical periods. Women have made their own interventions in the forms and languages of art because they are necessarily part of their society and culture. But because of the economic, social and ideological effects of sexual difference in a western, patriarchal culture, women have spoken and acted from a different place within that society and culture.

The most signal omission of feminist art history to date is our failure to analyse *why* modern art history ignores the existence of women artists, why it has become silent about them, why it has consistently dismissed as insignificant those it did acknowledge. To confront these questions enables us to identify the unacknowledged ideology which informs the practice of this discipline and the values which decide its classification and interpretations of all art.

2

Crafty women and the hierarchy of the arts

The sex of the artist matters. It conditions the way art is seen and discussed. This is indisputable. But precisely how does it matter? Art history views the art of the past from certain perspectives and organizes art into categories and classifications based on a stratified system of values, which leads to a hierarchy of art forms. In this hierarchy the arts of painting and sculpture enjoy an elevated status while other arts that adorn people, homes or utensils are relegated to a lesser cultural sphere under such terms as 'applied', 'decorative' or 'lesser' arts. This hierarchy is maintained by attributing to the decorative arts a lesser degree of intellectual effort or appeal and a greater concern with manual skill and utility.

The clear division of art forms into fine arts and decorative arts, or more simply the arts and the crafts, emerged in the Renaissance and is reflected in changes of art education from craft-based workshops to academies and in the theories of art produced by those academies. By the mid-nineteenth century the complete divorce of 'high art' and craft was a cause of considerable concern to Jane Morris's husband, William Morris, who looked back to the Middle Ages when this damaging division was not so absolute. He also warned of the immediate dangers, to all forms of art, from this hierarchy:

> I shall not meddle much with the great art of Architecture, and still less with the great arts commonly called Sculpture and Painting, yet I cannot in my own mind quite sever them from those lesser, so called Decorative Arts, which I have to speak about: it is only in latter times and under the most intricate conditions of life, that they have fallen apart from one another; and I hold that, when they are so parted, it is ill for the Arts altogether: the lesser ones become trivial, mechanical, unintelligent, incapable of resisting the changes pressed upon them by fashion or dishonesty; while the greater, however they may be practised for a while

by men of great minds and wonder-working hands . . . are sure to lose their dignity of popular arts, and become nothing but dull adjuncts to unmeaning pomp, or ingenious toys for a few rich or idle men. (*William Morris, Selected Writings and Designs*, ed. Asa Briggs, 1962, p. 84)

The art and craft division can undoubtedly be read on class lines, with an economic and social system dictating new definitions of the artist as opposed to the artisan. However, there is an important connection between the new hierarchy of the arts and sexual categorization, male-female. An early intimation of both a hierarchy of values and the sexual division in that hierarchy occurs in a passage of 1713 from a major eighteenth-century aesthetic theorist, Lord Shaftesbury:

So that whilst we look on paintings with the same eyes as we view commonly the rich stuffs and coloured silks worn by our Ladys, and admir'd in Dress, Equipage or Furniture, we must of necessity be *effeminate* in our Taste and utterly set wrong as to all Judgement and Knowledge in the kind. (Michael Levey, *Rococo to Revolution*, 1966, p. 121, our italics)

Shaftesbury asked for discrimination between painting and the decorative arts, but why is lack of discrimination effeminate? The fact that the vast majority of creative work that covered surfaces of dress, equipage and furniture in the time of Lord Shaftesbury was embroidery by women suggests that the sex of the maker was as important a factor in the development of the hierarchy of the arts as the division between art and craft on the basis of function, material, intellectual content and class.

An example from the development of the stratification in the fine arts themselves, the history of flower painting, provides the necessary link between sex and status. It shows how the presence of women in large numbers in a particular kind of art changed its status and the way it was seen. Flower painting originated as a branch of still-life painting all over Europe in the sixteenth and early seventeenth centuries, becoming a major genre in Holland during the seventeenth century and continuing to attract a substantial number of practitioners well into the twentieth century. A few women were involved in flower painting from the beginning, for example Fede Galizia (1578–1630) (fig. 28), Clara Peeters (1594–post 1657) (fig. 29) and Louise Moillon (1610–96). Flowers were used as metaphors richly resonant with meaning, and were symbolic of morality and mortality, appearing as allegories of vanity and the cycles of human life, birth, blossom, death and decay.

The still-life by Maria van Oosterwijk (1630–93) (fig. 30) is a most comprehensive example of the genre of *vanitas* or 'vanity' painting and contains

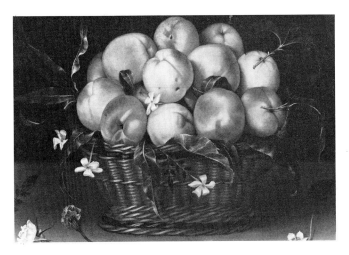

28 Fede Galizia, *Basket of Peaches*, n.d.

Galizia was born in Milan, the daughter of a miniaturist, Nunzio Galizia. She made her reputation as a portraitist and painter of religious subjects, one of which depicted *Judith and her Handmaid* (Sarasota, Florida, Ringlings Museum). Yet it is her still-lifes which are particularly remarkable. Her works in this genre are some of the earliest examples of pure still-life in Italy. Although very few of them are signed and dated, her distinctive treatment and daringly simple compositions are easily recognized. Galizia's combinations of sensuously textured and rounded forms of fruits with pale-toned, aromatic plants and flowers both satisfy compositional necessity and convey such allegorical meanings which underlie the genre of still-life as, for instance, the five senses and the brevity of life.

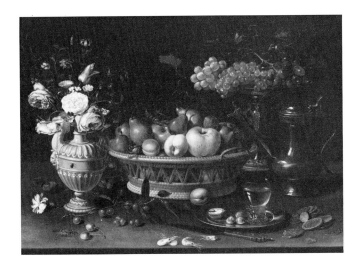

29 Clara Peeters, *Still-life with Nuts and Fruit*, post 1620

Careful analysis of Peeters's early dated works and comparison with the contemporary practice of the genre of still-life in Flanders has led Ann Sutherland Harris to conclude that 'Peeters would appear to be one of the originators of the genre'. Still-life painting requires a certain virtuosity in representation of different textures, objects and reflections on metal and glass surfaces. In the Ashmolean canvas, fruits, flowers, nuts, a plate, a tankard, a basket, wine, metal coins, insects and crustaceans provide a range of interest and virtuoso display of oil painting. In the reflection in the tankard we glimpse a portrait of the artist herself at work. The choice of objects, however, is not arbitrary; they are part of a complex symbolic vocabulary which evolved in still-life painting to signify, in this case, worldly possessions (coins), earthly pastimes (wine and food) or the transience of life (full-blown roses).

30 Maria van Oosterwijk, *Vanitas*, 1668

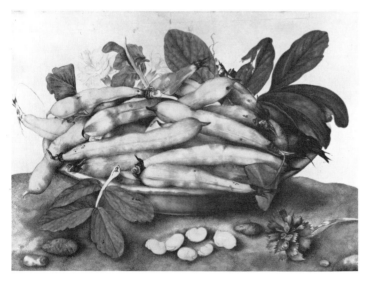

31 Giovanna Garzoni, *A Dish of Broad Beans*, n.d. Garzoni worked in many Italian cities, enjoying a substantial reputation and its material rewards in Florence and settling in Rome where she became a member of the Accademia di San Luca. On her death she left all her possessions to that institution and following her instruction a monument to her was erected in the Accademia's church.

Her pictures of fruits and animals are some of the finest botanical studies of the seventeenth century, but belonged to a different tradition of still-life to that represented by the emblematic works of Clara Peeters (fig. 29). Garzoni undertook a more scientific examination of natural forms which are presented in clear, carefully-drawn compositions. Her favoured medium was not oil paint on canvas but either watercolour on vellum or tempera on parchment, which avoid illusionist effects in the painting of objects, textures and appeal to the senses in favour of a more analytical concern with forms and structures of the natural world. As Ann Sutherland Harris has pointed out, Garzoni's blend of still-life and analytic drawing 'goes back ultimately to Leonardo and Dürer' while anticipating the more scientific botanical studies of Maria Sibylla Merian (figs 32 and 33).

symbols which, in the language of still-life compositions, express a moral on the transience of worldly things, the vanity of earthly pleasure, the brevity of life. Oosterwijk's *Vanitas* points to the ambivalence of the genre which ostensibly warns against preoccupations with earthly things while using the illusionism of oil paint to celebrate and reproduce material possessions. Each object is accurately and sensitively reproduced, as a reminder perhaps that the very strength of worldly pleasure, possessions and consumption depends upon its evanescence. Oosterwijk included an enormous range of examples from the three groups of objects commonly used to convey this moral. The professional life is represented by the pen and ink. Worldly wealth is symbolized by the account book and coins. Frivolous pastimes are present in the flute lying on the music and a glass of aquavita. All the accompanying flowers, animals and insects contribute to the theme; the anemone, for example, is associated with sorrow and death and the knapsack stands for the journey of life (see also figs 31–36).

Yet despite the complicated iconographic programmes of many flower paintings, one twentieth-century commentator wrote: 'Flower painting demands no genius of a mental or spiritual kind, but only the genius of taking pains and supreme craftsmanship' (M. H. Grant, *Flower Painting Through Four Centuries*, 1952, p. 21). The explanation for Grant's blindness can be found within his own text:

> In all three hundred known years of their production, the total practitioners of flowers down to 1880 is less than 700 and of these by no means all are florists *pur sang*, that is to say unassociated with various forms of still-life. Whilst only a very small proportion are artists of the highest or even high merit. Actually, more than 200 of these are of late eighteenth and nineteenth century and at least half of them are women. (p. 21)

By the late eighteenth century flower painting had become a common genre for women artists. The characterization of flower painting as petty, painstaking, pretty, requiring only dedication and dexterity is related to the sex of a large proportion of its practitioners, for as the following comment by the late nineteenth-century writer Léon Legrange shows, the social definition of femininity affects the evaluation of what women do to the extent that the artists and their subjects become virtually synonymous: 'Let women occupy themselves with those kinds of art they have always preferred . . . the paintings of flowers, those prodigies of grace and freshness which alone can compete with the grace and freshness of women themselves' ('Du rang des femmes dans l'art', *Gazette des Beaux-Arts*, 1860). One can hardly imagine a serious art historian attempting to explain Michelangelo's *David* by equating its lithe, athletic

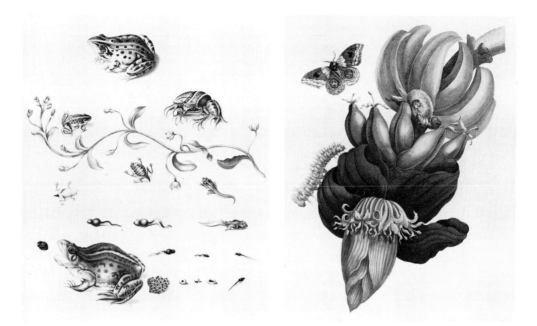

32 (*above, left*) Maria Sibylla Merian, *Metamorphosis of a frog*, n.d.
Merian was born in Frankfurt, daughter of a geographer and engraver who owned a publishing house, and step-daughter of a flower painter. She herself trained as a flower painter. She was probably familiar from an early age with the role of artists in the scientific study of nature; it was her father who published in 1641 a new edition of one of the first sets of engravings of different flower species. But while other artists were content simply to illustrate specimens, Merian collected and reared insects herself and painted them very carefully on parchment. It was she who discovered the metamorphosis of the butterfly, its development from egg to insect, and recorded her observations in a massive catalogue of 186 European moths, butterflies and other insects, *The Wonderful Transformation of Caterpillars and [their] Singular Plant Nourishment*, published in three voloumes in 1679, 1683 and 1717. The study of the life cycle of a frog may have been intended for a similar book on European amphibians and reptiles. Nochlin and Sutherland Harris (1977) point out that her method of study and presentation 'revolutionized the sciences of zoology and botany and laid the foundation for the classification of plant and animal species made by Charles Linnaeus in the eighteenth century' (p. 154).

33 (*above, right*) Maria Sibylla Merian, *Metamorphosis Insectorum Surinamensium: Banana Plant*, 1705
In 1685 Merian left her husband and with her mother and two daughters went to live in a colony of Labadists in West Friesland in the United Provinces. The Labadists were a recently formed religious sect whose founder rejected formal marriage ties along with other aspects of Roman Catholicism. Sects which challenged the hierarchy of clearly defined church and state authority attracted many women in the seventeenth century. Anna Maria van Schurman, another Dutch feminist artist and writer, was also a Labadist.

In 1690 Merian moved to Amsterdam where she became acquainted with the director of the botanical gardens and such owners of natural history collections as Rachel Ruysch's (fig. 34) father. During her stay with the Labadists she had seen and become interested in insect and plant specimens from the Dutch colony of Surinam. The sect had a mission in the colony and her elder daughter was already living there. In 1699 Merian sailed for Surinam with her younger daughter, and, for two years, with her daughters' help, she recorded, in an album of watercolours, the *Surinam Notebooks*, the insect, plant and animal life in Surinam. In 1701 she returned to Amsterdam and *Metamorphosis Insectorum Surinamensium* was published four years later. The *Banana Plant* shows how she combined rigorous scientific observation with her own response to the specimen and a concern for pattern and composition. Merian's commentaries on the plates reflect her multi-disciplinary approach, for they provide not only scientific data but also information she obtained from local inhabitants on the use of plants and animals in cooking, for example, or for inducing abortions.

34 Rachel Ruysch, *Still-life with a Snake*, c. 1685–90

Clara Clement (1904) claimed that Rachel Ruysch was influenced by Sibylla Merian who knew Ruysch's father, a professor of botany and anatomy and an amateur painter, living in Amsterdam. Ruysch certainly shared Merian's intense curiosity about natural life. She too catalogued species of flowers, fruit, insects and reptiles, but Ruysch is quite rightly better known for her still-life painting in which she combined her knowledge of the natural world, the cycles and food chains observed and recorded by Merian, with the symbolism and allegory of the still-life tradition.

Aged fifteen she was apprenticed to the flower painter van Aelst but by 1685 she had invented a style completely her own. Ruysch placed her still-life compositions in shadowed, natural settings with the arrangement dominating the enviroment. 'Still-life' really seems a misnomer for these paintings which project an immense sense of energy, profusion and movement both by the composition and by the mass of insect life she painted.

In *Still-life with a Snake* she represented interdependence in the natural world—protection and destruction. Yet at the same time everything included in the painting carries a second order of symbolism, more emblematic. Judging by the dual symbolism of each object, the still-life probably refers to the death and resurrection of Christ. The snake, the rat and the locust are symbols of destruction but in nature they destroy for survival. The thorny thistle represents existence and non-existence, ecstasy and anguish, pleasure and pain, and relates to the symbolism of the cross. Feeding on the thistle flowers are red admiral butterflies, symbolizing life and transience, the soul and transcendence. The whole composition is based on the spiral echoed in the snail's shell. But quite apart from the esoteric symbolism, the painting presents a brutal image of conflict and the co-existence of opposites.

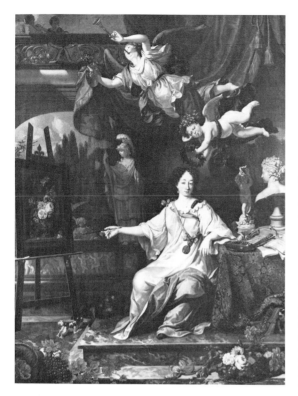

35 Constantin Netscher, *Rachel Ruysch in her studio*, n.d.

This portrait of Ruysch in her studio has been attributed to two of the artist's contemporaries, Constantin Netscher and Maria van Oosterwijck. It illustrates the professional success the painter achieved during her life-time. In 1701 she became a member of the guild of painters in The Hague along with her husband, the portraitist Juriaen van Pool, father of her ten children. In 1708 the Elector Palatine invited her to become court painter at Düsseldorf, and it is his medal that hangs round her neck in this portrait. She usually signed her work and roughly one hundred autograph paintings are known, yet in this portrait she appears more akin to a goddess of culture—a modern counterpart to the statue of Minerva, Goddess of Art, depicted in the background—than to a prolific professional painter. Her palette lies casually on a sheet of music, while the antique sculpture, the marble steps and the table carpet dominate the scene. References to her real achievement, the teeming still-lifes, are scattered along the lower edge of the canvas, and she gestures absently to her distant easel with the wrong end of her brush. Nevertheless, the portrait was intended as a tribute; a cupid crowns her with laurels while another palette and some brushes are borne aloft by a winged figure of Fame.

36 Mary Moser, *Vase of Flowers*, n.d.

vigour with the temperament and physique of the artist himself. The historical process by which women came to specialize in certain kinds of art and the symbolism of still-life and flower painting have been obscured by the tendency to identify women with nature. Paintings of flowers and the women who painted them became mere reflections of each other. Fused into the prevailing notion of femininity, the painting becomes solely an extension of womanliness and the artist becomes a woman only fulfilling her nature. This effectively removes the paintings and the artists from the field of fine arts. Descriptions of flower paintings by nineteenth-century critics and modern art historians employ exactly the same terms that are used to justify the secondary status accorded to crafts, which are similarly described as manually dexterous, decorative and intellectually undemanding.

Feminist historians have reacted to the hierarchical classification of art by asserting the value of women's work in the crafts. Some have hailed embroidery and other forms of needlework as women's 'true cultural heritage':

Women have always made art. But for women the arts most highly valued by male society have been closed to them for just that reason. They have put their creativity instead into needlework arts which exist in a fantastic variety wherever there are women, and which in fact are a universal female art form transcending race, class and national borders. Needlework is the one art in which women controlled the education of their daughters and the production of art, and were also the critics and audience . . . it is our cultural heritage. (Patricia Mainardi, 'Quilts: The Great American Art', *Feminist Art Journal*, Winter 1973, p. 1)

While women can justifiably take pride in these areas, asserting their value in the face of male prejudice does not displace the hierarchy of values in art history. By simply celebrating a separate heritage we risk losing sight of one of the most important aspects of the history of women and art, the intersection in the eighteenth and nineteenth centuries of the development of an ideology of femininity, that is, a social definition of women and their role, with the emergence of a clearly defined separation of art and craft.

The history of English embroidery shows how a medieval art became a 'feminine' craft. Embroidery may well be considered one of women's richest contributions to culture, but simply to glorify its history and to defend its value as a cultural product, leads us into the sentimental trap which ensnared Victorian historians of needlework. They were, for very different reasons, equally dedicated to claiming needlework as an *art*. Numerous nineteenth-century women wrote on embroidery, beginning with Elizabeth Stone, whose *Art of Needlework* was published in 1840. She insisted that there was an

indissoluble, God-given link between her sex and the craft and provided needlework with a long, pious history to sanction the hours upper- and middle-class women spent at their 'work'. Even in the Wilderness, she wrote, the daughters of Israel were never without their needles:

> With proud and pleased humility did the fair inmates of these tents, the most accomplished of Israel's daughters, display to their illustrious visitors the 'fine needlework' to which their time and talents had been for a long season devoted. (Elizabeth Stone (ed. Viscountess Wilton), *Art of Needlework*, 1840, p. 29)

Not all historians of embroidery went so far as to transport the Victorian drawing-room into the desert, but all effected a complete identification between women and the craft. 'Of one thing we may be sure—that it is inherent in the nature of English-women to employ their fingers' (Lady Marion Alford, *Needlework as Art*, 1886). Today we live with a legacy of Alford's certainty. Some art schools teach embroidery, but the vast majority, if not all, the students are women, and stitchery is commonly disparaged as 'women's work'.

The earliest references to British embroidery workers, however, dispel the notion that embroidery has always been an exclusively female craft. In pre-twelfth-century Britain, needlework was practised both by monks and nuns in religious houses and by independent professionals. It was also common for royal and noble households to have their own workshops. Some of the most famous pieces of Anglo-Saxon and Norman embroidery that have survived were made by queens and their household workshops. This association conferred on the practice a particular status in later periods. Embroidery was one of a number of arts and crafts which all served the same function, the glorification of the ruling institutions, church, monarchy and the nobility. Individuals of both sexes practised in all the arts. Monks and nuns, for example, both illuminated manuscripts and embroidered so that the two media display the same styles and design.

But crucial changes took place in British needlework production during the thirteenth and fourteenth centuries which affected both men's and women's relationship to the craft. Medieval embroidery culminated in a style known as Opus Anglicanum, with its silver-gilt thread, seed pearls, semi-precious stones and fine silk embroidery in split stitch which delineated the most subtle nuance of feature and gesture (fig. 37). Greatly in demand, it was exported all over Europe and the mode of production changed to meet the needs of the expanding market. Whereas the commercial production of embroidery had previously been in the hands of individuals, often women, scattered around the

country, it came to be produced in tightly organized, male-controlled guild workshops, centred on London.

Although early records of the Broderers Guild were destroyed in the Great Fire of 1666, a few names of practitioners survive, and we may surmise that the situation of women in the Broderers Guild was similar to that of women in other craft guilds, as described by Eileen Power in *Medieval Women*. She points out that although there was hardly a craft where women were not present, they were rarely admitted as full guild members. The family was the basic economic unit of which women were active members as daughters, wives and widows of guild masters, although some women did work independently as *femmes soles*. Thus in the thirteenth and fourteenth centuries the majority of recorded payments for embroidery were made to men for orders executed, perhaps, by their workshop staffs. There is evidence, however, of women's presence at all levels of production. The name of an embroidery apprentice, Alice Catour, has survived because in 1369 her father brought a 'bill of complaint' against the man to whom she was apprenticed, claiming that he beat her and failed to provide for her. And amongst the list of those who received payments for embroidery in the thirteenth century we find Mabel of Bury St Edmunds who undertook a great many commissions for Henry III.

So long as family industry survived, men and women collaborated in embroidery production. It was only with the social and economic changes beginning in the Elizabethan era that women's relationship to embroidery altered. The Reformation brought the large-scale production of ecclesiastical embroidery to an end, while greater national prosperity led to enormously increased demand for domestic embroidery. Tighter regulations and quality control were placed on embroidery production and the Broderers Guild was reconstituted as a company in 1568. All the officials were men. Simultaneously a much sharper division developed between amateur and professional work and the numbers of amateurs increased rapidly. They were all women.

A crucial factor in this development was the growing separation between the public and private spheres, the home and place of work. Sheila Rowbotham describes how the change affected women's lives:

> As crafts became more intensely capitalised the wives of larger tradesmen no longer worked in the business. . . . The external world of work became the sphere of men exclusively, and the internal world of the family and the household was the proper business of the woman. (*Women, Resistance and Revolution*, 1972, p. 26)

The worlds, of course, divided gradually. And there was one consistent feature in embroidery production which was to shape its future: it continued to

be made by queens. Both Elizabeth I and Mary, Queen of Scots, wielded the needle. Nicholas White wrote to Elizabeth's minister, Cecil, describing how Mary occupied herself during her imprisonment:

I asked Her Grace how she passed the tyme within. She sayd that all day she wrought with her nydill and that the diversity of the colours made the work seem less tedious, and contynued so long at it that veray payn made hir give over. . . . Upon this occasion she entered into a pretty disputable comparison between karving, painting and working with the nydill, affirming painting in hir awne opinion for the most commendable qualitie.

Mary's conversation with Nicholas White suggests, by bracketing embroidery with sculpture and painting, that in her life-time needlework had not yet been separated completely from the other arts.

Nor had it yet become divided as a working-class craft and a middle-class accomplishment. But the very fact that embroidery was practised as a pastime by a captive queen contributed to its future use. In 1738 Daniel Defoe observed that women 'act as if they were ashamed of being tradesmen's wives and scorn to be seen in the counting house much less behind the counter. . . . The tradesman is foolishly vain of making his wife a gentlewoman' (*The Compleat English Tradesman*, quoted in I. Pinchbeck, *Women Workers and the Industrial Revolution 1750–1850*, 1969). Embroidery, however, with its aristocratic connections, was a perfect proof of gentility, providing concrete evidence that a man was able to support a leisured woman, so that by the eighteenth century 'women's work', as it was called, played a crucial part in maintaining the class position of the household. It conveyed class connotations on several levels. Women were encouraged to ornament every conceivable surface because decoration in itself suggested a refined, tasteful life-style. And at the same time, the act of embroidering, the hours a woman spent sitting stitching for love of home and family, symbolized the domestic virtues of tireless industry, selfless service and praiseworthy thrift. 'It is as scandalous for a woman not to know how to use a needle as for a man not to know how to use a sword', wrote Lady Mary Wortley Montague in 1753. Thus, the delicate flowers patterning an eighteenth-century gentleman's waistcoat displayed both the value of his wife and the quality of his economic circumstances.

Needlework began to embody and maintain a feminine stereotype. The status of the craft plummeted and became prey to satirical attacks from men such as Addison who began a debate on women's devotion to needlework:

What a delightful entertainment must it be to the fair sex, when their

native modesty, and tenderness of men towards them, exempts them from public business, to pass their time in imitating fruit and flowers. . . . Another argument for busying good women in works of fancy is because it takes them off from scandal, the usual attendant of tea-tables and all unactive scenes of life. (*Spectator*, no. 606, 1712)

And in an *Idler* essay of 1758, Dr Johnson wrote as a husband whose wife kept their daughter incessantly at work:

Kitty knows not at sixteen the difference between a Protestant and a Papist because she has been employed three years in filling the side of a clout with a hanging that is to represent Cranmer in the flames. And Dolly, my eldest girl, is now unable to read a chapter in the Bible having spent all her time working an interview between Solomon and the Queen of Sheba. (Quoted in E. A. Standen, *Working for Love and Working for Money: Some Notes on Embroideries and Embroiderers of the Past*, 1966, p. 19)

Women too questioned their sex's preoccupation with embroidery, but not to ridicule it. They tried to explain why women dedicated so many hours to their work. One reason was that it made a considerable contribution to the domestic economy. Women did indeed furnish and clothe their households. Their needlework had both a decorative and utilitarian function. Anne Sherley's will of 1622, for example, listed items she embroidered including ten carpets, four long cushions and six chairs. Opponents of embroidery attacked such industry as misplaced economy. The *Ladies Magazine* of March 1810 printed an article 'On Female Education' blaming women's general ignorance on the time spent on their sewing and suggesting that they should buy rather than sew their embroidery:

Twenty pounds paid for needlework would give a whole family leisure to acquire a fund of real knowledge. They are kept with nimble fingers and vacant understanding, till the season for improvement is utterly passed away.

Yet in the same issue of the magazine there were the usual needlework patterns and the enthusiastic descriptions, stitch by stitch, of the embroidery worn by ladies at Court. Clearly thrift was only one of a number of factors behind women's compulsive needleworking.

Mary Lamb, Charles Lamb's sister, pointed to some of the confused motivations in a caustic, feminist essay, 'On Needlework' (1815). She argued that women should abandon amateur embroidery altogether:

Is it too bold an attempt to persuade your readers that it would prove an incalculable addition to general happiness, and the domestic comfort of both sexes, if needlework were never practiced but for a remuneration in money. As nearly, however, as this desirable thing can be effected, so much more nearly will women be upon an equality with men. (*Miscellaneous Prose 1798–1834*, 1903, p. 177)

Because embroidery is not seen as 'real' work, she continued, it does not allow women 'real' leisure. Moreover, it serves to occupy women, giving meaning to their empty lives but simultaneously preventing them from finding more useful or rewarding activities. It absorbs women's time and energy and even in monetary terms its contribution to the domestic economy is negligible:

I, who have known what it is to work for *money earned*, have since had much experience in working for *money saved*; and I consider, from the closest calculation I can make, that a penny saved in that way bears about a true proportion to a farthing earned. . . . At all events, let us not confuse the motives of economy with those of a simple pastime.

Mary Lamb herself worked for 'money earned' as an embroiderer. It was one of the very few occupations open to middle-class women 'necessitated by the pecunary misfortunes of their parents to earn a livelihood' (J. R. Pickmere, *Pamphleteer*, vol. XXVIII, 1827, pp. 115–16). Mary Lamb accused amateurs of taking work away from needy professionals, who were underpaid and overcrowded. Both men and women ran sweated workshops as well as controlling female outworkers.

Mary Lamb referred to embroidery as a 'simple pastime' but she knew it was much more than that. Even the men who mocked embroidery recognized it was an art form for women. Addison wrote a satirical article posing as a man whose wife put him to great expense by being too industrious. She painted fans and miniatures, which had to be mounted by specialists; she purchased materials for her embroidery and employed Huguenot assistants, 'For as I told you, she is a *Great Artist* with her Needle, 'tis incredible what is appropriated to her personal use, as Mantuas, Petticoats, Stomachers, Purses, Pin-cushions and Working aprones' (quoted in Standen, 1966, our italics). Reality and the ridiculous are juxtaposed to raise a laugh. The notion that a female amateur embroiderer could aspire to be an artist was considered ludicrous. But at the same time, Addison's audience was familiar with middle-class women's activities within the home; cut off from oil painting and sculpture they developed miniature painting, shell work, wax modelling, embroidery (fig. 38) and paper mosaic.

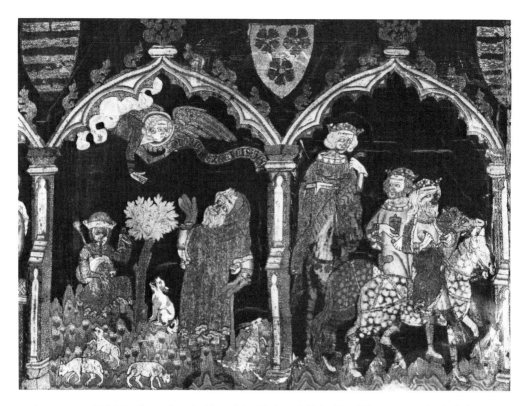

37 Anonymous (British), *Scenes from the Lives of the Virgin and Christ* (detail from apparels of albs), 1320–40

38 (*above, left*) Anonymous (British), *Mantua* (back view), *c.* 1740

39 (*above, right*) Mary Granville Delany, *Flora Delanica: Phlomis Leonorus*, 1772–85

Mary Delany (fig. 39) was the daughter of a landowner and her art was typical of the amateur work by women of her class. She painted, copying Old Master pictures and making portraits of family and female friends in oil and crayon. She embroidered clothing, hangings and coverings. She decorated playing cards, made ornamental shell work, designed furniture, spun wool, wrote and illustrated a novel, and invented *papier collé*. The extent of her art activity was extraordinary, perhaps explained by the fact that she was widowed twice and childless, but it was not exceptional. Walpole devoted a chapter in the fifth volume of his *Anecdotes of Painting* to 'Ladies and Gentlemen Distinguished by their Artistic Talents'. Although the 'ladies' become the butt of his humour, 'The poetry, paintings and playing of several young women . . . may properly be called Miss Doings', he has nothing but praise for Mary Delany and wrote gallantly to her that 'he could not resist ye agreeable occasion of doing justice to one who had founded a new branch', a reference to her *papier collé*, or 'paper mosaic', as he called it, which she began at the age of eighty. Using scissors, coloured paper and paste she created roughly one thousand botanically accurate illustrations of flowers and shrubs in ten volumes known as *Flora Delanica*. An embroiderer's knowledge of colour and texture is evident in this superb work. Each stamen, shadow and surface is cut out, each tiny variation of colour recorded by a separate sliver of paper.

Yet women had a slightly ambivalent relationship towards embroidery for by the late eighteenth century it had become synonymous with femininity. Its practice was marked by the constraints it imposed on women's lives and it acted as a restraining force. Samplers are a good example of this (fig. 40). With the increase in amateur embroiderers during the Renaissance, women began to make and exchange embroidery which provided examples of designs and stitches. These 'exemplers', from the old French *examplaire* or *essamplaire*, were carefully preserved and bequeathed in wills, but the arrival of pattern books, first published in 1523, replaced them. Instead the sampler became an educative exercise for young girls. By Mary Ann Body's (fig. 40) day the idea of the sampler as a collection of patterns had disappeared and 'The sampler and embroidered picture, which had been successive stages in the training of young needlewomen in the seventeenth century, were now combined in a single exercise' (Douglas King, *Samplers*, Victoria and Albert Museum, 1960). Compared to the virtuosity of earlier samplers, those of the late eighteenth century were naive and technically limited. To work a sampler was no longer an exercise of skill, it had become instead a display of 'femininity'. The act of embroidering both embodied and maintained the feminine stereotype. It still carried overtones of aristocratic status, but the domestic qualities wanted in a good wife were impressed upon girls by the verses they stitched on their samplers.

From the seventeenth century on a girl's childhood was marked out by a series of embroidery projects. Martha Edlin's childhood was typical. Aged eight, she finished her first sampler and signed it with pride, 'Martha Edlin 1668'. It took her another year to complete her white-work sampler, and then she began an embroidered casket which she signed in 1671. Her final assigned task was to embroider a jewel box and she finished it in 1673, aged thirteen, when her training was considered complete and she was permitted to select her own embroidery projects, her proof of womanhood.

To rebel against needlework was therefore to rebel against femininity. Anne Finch, Countess of Winchelsea (1661–1720), in order to assert her identity as a poet, had to reject embroidering as the embodiment of both femininity and female art practice. Cora Kaplan points out in her paper, 'Language and Gender', that these lines also query the flower/female metaphor:

> My hand delights to trace unusual things,
> And deviates from the known and common way;
> Nor will in fading silks compose
> Faintly the inimitable rose . . .

As objects, samplers are often beautiful, and we rightly admire the use of colour, texture, the designs of stitches and the distinction of motifs. But they also represent a female childhood structured around the acquisition of prescribed feminine characteristics. Patience, submissiveness, service, obedience and modesty were taught both by the concentrated technical exercises as well as by the pious, self-denying verses and prayers which the samplers carried.

The earliest surviving religious or moral inscription on a dated sampler appears on Ann Turner's of 1686. Similar verses advocating obedience, love of God and family, self-sacrifice, hard work, chastity and charity continued to be stitched throughout the eighteenth and nineteenth centuries. Frequently the verses display a sadness, almost a relief at the shortness of life and the fading of beauty: 'Jane King will be happy when Christ shall set her free.' But the same diligence and feeling that went into displays of conformity and obedience sometimes turned into rebellion, 'Polly did it and she hated every stitch she did', or to political commitment, as in a sampler addressed to a man who campaigned to reduce the hours children worked in factories. Yet within the limitations imposed upon them, women made samplers into an expressive form. There were friendship samplers, stitched messages exchanged by women friends, and commemorative samplers recording national events such as the Peace of 1802 or cataloguing family births and deaths. Ironically one sampler

even protests against women's confinement to the home and the deprivation of men's companionship:

> I ask not for a kinder tone, for thou wert ever kind.
> I ask not for less frugal fare, my fare I do not mind.
> I ask not for attire more gay, if such as I have got
> Suffice to make me fair to thee, for more I murmur not.
> But I would ask some share of hours that you on clubs bestow
> Subtract from meetings amongst men, each even an hour for me.
> Make me companion of your soul as I may safely be.
> If you will read I'll sit and work, then think when you're away
> Less tedious I shall find the time, dear Robert of your stay.

Today, however, samplers are not generally seen as expressive art forms, and if they are valued at all it is for nostalgic reasons or for the manual dexterity they display. Despite the assertions to the contrary by Victorian needlework historians and contemporary feminists, it is highly significant that embroidery was only acknowledged as an art form when it copied fine art prints and oil paintings. In the eighteenth century Mary Linwood was the best known of the 'needlepainters'. In 1798 an exhibition of over one hundred of her glazed, framed, embroidered pictures, copies of Old Master paintings, opened at the Hanover Square Rooms in London and subsequently toured the country. A critic commented approvingly:

> The ladies of Great Britain may boast in the person of Miss Linwood an example of the force and energy of the female mind, free from any of those ungraceful manners which have in some cases accompanied strength of genius in a woman. Miss Linwood has awakened from its long sleep the art which gave birth to painting. (*Library of Anecdote*, quoted in Jourdain, 1910, pp. 171–2)

Mary Linwood's needlepictures translated oil paintings into the medium of embroidery, the skill of a woman's fingers serving and subservient to fine art. For this she was praised, though misguidedly. That embroidery has a history is ignored by this critic, for whom it only 'awakens' and wins recognition when it apes painting and moves outside the domestic sphere to be exhibited publicly as framed pictures. It is also suggested by this critic that embroidery is an earlier form of art—it 'gave birth to painting', a choice of words that subtly implicates it with women's reproductive role while placing both at a less advanced stage of development.

In one text on prehistoric art this implicit suggestion is made explicit and

prehistoric forms of craft are identified with the feminine spirit in art:

> The geometric style is primarily a feminine style. The geometric ornament seems more suited to the *domestic*, pedantically tidy and at the same time superstitiously careful spirit of woman than that of man. It is, considered purely aesthetically, a petty, lifeless and, despite all its luxuriousness of colour, a strictly limited mode of art. *But within its limits*, healthy and efficient, pleasing by reason of the *industry* displayed and its *external decorativeness*—the expression of the feminine spirit in art. (H. Hoernes and O. Menghin, *Urgeschichte der bildenden Kunst*, 1925, p. 574, our italics)

This passage runs the gamut of the now familiar package of derogatory definitions: limitedness, decorativeness, industriousness and pettiness. However, in the wake of developments in contemporary abstract art certain 'geometric crafts' have invited comparison with fine art forms because of their non-representational and colourful forms on large two-dimensional surfaces. In order to justify a change of status for such crafts and to move them from the antique trade or folk museum on to the fine art circuit, they have to undergo a particularly revealing transformation. Woven blankets by American Navaho Indian women (fig. 41), for example, have been exhibited in major museums of art in Los Angeles (1972), London (1974) and Amsterdam (1975). Some writers who reviewed the exhibitions provided anthropological accounts of the blankets and the people who made them, but those who wished to see them as art works had to expunge all traces of craft association. Ralph Pomeroy introduced his appreciative, formalist critique of the London exhibition with this higly revealing statement:

> I am going to forget, *in order to really see them*, that a group of Navajo blankets are not only that. In order to consider them, as I feel they ought to be considered—as Art with a capital 'A'—I am going to look at them as paintings—created with dye instead of pigment, on unstretched fabric instead of canvas—by *several nameless masters of abstract art*. ('Navaho Abstraction', *Art and Artists*, 1974, p. 30, our italics)

Several manoeuvres are necessary in order to see these works as art. The geometric becomes abstract, woven blankets become paintings and women weavers become nameless masters. This term is crucial. In art history the status of an art work is inextricably tied to the status of the maker. The most common form of art historical writing is the monograph on a named artist, often supported by a *catalogue raisonné* of all the paintings and drawings so that a

group of works is given coherence because it is seen to issue from the hand of an individual. In other words, the way a work of art is viewed depends on who made it. By contrast, books on craft history are more concerned with the objects themselves, in relation to how they were made, their purpose and function; the maker is of secondary importance. Thus in order to give the final stamp of approval to Navaho products as art, Pomeroy conjures up 'nameless masters', a phrase which echoes that used by modern historians to create an artistic identity for an artist whose name has become lost to history. He does not call them 'nameless mistresses', nor even the neutral term 'nameless artists'; he calls them 'masters'. This indicates once again that in modern art history the fine artist is synonymous with the male artist. These blankets can be appreciated aesthetically and formally by critics such as Pomeroy only by creating a new status for the maker which includes not only a change of terminology but also of sex and, implicitly, of race.

The treatment of Navaho women at the hands of critics shows how much the status of the maker matters in the evaluation of art, and that status depends on sex, not because it biologically predetermines the kind of work produced but as a result of a more significant aspect of the sexual division in our society. The two historians of Neolithic art quoted above, Hoernes and Menghin, provided a clue, for the feminine spirit in art is also linked with the domestic sphere.

But why would women's activities in the home be given a lower status than men's outside the home? Using the theories and analyses of structural anthropology, developed in the work of Claude Lévi-Strauss, feminist anthropologists have tried to confront the problem of women's secondary status. Lévi-Strauss's analyses of myths and belief systems of many cultures have shown how differences in the status of objects, practices, customs and indeed groups of people depend on the place they are given on a symbolic scale from Nature to Culture. This scale provides one of the most important structures of differentiation by which human society represents, defines and evaluates its activities. For one of the most distinctive features of human society is that people, unlike animals, produce their own means of subsistence. They transform raw materials into tools, houses, clothes and utensils. Human society distinguishes itself because it works over raw materials to produce cultural artefacts. In an article, 'Is Female to Male as Nature is to Culture?', Sherry Ortner argues that one possible way of accounting for women's secondary status is that their roles are perceived as occupying an intermediate position on the symbolic and structuring scale from Nature to Culture. On the one hand, because of women's role in bearing and initially nursing children, women could be considered closer to Nature. But at the same time, the complementary roles, cooking for children and initiating their education and socialization, are obviously cultural and social. Yet these roles are performed in a particular

place, the home. She gives the example of cooking, one of the most common transformations of nature to culture:

> In the overwhelming majority of societies cooking is women's work. No doubt this stems from practical considerations—since the woman has to stay at home with the baby, it is convenient for her to perform chores centered in the home. But if it is true, as Lévi-Strauss has argued, that transforming the raw into the cooked may represent, in many systems of thought, the transition from nature to culture, then here we have women aligned with this important culturising process, which could easily place her in the category of culture, triumphing over nature. Yet it is interesting to note that when a culture (e.g. France or China) develops a tradition of *haute cuisine*—'real' cooking as opposed to trivial, ordinary, domestic cooking—the high chefs are almost always men. Thus the pattern replicates that in the area of socialisation—women perform lower level conversions from nature to culture, but when culture distinguishes a higher level of the same functions, the higher level is restricted to men. (In *Women, Culture and Society*, ed. Rosaldo and Lamphere, 1974, p. 80)

Women's work is inevitably in the sphere of culture as opposed to nature and women often perform tasks similar to those of men, but their work is awarded a secondary status because of the different place the tasks are performed. The structures of difference are between private and public activities, domestic and professional work.

This provides an important insight into the structure of sexual division in art hierarchies. For in fact what distinguishes art from craft in the hierarchy is not so much different methods, practices and objects but also where these things are made, often in the home, and for whom they are made, often for the family. The fine arts are a public, professional activity. What women make, which is usually defined as 'craft', could in fact be defined as 'domestic art'. The conditions of production and audience for this kind of art are different from those of the art made in a studio and art school, for the market and gallery. It is out of these different conditions that the hierarchical division between art and craft has been constructed; it has nothing to do with the inherent qualities of the object nor the gender of the maker.

The example of the Navaho blankets shows what has to be changed in order to effect the transformation of Indian weaving into accepted definitions of Fine Art. The recent critical acclaim of American patchwork quilts which also led to exhibitions in art galleries shows, more interestingly, what has to be left out.

In the expensively produced, richly illustrated books and adulatory essays on patchwork quilts that have accompanied their appearance in art galleries

and on the walls of dealers' showrooms the fact that women made the quilts is not easily overlooked. Yet, characteristically, the role of the maker is rendered less significant. One exhibition in 1972, at the Whitney Museum of Modern Art in New York, was entitled 'Abstract Design *in* American Quilts' (our italics), emphasizing the formal elements in the quilts as their reason for new-found recognition as art. The creators of abstract forms are oddly acknowledged in the introductory essay of the exhibition catalogue and indeed the exhibition was dedicated to 'the anonymous women whose skilled hands and eyes created the American quilt'. This separates the makers from the objects, dedicating the exhibition to them suggests that they are not present, that they are not represented by the work they made. It is practically inconceivable that an exhibition devoted to the works of, say, van Gogh, would also be dedicated to him. Moreover the women are reduced to skilled hands and eyes as if quilt-making bypasses the mind, feeling, thought or intention. Quilts were not even made anonymously. They were frequently signed and dated, exhibited proudly at county fairs and recorded in wills. We owe their very existence in this century to the value placed on them by the families who treasured them and passed them on from generation to generation or to the admirers who collected and carefully preserved fine examples of that art.

The patchwork quilts are rightly celebrated as objects of great beauty. Made from thousands of pieces of shaped and coloured fabric, sewn into elaborate and intricate patterns, they produced rich colouristic effects and contained symbolic meanings. They were given a variety of suggestive titles, 'Mariner's Compass', 'Jacob's Ladder', 'Star of Bethlehem' and 'Sunburst', the last superbly conveying the effect of the radiating beams of the sun and the beneficence of its golden light. But some of these names, rather than being specific titles of quilts, refer instead to categories of basic methods of putting the fabrics together. This has often, erroneously, led to a dismissal of quilt-making as mere repetitious use of pattern. But, individual quilt-makers used the basic patterns to dramatically different effect by choice of colours, size of pieces, optical illusion and intended meaning (figs 42–44A, B, C).

One such type, 'Log Cabin', is made from thin rectangles of material sewn in squares in a manner that recalls and records the dwellings of American settlers from which it derives its name. However, the hundreds of quilts based on this method are so remarkably varied and different from one another, largely because of the more important role of the compositional use of colour and the playing-off of figure against ground. This decisive role of the individual quilt-maker is completely effaced in typical histories of the craft as the following passage indicates:

In these geometrical creations, every seam is a straight line. Any person

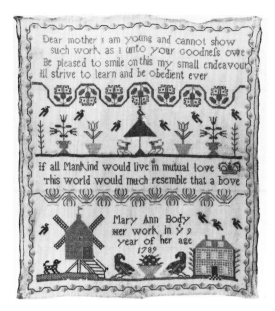

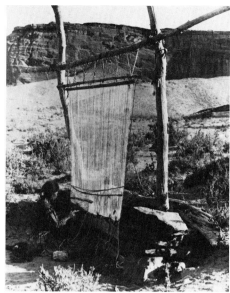

40 (*above, left*) Mary Ann Body, *Sampler*, 1789

41 (*above, right*) *Navaho Weaver*, Los Angeles, Southwest Museum, photograph. Navaho weaving is made by women and in their mythology it was a female deity, the Spider Woman, who told Navaho women how to weave.

42 Anonymous, *Sunburst*, *c.* 1840, patchwork quilt
The term 'patchwork quilt' describes that form of art which is made by sewing small pieces of fabric together to form a single surface which is secured to a backing sheet by means of patterns of stitches known as quilting. This elaborate and intricate quilting provides a counter-pattern of stitches to the shape and colour arrangement of the patterned top layer. Elaborate examples of American virtuoso quilting, not on patchwork but on large pieces of plain fabric, such as glazed wools and linens, known as 'linsey woolsey', or in white thread on cotton, known as 'white work', have survived from the eighteenth and nineteenth centuries.

43 Anonymous, *Log Cabin*, 1890, patchwork quilt, West Gardiner, Maine

44A Anonymous, *Log Cabin: Diamond, c.* 1869, patchwork quilt

44B Detail of 44A

44C *Medley Quilt, c.* 1900

who could thread a needle and sew could learn to make an even stitch in a straight line. In this way she assembled her countless dozens of pre-cut pieces. . . . The fabrics that were available in country towns *had a way of creating their own patterns.* (Carlton L. Safford and Robert Bishop, *America's Quilts and Coverlets,* 1972, p. 86, our italics)

The revaluation of the quilts which has led to their exhibition in museums and to lavish illustration quickly disposes of the notion that a so-called utilitarian art form such as the quilt is inherently less aesthetically significant than painting. However, the very fact that this recognition of quilts as art has been achieved by spotlighting the finished object in isolation as a valuable commodity and by dissociating them from the means of their production shows how important the particular place and ways of making are to the definition of art. The role of the maker has had to be reduced and the processes of production either sentimentalized or suppressed entirely because their connections with the traditional notions of craft might get in the way of an interpretation of quilts as art.

The contradictions of significant omissions by commentators on quilts are highly revealing for it is precisely the particular history and conditions of production of the quilts which provide the basis for a radical critique of art history. The implications of this have not been examined fully either by feminists in their attempt to valourize women's separate cultural heritage or by collectors and dealers in search of higher prices for their now more valuable commodities.

Patchwork and quilting have a very long history, but these practices became a distinctive feature of American society in the eighteenth and nineteenth centuries, and they played an important role in the communities that settled the continent. The names of many quilt types commemorate the pioneer life and the great movements of people, for instance, 'Log Cabin', 'Barn Raising', 'Prairie Lily' and 'The Road to California'. The significance of needlework in the education and preparation of women for marriage was carried over from Europe with the pioneer women. Responding to specific socio-economic and cultural needs of the new communities, women's needlework made an important contribution to their society on many levels. Quilting and other forms of needlework were used to provide the necessary warm bedding. In a cold Massachussetts winter at least five quilts could be needed by each member of the family. But since ready-made bedding and factory-produced blankets could not be easily purchased before the 1890s, these needs were met in the home and women made them:

To create with brain and fingers, with needle and thread, goods of

admittedly economic value was perforce part of a woman's job. A wife was an asset and boys were not afraid to marry young. Two could live as cheaply as one in those days and it was a working wife who made that possible. Trained from babyhood that she might make good in marriage partnership, a girl was taught sewing and the first thing she sewed was patchwork. (Ruth Finlay, *Old Patchwork Quilts and the Women Who Made Them*, 1929, p. 33)

In addition to making quilts out of sheer necessity, quilt-making also served to punctuate and celebrate pioneer women's lives. In preparation for the profession of marriage and the setting up of a new household, a woman's girlhood was passed in learning to sew and preparing her trousseau of up to twelve quilts. One quilt survives with the following motto embroidered on it:

> At your quilting, maids don't dally
> A maid who is quiltless at twenty-one
> Never shall greet her bridal sun.
> (Cited in Safford and Bishop, *America's Quilts and Coverlets*, 1972, p. 86)

The thirteenth quilt of the trousseau was the bridal quilt, made of the most expensive materials a woman could afford as a display of her excellence with the needle. It was begun at the time of engagement and its completion set the date for the wedding. Together with the twelve other quilt-tops it was stuffed, backed and quilted at a special quilting bee, which, as Finlay states, was the most solemn and important recognition of betrothal.

Other quilts celebrated the main events and concerns of the community's or household's lives. Quilts were made to mark the eldest son's coming of age. In sombre colours, quilts memorialized the dead, while some were expressions of political loyalties, Mrs Cook's Secession Quilt of 1866, for instance, or one that commemorates the death of George Washington. Many a Republican may have slept soundly under a quilt designed to signify the family's allegiance to the Democratic Party. Some of these quilts made for such purposes were never used, but exhibited, presented as gifts or carefully preserved as family heirlooms. Another group, called medley or friendship quilts, recorded families and women's friendships within a community (fig. 44C). In this, a medley quilt, each component square is made by a different woman. Some are signed and dated. It was obviously made over a period of time since the dates span two decades. Some of the makers were closely related. Quilts of this composite type were made for a variety of reasons to celebrate the friendships

in a small community as well as for more specific reasons—mourning a death or recording a current event. The individual contributions to the quilt provide examples of the many different patterns and methods used in making patchwork quilts. Some are plain and simple and the interest of the piece is carried by the pattern of the quilting stitches themselves. Others are miniature versions of the designs used for instance in 'Sunburst' (fig. 42) or of the star motifs so often found in quilts, like that of the eight-pointed 'Star of Bethlehem', visible in the upper left of the quilt. Crosses, particularly the St Andrew's Cross of Scotland, were understandably common in the work of women in these immigrant communities, while arrowhead motifs also make an appearance, even at times combined with the St Andrew's Cross, bearing witness to the creative intermingling of cultural and religious traditions. Other sections of the quilt belong to no generic category of designs, but are fine examples of the free and adventurous compositions known as 'crazy quilts'. Crazy quilts were very popular in the nineteenth century, often made of richer materials like velvet and silk, to be used for show, or as a 'throw' to be used in the parlour rather than as a bed coverlet. Quilting was not so often used in these works, instead they were tufted, i.e. stuffed and then sewn down in such a way as to create an uneven surface and shallow relief. Many were also displays of intricate embroidery which not only elaborated the patterns but was used to inscribe names and mottoes onto the quilt. Crazy quilts were often virtuoso compositions of free abstract shapes, but some are figurative, as for instance a quilt made by Mrs A. E. Reasoner in 1885 (Newark New Jersey, Newark Museum). She was the wife of a Railroad Superintendant and her quilt shows the route the railway followed through the county. It is done in such a way that the embroidery, colour and shapes act on two levels. At first sight it is a purely abstract composition with daring use of odd and diverse shapes, but on closer examination these forms suggest a readable picture and it offers a historically interesting document of the feel of the countryside through which the railway snakes down to the river. However, in their study of American quilts (*America's Quilts and Coverlets*, New York, 1972) Safford and Bishop described that quilt in the following typical terms as 'a fine example of the imaginative whimsey shown by the wife of a railroad man'.

Personal, political, religious and social meanings were sewn into these quilts in abstract forms by means of colour and symbolic compositions. Free from the pressures of the dominant conventions of contemporary painting, perspective, illusionism and narrative subject matter, the quilt-makers evolved an abstract language to signify and communicate their joys and sorrows, their personal and social histories. It is this exploration of abstract forms and colours which invited the reconsideration of quilts in recent times because they thus compare with contemporary forms of modern art. But when the quilts are appreciated as

decorative wall hangings or examples of abstract *design* rather than as structures of abstract symbols, it is this specific language that is suppressed and denied.

Furthermore, skill with one's needle was necessary for full membership in the community. Finlay records: 'starting from the grimness of economic need the quilt became a social factor. Soon no function was more important than the quilting bee in town or country' (p. 33). The quilting bee (fig. 45) was the occasion on which women in the community came together to sew the quilt-tops, designed and made by individual women, onto the backing and stuffing. This is the procedure that is, strictly speaking, quilting, since by means of patterns of tiny stitches the quilt-top and other layers were secured and given their final appearance. This collective part of the process has been used wrongly to argue that quilts are not artistically significant because they are made by many unknown hands. However, the actual quilt-top was always the work of one person. But, since the quilting meant working over another woman's work, it behoved all women to be expert with their needles or else be left out of this activity. Exclusion from a quilting bee amounted to social exclusion since the occasion was not only a gathering of women but a place of meeting, matchmaking and communication for the whole community. At one such occasion, for instance, women in Cleveland, Ohio, heard the first speech in support of women's suffrage made in that state by the later famous feminist campaigner and writer, Susan B. Anthony.

Patchwork quilt-making was a domestic art and therefore different from painting or sculpture. Because of the place quilts were made, at home by women in the fulfilment of domestic duties, they are a distinctive form of art with different kinds of relations between maker and object and between object and viewer or user which, as William Morris foresaw, are in some ways richer than the relations of making, using and reception customary in high art. Usefulness and aesthetic sensibility coincide, work and art come together, individual and group collaborate. It is precisely the specific history of women and their artwork that is effaced when art historical discourse categorizes this kind of art practice as decorative, dexterous, industrious, geometric and 'the expression of the feminine spirit in art'.

However, the use of these terms which maintains the hierarchy and establishes distinctions between art and craft represents an underlying value system. Any association with the traditions and practices of needlework and domestic art can be dangerous for an artist, especially when that artist is a woman.

A contemporary abstract artist, Stephanie Bergman (fig. 46), who uses stained and dyed fabric in large sewn compositions, had to be quite explicitly defended against any hint of feminine craft:

45 Anonymous, *The Quilting Party*, late nineteenth century

46 Stephanie Bergman, *Bayswater*, 1976
In some ways, Bergman's methods of using colour, shaped pieces and stitching are similar to those of the quilters. But her work is not a quilt; it is made as a modern painting and to assert that it has to be distinguished from patchwork is to fall into the trap of seeing all work by women in a stereotyped context of a stereotypically 'feminine' tradition, whereas it is precisely by mixing paint and canvas with stitching and dyed fabric that Bergman transforms sex-based distinctions between the fine arts and the crafts.

These pictures are held together by stitches. Working with a stockpile of canvas she has colour dyed or otherwise saturated with pigment, Bergman scissors the stuff into shapes that she then machine seams together. Baldly stated like this, the process sounds dire, an unpromising way to go about making pictures, and more specifically since it is a woman doing it. In fact, the result has nothing to do with patchwork quilts and cottage industries, and painting is the only generic term that will do. (Judith Marle, *Studio International*, vol. 18, no. 165, 1974)

Strange contortions of the English language struggle to ward off unspecified dangers, threats to Bergman's identity as a practitioner in the fine arts and her work's status as art. But why is the spectre of domestic art so menacing, especially for a woman? Because high art and the fine artist have come to mean the direct antithesis of all that is defined by the 'feminine stereotype'.

Our discussion of women's art is therefore not concerned with a feminine sensibility, natural preference and inclination in subject matter, nor with separate spheres and hidden heritages. Women artists have always existed. The important questions concern women artists' relationship to an ideology of sexual difference in which the notions of masculine and feminine are meaningful only in relation to each other. What accounts for the endless assertion of a feminine stereotype, a feminine sensibility, a feminine art in criticism and art history? Precisely the necessity to provide an opposite against which male art and the male artist find meaning and sustain their dominance. That there are Old Masters and not Old Mistresses and that all women's art is seen homogeneously as inevitably feminine in painting and sculpture as much as in the crafts is the effect of this ideology. We never speak of masculine art or man artist, we say simply art and artist. But the art of men can only maintain its dominance and privilege on the pages of art history by having a negative to its positive, a feminine to its unacknowledged masculine.

Ideology is not a conscious process, its effects are manifest but it works unconsciously, reproducing the values and systems of belief of the dominant group it serves. As we have shown the current ideology of male dominance has a history. It was adumbrated in the Renaissance, expanded in the eighteenth century, fully articulated in the nineteenth century and finally totally naturalized with the result that in twentieth-century art history it is so taken for granted as part of the natural order it need not be mentioned. This ideology is reproduced not only in the way art is discussed, the discipline of art history, but in works of art themselves. It operates through images and styles in art, the ways of seeing the world and representing our position in the world that art presents. It is inscribed into the very language of art.

Women artists are not outside history or culture but occupy and speak from

a different position and place within it. We can now recognize that place, that position, as essential to the meanings of western culture, for the opposition, feminine, ensures masculine meanings and masculine dominance. But that position is, for women themselves, contradictory and problematic, for if feminine is the negative of masculine and masculine is dominant, how do women artists see themselves and how do they produce meanings of their own in a language made by a dominant group which affirms men's dominance and power and reproduces their supremacy?

3
'God's little artist'

The concept of the artist as a creative individual is a modern one. Before the eighteenth century, the term was applied to an artisan or craftsman, on the one hand, or, on the other, to someone who displayed taste. The first modern usage of the word 'artist' given by the *Oxford English Dictionary* dates from 1853. It was F. D. Maurice in *Prophets and Kings* (1853) who used the word to describe 'one who cultivates one of the fine arts, in which the object is mainly to gratify aesthetic emotions by perfection of execution whether in creation or representation.' The modern definition is the culmination of a long process of economic, social and ideological transformations by which the word 'artist' ceased to mean a kind of workman and came to signify a special kind of person with a whole set of distinctive characteristics: artists came to be thought of as strange, different, exotic, imaginative, eccentric, creative, unconventional, alone. A mixture of supposed genetic factors and social roles distinguish the artist from the mass of ordinary mortals, creating new myths, those of the prophet and above all the genius, and new social personae, the Bohemian and the pioneer.

This transformation began with the striving of craftsmen to become respected members of the intellectual community and cultural élite. These developing notions reached new heights with the genesis of the Romantic myth of the eighteenth and nineteenth centuries when the artist not only inherited the mantle of priests and became the revealer of divine truths, but also assumed a semi-divine status as an heir of the original 'Creator' himself. And finally, today, to be an artist is to be born a special person; creativity lies in the person not in what is made. Indeed, in certain art practices it is sufficient for an artist to designate an object as art for it to become so.

Over the same period, more and more exclusively male attributes accrued to this special persona. In his study of nineteenth-century ideas of the artist, *Icarus—Image of the Artist in French Romanticism* (1961), Maurice Shroder

examines the growth of an analogy between artistic creativity and male sexuality, citing such comments as that of Flaubert, who called the artist 'a "fouteur" who feels his sperm rising for an emission'. Such notions have their roots in the Renaissance when artists were advised to be continent and chaste so as to preserve their 'virility' for their art. This notion carries through to modern art; Vincent van Gogh told a fellow artist: 'Eat well, do your military exercises and don't fuck too much, and because of not fucking too much, your paintings will be all the more spermatic' (*Complete Letters*, vol. III, LB 14 1888). These quotations show the analogy at its most explicit, but we can easily recognize it in the language of modern art criticism, whose praise is bestowed on vigour, thrust, force and, above all, mastery.

Concurrently, new meanings were given to the phrase 'woman artist'. While in the second half of the nineteenth century such novels as *The Masterpiece* (1886) by Zola represented the life of a Bohemian Parisian artist wrestling heroically with his art, symbolized by a female figure, other novels, of a very different sort, describe the struggles of women artists attempting to reconcile their lives as women with the identity of artist increasingly conflated with notions of maleness and particularly masculine sexuality. These include *Avis* (1879) by Elizabeth Stuart Phelps, *The Master-Christian* (1890) and *Nehemiah P. Hoskins, Artist* (1896) by Marie Corelli. And in *Olive* (1850) by Dinah M. Craik, an artist, Vanburgh, explains to his aspiring pupil, Olive, why the heights of creativity are not for her. Far from being a parody, the man's tone is intended to impress and convey the extraordinary sensibility and almost religious devotion of his passionate, artistic nature:

> 'I said it was impossible for a woman to become an artist—I mean a *great* artist. Have you ever thought what that term implies? Not only a painter but a poet; a man of learning, of reading, of observation. A gentleman— we artists are the friends of kings. A man of stainless virtue. A man of iron will, indomitable daring, and passions strong, yet kept always leashed in his hand. Last and greatest, a man who, feeling within him the divine spirit, with his whole soul worships God!'
>
> Vanburgh lifted off his velvet cap and reverently bared his head; then he continued, 'That is what an artist should *be*, by nature.' (p. 161)

The developments that led to the nineteenth-century conviction that greatness in art was the natural privilege of man are, however, paralleled by evolving definitions of the woman artist. In order to chart, of necessity in a schematic form, the considerable changes in the ideology and definition of the artist and the parallel ideological construct of the woman artist we will consider three distinct phases: the artist and social class in the sixteenth

century, the artist and the academies in the eighteenth century, and the image of the artist in nineteenth-century novels and diaries. Such a survey leads to unexpected conclusions. It does not produce a picture of a steady integration of women artists from a few celebrated novelties in the Renaissance to the crowded women's studios of the nineteenth century. A structural analysis of the representations of the artist in painting, criticism, fiction and autobiography demonstrates that within the changing definitions of the artist over this period images of the 'artist' and the 'woman artist' became increasingly separate and clearly differentiated categories.

This should not, however, be confused with the effects of modern feminist attempts to reconstruct for women a particular and distinct history—an exclusive lineage of women artists, 'a hidden heritage'. For instance Ann Sutherland Harris presents Sofonisba Anguissola as a heroic pioneer, 'the first to become an international celebrity as an artist. . . . As such she is a figure of considerable historical importance' (p. 106). For Sutherland Harris Anguissola's significance lies in her role as a founder of a tradition of women artists. This retrospective imposition of a linear and progressive historical model on the activities of women artists in the past tends, on the one hand, to sever them from a broader historical frame. On the other, it obscures the dialectical relationship of women artists to the dominant definitions of the artist. These definitions changed. At times they worked to women's advantage, while at others they created unresolvable contradictions. It is this complex and non-unitary history to which we have to attend.

We can begin by analysing the implications of Anguissola's class position and how she represented herself as artist in self-portraits in relation to Renaissance artists' ambitions for a higher social status. Like other Renaissance women artists (fig. 47), Anguissola portrayed herself playing a musical instrument (fig. 48). But what is signified by showing the artist at a spinet, rather than at work holding the insignia of her profession, palette and brush?

As the study of embroidery has shown, major reorganizations of art production were taking place in the sixteenth century. From having been closely involved in the economic unit of production in the household, and indeed later in the guilds themselves, women were being gradually excluded. Their non-involvement in trade tended to signify a rise in the status of their own individual family; while their new activity as amateur, rather than professional, embroiderers confirmed that status. For embroidery was traditionally practised by 'ladies' in aristocratic households and had for centuries been practised by queens. By becoming less involved with production women contributed to the upward mobility of the artisan and mercantile classes. At the same time artists attempted to distinguish themselves from the

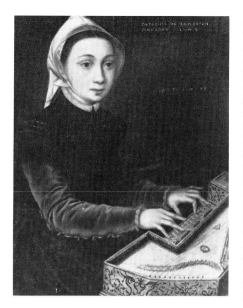

47 Catharina van Hemessen, *Young Woman Playing the Virginals*, 1548

Although, in the past, this painting was thought to be a self-portrait, recent research suggests that it is a portrait of the artist's sister and a companion piece to a self-portrait, in Basel. The panels are the same size and face in complementary directions. In juxtaposing reproductions of a northern painting of a woman at a musical instrument with a contemporary Italian treatment of a similar subject (fig. 48) it is the differences we want to draw out. Each artist shared more with her respective local school than with each other, although they both happened to have been women. This is evident from the emphasis on volume and the suggestions of depth in Anguissola's painting in contrast to the flattened and more linear figure style of Hemessen's. The placement of a figure, that of Anguissola's chaperone, beyond the virginals draws the spectator's eye into the picture's illusionist space, while in Hemessen's portrait the written inscriptions serve to flatten any depth evoked by the dark areas beyond the figure. But if Hemessen did intend a companion pair showing a woman painting a picture and a woman playing a musical instrument, she was none the less asserting women's skills in the arts and women's membership of a cultured, accomplished, educated group, indeed the very image of woman Anguissola represented in her self-portrait, the artist as an accomplished musician.

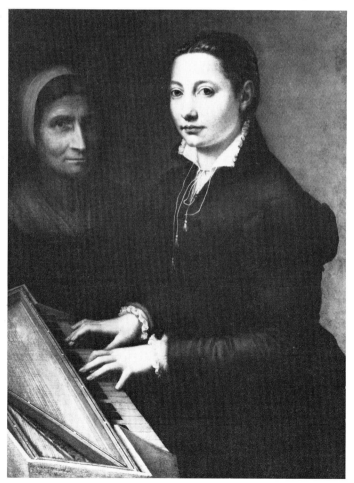

48 Sofonisba Anguissola, *Self-portrait*, 1561[?]

craftsman, the manual executor of other people's (the patron's) ideas and designs. The artist aspired to equal status with the intellectual, the patron, the writer, the poet, the philosopher or the theologian. In their study of the changing status and identity of the artist, *Born Under Saturn* (1963), Margot and Rudolf Wittkower document the change from craftsman to artist in the Renaissance. The new ideal differed from the artisan 'in that he [the artist] was conscious of his intellect and creative powers' (p. 15). They quote from the treatise on art by Lorenzo Ghiberti (1378–1455), who was one of the first to write an artist's autobiography and to assert this new identity: 'Few are the things of importance created in our country that have not been *designed* and carried out by my own hand' (p. 15). ('Designed'—disegnare—should not be understood in the modern English sense, as in 'interior design' or graphic 'design'. It refers to drawing, composition and thus creation. See back to the discussion of medieval practice where the 'design', formal arrangement and theological content, was prescribed in advance and the embroiderer or illuminator adapted the formula to his or her particular medium.) Furthermore, the Wittkowers cite Alberti (1404–72), who fostered the higher aspirations of artists by what was, in fact, a misinterpretation of the social position of artists in antiquity to whom he attributed an almost noble social status in order 'to adduce prestige for their modern successors' (p. 16).

The new emphasis was on the intellectual claims of the artist as opposed to manual skill. Anguissola's self-portraits can be seen as 'signs of the times'. The way she represented herself emphasizes her noble birth and membership of the cultured élite. Anguissola painted more portraits of herself than any artist between Dürer and Rembrandt; at least twelve are known by her. This *Self-portrait* (fig. 48) is the latest dated self-portrait and the only one known to have been painted in Spain. Anguissola's self-portraits show her with many different attributes. Some do emphasize her profession and depict her being painted by her teacher, at work on a painting or holding a palette. But others stress her family's nobility, her education and accomplishments. Moreover the presence of the chaperone, who also appeared in the picture, *Three Sisters Playing Chess* (fig. 11) also serves to signify Anguissola's position as a noblewoman.

Though artists of the period were rarely themselves from the nobility, the attributes and activities of that class corresponded with the new aspirations of the Renaissance artist. Anguissola's class thus rendered her activity as an artist acceptable, and this perhaps underlines Vasari's fulsome praise of Anguissola and her sisters. Significantly, the other Renaissance women he mentions, Properzia de' Rossi, for instance, were also noblewomen, and the way he emphasizes the feminine accomplishments of these noble artists served to bring out precisely those features of their social position that accorded with the emerging notions of the artist.

There was then a difference in the position of male and female artists but it did not necessarily operate to women's disadvantage. While Renaissance male artists struggled upwards from the class of artisans, the professional extension of a noblewoman's educated accomplishments ensured her some recognition. However, in the supporting rhetoric of the Renaissance, the artist aspired higher than the aristocracy, aiming at divinity itself. Michelangelo, a heroic figure in the campaign to redefine the status and nature of the artist, was dubbed by his contemporaries 'Il Divino'. And Albrecht Dürer, one of the few famous self-portraitists of the period, dared even to paint himself as Christ in the Self-portrait of 1500 (Munich, Alte Pinakothek). Alberti considered painting the highest amongst the arts because it contained 'a divine force'. This Renaissance notion was partly derived from classical ideas of divine madness in the arts, as well as from the medieval notion of God the Father as artist, the architect of the universe (see Wittkowers, p. 98). Patriarchal mythology lent support to the artists' claims but, for obvious reasons, seriously circumscribed the identification of the female sex with the notion of the artist.

In the seventeenth and eighteenth centuries the foundation of official academies of art secured for the artist surer claims to intellectual recognition. These academies changed the status of the artist in many ways, but particularly by creating a new system for training, with the effect of professionalizing the practice of art and rationalizing its study. Artists were 'educated' rather than 'trained' by following a rigorous curriculum of study based on learned theories of art which encouraged artists to model themselves on the 'great masters' of antiquity and the Renaissance.

A painting by Johann Zoffany of *The Academicians of the Royal Academy* in 1772 (fig. 49) provides portraits of one such collection of learned men; Sir Joshua Reynolds, author of the *Discourses on Art* and the first President of the Royal Academy, is recognizable in the centre by his prominent ear trumpet. But the painting is also intended to convey the 'ideal' of the academic artist. The Academicians are shown in casual, confident poses, dressed as gentlemen of rank, participating in a discussion of the nude. They are in the life-room of the Royal Academy, surrounded by classical casts and life models. Within academic curriculum the study of the naked human form was the most privileged course, and the nude was considered to be the basis for the supreme achievements of great artists. The Academicians are presented as learned and at ease with their learning. They are men of reason. Thus Zoffany's painting can be seen as both a portrait and an idealized depiction. It is about eighteenth-century notions of the nature of the artist and the manner in which art should be pursued and practised.

There were, however, two female members of the Royal Academy, Mary Moser (1744–1819) and Angelica Kauffman (1741–1807). But they could not

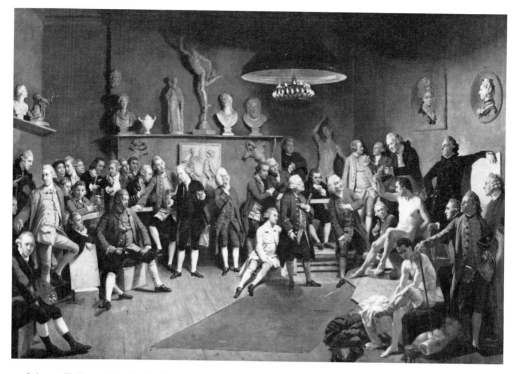

49 Johann Zoffany, *The Academicians of the Royal Academy*, 1772

A Swiss who worked in England, Zoffany was a portraitist of theatrical scenes and group compositions, such as this portrait of the Royal Academicians, which were known as 'conversation pieces'. Zoffany was himself a founder member of the Royal Academy. His conversation pieces provide useful information about eighteenth-century tastes, attitudes to art and the status of artists. A group portrait of connoisseurs admiring the classical and Renaissance collections in *The Tribuna of the Uffizi Gallery in Florence* (1772-80; Royal Collection) complements this painting of the Academicians. However, the centrepiece of the Tribuna painting is not a male model in a heroic pose, such as the one in this group portrait, but, rather, a female figure, the highly admired classical nude, the epitome of female beauty, *The Medici Venus*. The statue of Venus, woman as marble goddess, sexual object, is looked at appreciatively by the gathering of connoisseurs. In the painting of the Academicians in the life-class discussing the principles of the nude in classical art, the two women Academicians are excluded. In Zoffany's two paintings, the contrast is clear between woman, acceptable as an object in art, and woman as artist, prohibited from making art's most prestigious and admired objects.

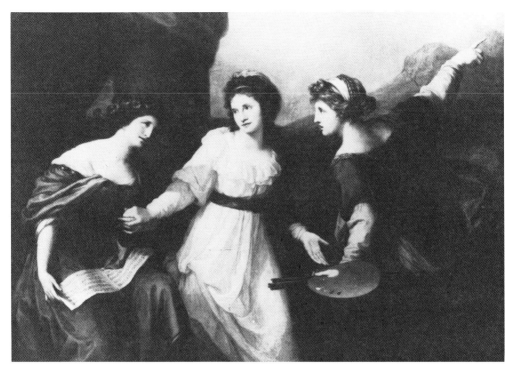

50 Angelica Kauffman, *Angelica Hesitating between the Arts of Painting and Music*, 1794
Angelica Kauffman had an unorthodox girlhood. She travelled with her father, an itinerant muralist and portraitist, through Switzerland, Austria and north Italy. He instructed her in painting and she also trained as a musician, singing and learning to play a variety of musical instruments. It was perhaps her contact, in Florence and Rome, with neo-classical theorists and painters that strengthened her determination to become a history painter, escaping women's usual restriction to still-life and portraiture. In Rome she was elected to the Accademia di San Luca in 1764 and two years later she travelled to London where she became a founding member of the Royal Academy in 1768.

be accommodated in this image. In the interests of historical accuracy Moser and Kauffman could not be entirely excluded from an official group portrait of the Academicians, but they could not be included in a group discussing the nude model. Women were not allowed by the Academy to study in the life-class and this prohibition may have been so strong that Zoffany could not, even in a painting, show women Academicians in the same room as naked male models. It is nevertheless strange that Zoffany indicated their membership of the Academy only by murky, uninformative and almost unrecognizable portraits on the right-hand wall. He did not even depict their faces with the same scrupulous care that enables us to identify all of their male colleagues.

This difference means that Kauffman and Moser do not appear as practising artists but as pictures of women hanging on the walls, as works of art. Although their membership is recorded in this way it is highly significant that women artists could only be present as pictures within a picture and that their features were so differently portrayed that they could be easily mistaken for part of the studio furniture, on a par with the casts and models amongst which the educated gentlemen of the Academy stand or lounge.

It is helpful to compare this portrayal of the eighteenth-century Academic artists by Zoffany with a self-portrait by one of the women, Angelica Kauffman (1741–1807), whom he could not include in the group. Kauffman's painting *Angelica Hesitating between the Arts of Music and Painting* of 1775 (fig. 50) is similarly both a portrait and a statement about the artist. At first sight it invites comparison with the self-portrait by Anguissola (fig. 48), and, like that work, Kauffman's self-portrait advertises the artist's many abilities. But Kauffman showed herself choosing to pursue painting, making her farewell to music, and suggesting perhaps that it was no longer necessary to justify her position as an artist by referring to her many talents. Moreover Kauffman made clear her allegiances in painting with the device of a figure, representing painting, leading her towards the ruins of a classical temple, a reference to both the ideals of academic theory and the contemporary neo-classical movement. The painting is therefore a manifesto of her professional practice as a painter and commitment to the new movement in late eighteenth-century art.

However, there are crucial differences between this portrait by an eighteenth-century woman artist and that by Anguissola, differences which signify a quite new tension between the notion of woman and the notion of the artist at this date. It is a tension that remains unresolved within the painting by Kauffman and which helps to explain why Zoffany could not represent Kauffman in his painting of the Royal Academicians except as an image on the wall. Anguissola's portrait of herself as artist emphasized neither sex nor skill so much as her class whose attributes matched those of the developing

ideals of the Renaissance artist. In her painting her sex and her practice were not in conflict. But in Angelica Kauffman's neo-classical and allegorical painting, her statement about the kind of artist she was collides with the representation of that artist as female.

This painting signifies a transition from the portrait of the artist with the attributes of that profession to an allegorical representation of woman and art. The painting can be 'read' on two levels. The first is that of Angelica Kauffman as a painter choosing to make a statement about her gifts and allegiances. The second level concerns the problematic effects of attempting this as symbolic narrative or allegory. It is this aspect which determines the way in which the portrait of Angelica Kauffman will be perceived. The spectator is not confronted with an active personality, a decisive agent making a choice, but with a picture, a spectacle, of beautiful women. The painting hovers between autobiography and mythology, and it is this ambiguity that reveals a new phase in the history of the identity of the woman artist.

The artist is shown making her choice between painting and music but the two arts are represented allegorically by female figures. Kauffman appears on the same plane and in the same scale as these two ideal figures and this immediately obscures the necessary distinction between the different status of the allegorical figures who represent the arts of music and painting and the artist. That this is no mere artistic failure but rather a problem of the representation of women can be made clear by considering an alternative pictorial formula by which the idea of choice could have been represented allegorically. Eighteenth-century artists, with their knowledge of the classics, would have been familiar with the legend of Hercules at the crossroads. Even within a mythological convention there would have been less confusion of meaning and a clearer distinction between allegorical and 'real' figures if a *male* protagonist was seen choosing between two arts allegorically represented by idealized female figures with symbolic attributes. Moreover because Kauffman was a woman the classical model evoked by such a composition of three women is that of the Three Graces. Given that implicit reference, the allegorical figures claim Angelica Kauffman the artist as one of them. The meanings of this portrait of a woman are thus undermined. The figure of Kauffman becomes an image, almost an allegorical type, by its juxtaposition with the other two images of art and music. Yet at the same time the allegorical figures themselves threaten to break out of their ideal status and become the companions of the artist rather than her muses. This tension is further reinforced by the manner in which the artist is painted; her dress, her appearance and her sad farewell to music are offered to the spectator as the image of a beautiful and affecting woman. She, with the other two female figures, appear before us as objects of beauty. The painter James Barry said of

this picture 'how I envy plaintive music the squeeze she receives'. The ultimate effect of this painting is to show us the woman artist as beautiful, an inspiration to the spectator as well as to herself in the creation of beauty in art.

Women artists of this period were not admired for their Reason but expected to be beautiful and desirable. Ellen Clayton (1876) commented on the way Angelica Kauffman was received when she arrived in London in 1766:

> Happy and genial, elegant and refined, Angelica was warmly welcomed by her brother artists. Fuseli and Dance she had already met in Rome: both were reported to be in love with her. . . . But even Mr Reynolds himself was said to be ready to lay his hand, heart, and enviable position at her pretty feet. . . . People presumed that because she was what ladies call 'very nice looking' and in every way attractive she must be a rank coquette. (*English Female Artists*, vol. I, pp. 247–9)

Her career was surrounded by amorous rumour and her merits as an artist confused with her personal charm, while at the same time it was claimed that no one with her looks could be as good an artist as she appeared to be. In the fifth volume of *Anecdotes of Painting* Horace Walpole wrote of Kauffman, 'she was pretty, sung well, and had a good character. She painted in oil; genteely but lightly.'

In France, Vigée-Lebrun received similar treatment. She was described by her contemporaries as: 'The pride of France, the immortal pencil Elisabeth (sic), the modern Rosalba but more stunning than she, she joined to the voice of Favart [an opera singer] the smile of Venus' (Henri Roujon, *Elisabeth Vigée-Lebrun*, n.d., p. 33). In her own memoirs she proudly recalled the sensation she caused on account of the beauty of her face:

> Since I have already told you, dear friend, how much attention I excited at promenades and other sights, so much so that I often had crowds around me, you can easily understand that several admirers of my countenance made me paint theirs also, in the hope of pleasing me, but I was so absorbed in my art that nothing had the power of distracting my thoughts. (*Souvenirs of Madame Vigée-Lebrun* (English edn), 1870, vol. I, p. 22)

And later she commented, 'In those days beauty was really an advantage' (p. 26). It was a dubious advantage, however, for she too was the object of suspicion and malevolent rumours that another artist, a man, Ménageot, had painted her pictures and even her commissioned portraits.

One artist who was neither suspected of fraud nor acclaimed was Anna

Dorothea Lisiewska-Therbusch (1721–82). Denis Diderot explained why she failed to establish her reputation successfully as a painter when she came to France in 1765:

> It was not talent she lacked in order to create a big sensation in this country . . . it was youth, it was beauty, it was modesty, it was coquetry; one must be ecstatic over the merits of our great male artists, take lessons from them, have good breasts and buttocks, and surrender oneself to one's teacher. (D. Diderot, *Diderot Salons*, ed. J. Adhémar and J. Seznec, 1957–67, vol. III, p. 250)

Lisiewska-Therbusch's self-portrait (fig. 51), painted a few years before her death, is direct, serious and, we imagine, accurate. Her prominent eye-glass brings to mind a pastel self-portrait by Chardin (Paris, Musée du Louvre), who introduced a new element into the imagery of the artist by showing himself in a workman-like guise with eye-glasses and eye-shield. Lisiewska's pose and attributes, however, do not stress her profession but, typically, emphasize her education and refinement. In the late eighteenth century such a self-presentation may be related to the development of the circles of intellectual women, for instance the 'blue stockings', who were disparaged for their desire to cultivate reason rather than romance.

Her contemporary, Rosalba Carriera, succeeded despite her lack of personal beauty, but this achievement merited special comment. In an article in the *Art Journal* of 1886, Carew Martin reviewed eighteenth-century responses to Carriera:

> owing her power to no natural attractions—she was far from good looking and well over thirty when she commenced her career—Rosalba Carriera succeeded in the midst of a society in which feminine frailty offered a surer claim to recognition than talent or virtue.

Her late pastel self-portrait (fig. 52) is a thoughtful, unselfconscious study in which mood and expression are more significant than detail of form or feature. Carriera's commissioned portraits with their clear colours and subtle portrayals of sitters in their confident elegance offer a harmonious picture of eighteenth-century ladies and gentlemen. However, the journals she kept for brief periods late in life reflect a melancholic temperament, and in middle age she was haunted by sadness and a fear of death. She did in fact go blind and some accounts suggest that she suffered a severe mental crisis. This self-portrait with its sombre background and shadowed face is quite different from the commissioned portraits. We do not have to rely on modern psychological

51 Anna Dorothea Lisiewska-
Therbusch, *Self-portrait*, 1779
Lisiewska was born in Berlin of Polish
parents. She and her sister Anna
Rosina (1716–83) were taught by
their father. Anna Dorothea worked
at the Wurttemberg court in Stuttgart
and later for Frederick II 'the Great',
King of Prussia. Between 1765 and
1768 she was in Paris where she was
made a member of the Académie, one
of the few, like Carriera, to break the
1706 ruling against female
Academicians.

Lisiewska married the painter
Therbusch and lived from 1771 in
Berlin, where she died. Her *oeuvre*
contains few major subject pictures;
she concentrated on portraiture, for
she never had the opportunity to
study anatomy sufficiently to fulfil her
ambitions as a history painter.

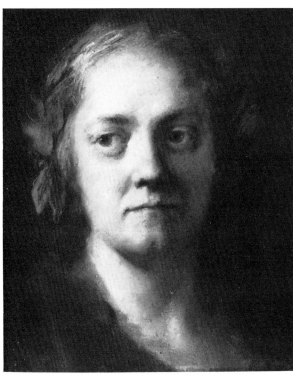

52 Rosalba Carriera, *Self-portrait*, n.d.

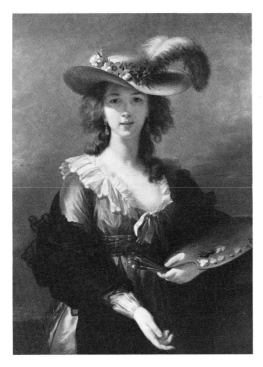

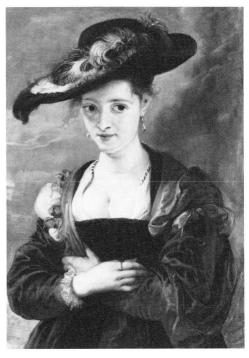

53 Elisabeth Vigée-Lebrun, *Self-portrait*, n.d.

54 Peter Paul Rubens, *Chapeau de Paille* (*The Straw Hat*), 1620–5

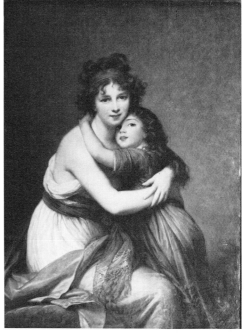

55 Elisabeth Vigée-Lebrun, *Hubert Robert*, 1788
This stunning portrait of Hubert Robert (1733–1808) instantly disposes of the notion that Vigée-Lebrun could not paint male sitters. It also anticipates the romantic masculine concept of the artist which emerged in post-Revolutionary Europe.

56 Elisabeth Vigée-Lebrun, *Portrait of the Artist and her Daughter*, 1789

readings of her self-image for Clement (1904) quotes from Zanetti's *Storia della pittura veneziana* which recounts her painting an allegorical self-portrait 'with the brow wreathed in leaves which symbolized death. She explained this as an image of sadness in which her life would end.'

Such self-portraits as those by Lisiewska-Therbusch and Carriera are in striking contrast to a portrait of the late eighteenth-century artist Elisabeth Vigée-Lebrun. Her self-portrait in the National Gallery, London (fig. 53) carefully depicts the rich stuffs of her dress, the neat pleats of trimmings, the textures of her soft hair and feathers. She holds her brushes and palette with an elegant and unworkmanly gesture, the paint colours neatly arranged to echo the decorative arrangement of flowers on her hat. She offers herself as a beautiful object to be looked at, enjoyed and admired, but conveys nothing of the activity, the work, the mindfulness of the art she purports to pursue. As an image of an eighteenth-century artist it is wholly unconvincing; its known source and intended reference is to a painting by Rubens, *Chapeau de Paille* (fig. 54), which Vigée-Lebrun had recently admired in Antwerp. The coquetry and sensual feeling of that painting is hardly an appropriate model for an artist to use as a basis for a self-portrait, but it is a typical representation of woman, not just a woman, but Woman, sexual, physical, the spectacle of beauty. Vigée-Lebrun's self-portrait was therefore constructed on the meanings 'Woman' as a sign carries in the language of art, meanings quite opposite to the notion of artist, being instituted by critical discourse of the late eighteenth century. A woman artist was acceptable in the eighteenth century but by very different criteria than those applied to men. She was acceptable only in so far as her person, her public persona, conformed to the current notions of Woman, not artist.

This contradiction between Woman as beauty or sexual object and artist is even more acutely represented in a painting of a male artist by Vigée-Lebrun, a prophetic image which intimates a new romantic phase in artistic identity. Her portrait of Hubert Robert (fig. 55) shows the artist in casual workmanly attire, his cravat carelessly knotted, his jacket wrinkled and worn. He leans on a parapet, prominently displaying his painting hand, while his left confidently and comfortably holds his palette and used brushes. These signs of his artistic practice in the foreground are complemented by the force of his torso turned to the right. His face is strongly lit, his eyes directed away from the spectator towards an invisible point, conveying his distant, unseen source of inspiration as well as his profound mental preoccupations. He sees beyond, unlike Vigée-Lebrun herself, who directly engages the gaze of the spectator. A new artistic persona, anti-social, self-contained, seeing with the eyes of the imagination, is coupled unproblematically with palette and brushes, the means to give visual form to his ideas. Constrained by the codes for representing Woman, Vigée-

Lebrun's image of herself is radically different.

Vigée-Lebrun's large production of paintings, her published memoirs, and her prominence in royal and artistic circles of pre-Revolutionary France has meant that of all women artists we have so far discussed she is probably the best known. Yet she is customarily introduced into art history books only to be disparaged as sweet, sickly, sentimental and a charming, decorative addition. For instance:

> Naturalness, which was not at all a discovery of Rousseau's but which he had made into a doctrine was really the century's last burst of optimism. At the emotional extreme it found Madame Vigée-Lebrun, who gave it *chic*, confused simplicity in dress with goodness of heart. Ravished by the charm of her own appearance, and hardly able to paint a male sitter, [!] Vigée-Lebrun continued the century's cult of women. By removing any suggestions of intelligence (naturally) as if it had been rouge, she created the limpid, fashionably artless portrait. . . . In Vigée-Lebrun we have the last view of eighteenth-century woman—who had begun as a goddess, became a courtesan, and now ended all heart—before Napoleon and the war banished her from the centre of events! (M. Levey, *Rococo to Revolution,* 1966, p. 154)

In this typical but unusually long paragraph on Vigée-Lebrun fact and fantasy are mingled with praise and prejudice. The eighteenth century's notion of nature, the cult of sentiment, the spectacle of 'beautiful women', all important elements of late eighteenth-century French society, are confused with the person and personality of the woman artist. There are contradictions evident in Vigée-Lebrun's work because she had to live as a woman artist, celebrated as a 'natural' beauty, and it should not surprise that she reproduced the ideology of a certain class and sector of French society. A corrective view, an alternative way of reading Vigée-Lebrun's work, is provided by Sutherland Harris:

> Finally no biography will do her justice that does not take into account the historical context of her career, a gradually disintegrating aristocratic society of which she was an ardent supporter and for which her work, both written and painted, provides an incomparable record. (L. Nochlin and A. Sutherland Harris, *Women Artists: 1550–1950,* 1976, p. 192)

Vigée-Lebrun was the daughter of a painter, a pastel portraitist. She was educated in a convent and with her father's encouragement studied art, first with Doyen (1726–1809), then with Gabriel Briard (1725–77). During her

training she received instruction and advice from Joseph Vernet (1714–89) and Jean-Baptiste Greuze (1725–1805). She was professionally active by the age of fifteen, supporting her family after her father died. At twenty-one she married the leading picture dealer of the day, Lebrun, which gave her access to a large collection of Old Master paintings. Her style as a portraitist, with its studied casualness and frequent use of landscape settings, owed a great deal to her synthesis of certain seventeenth-century and contemporary modes. In the mid-1770s she became involved in court circles and as one of Marie Antoinette's favourite artists she had to make hasty departure from Paris on the eve of the Revolution. She lived in exile until her death fifty-three years later.

Vigée-Lebrun's career coincided with the great upheaval in French society and culture. The class for which she painted was shaken and the dominant tastes they employed painters to reproduce were destroyed in the violent political struggle attendant on the Revolution. Vigée-Lebrun's flight from France announced her political loyalties, although after the Revolution a great number of artists submitted a petition to remove the artist from the list of proscribed émigrés. Vigée-Lebrun's career brings up interesting questions about the individual artist's relation to social change. On the one hand she was too closely involved with the disintegrating royal and aristocratic class of late eighteenth-century France, yet some of her work contains elements of the new social and political ideologies that contributed to the revolutionary overthrow of the ancien régime. For artists do not passively reflect a dominant ideology, but are part of the process of its construction. They both act and are acted upon. Vigée-Lebrun's practice as an artist involved an encounter with conflicting ideologies in a period of radical social upheaval, a period in which not only the whole structure of society, and relevantly women's roles within it, were transformed, but also in which the roles of artists and the content of their art changed and were publicly debated. Once one can see past the pretty face, one can see how intimately involved Vigée-Lebrun was in these developments.

In her article, 'Happy Mothers and Other New Ideas in French Art' (*Art Bulletin*, 1973), Carol Duncan analyses the emergence of a new moralistic, emotionally high-keyed representation of the family in which domestic life was represented as not only pleasant but blissful. In addition to Vigée-Lebrun she names the key painters as Greuze (1725–1805), Vigée-Lebrun's one-time advisor, and Fragonard (1732–1806). In this period the institutions of marriage and the family were gradually taking on their modern forms and a new concept of childhood emerged. Family, for instance, no longer meant merely line or dynasty, but designated the affective relations between parents and their children; marriage, hitherto an economic and social contract, was to become ideally an emotional partnership; childhood was being distinguished as a unique phase of human growth characterized by such notions as innocence

and naturalness. The promotion of these new ideas associated with the bourgeoisie became a veritable cause for some leading eighteenth-century philosophers and social theorists. Such ideas deeply affected the positions and roles of women. The cult of mother, clearly differentiated roles for parents of different sexes, the insistence on the emotional content of family relationships, are all constituent elements of what was at that date the progressive bourgeois ideology struggling against what was seen as a feudal and anti-rationalist social order represented by monarchy and a system of privileged estates. Vigée-Lebrun's painting of herself and her daughter (fig. 56) can be viewed in relation to these new ideologies. Painted on the eve of the Revolution, its classical dress and elegant composition belong to the old order. The novelty lies in the secular and familial emphasis, the Madonna and Child of traditional iconography replaced by mother and *female* child locked in an affectionate embrace. The *Self-portrait* (fig. 53) laid stress on the notion of *woman* within the phrase 'woman artist'. This portrait of the artist and her daughter elaborates that notion of woman, emphasizing that she is a mother.

The modern bourgeois ideology that woman's place is in the home and that woman's only genuine fulfilment lies in child-bearing—the 'you won't be an artist you'll just have babies'—is prefigured by this image. Moreover the painting links the two females in the circle of their embrace. The child is like a smaller, mirror image of her mother. The adult woman is to be fulfilled through her child; her daughter anticipates growing up to a future role identical to her mother's. The compositional device inscribes into the painting that closing circle of women's roles in bourgeois society.

By the nineteenth century, with the consolidation of the bourgeoisie as the dominant social class, women were increasingly locked into a place in the family; femininity was to be realized exclusively in child-bearing and child-raising. Artists who were women were not only subjected to the institutional restraints of the developing nuclear family but also to the assumption that, therefore, the natural form their art would take was the reflection of their domestic femininity. At the same time, however, 'artist' became increasingly associated with everything that was anti-domestic, outsiderness, anti-social behaviour, isolation from other men, disorder and the sublime forces of untamed nature. As femininity was to be lived out in the fulfilment of socially ordained domestic and reproductive roles, a profound contradiction was established between the identities of artist and of woman.

Moreover bourgeois women in the nineteenth century were required to perpetuate aristocratic traditions, to be beautifiers, civilizers, orderers in the face of the social mobility and economic instability of a chaotic and threatening world. In a poem nostalgically set in a feudal past and entitled 'The Princess' (1854), the Victorian Poet Laureate Tennyson concluded:

> Man for the Field and Woman for the Hearth,
> Man for the Sword and for the Needle she,
> Man to command and Woman to obey,
> All else confusion.

Short, verbless phrases establish by repetition the extreme polarities of man and woman, but uncertainty is betrayed in the abruptness of the last line. Firmly structured divisions alone could ward off threatened confusion. Louisa, Marchioness of Waterford (1818–91) gave interesting support to these notions. She painted sufficiently seriously to decorate the schoolhouse on her estate in Northumberland with improving frescoes and solicited advice from the most prominent art critic of her century, John Ruskin. But she nevertheless rejected the idea that she could become a full-time artist for two reasons. She argued that art is amoral and a woman must be virtuous and moral, and that a woman's role in life is a domestic one. She could never be totally dedicated to artistic practice, as she wrote to a friend:

> I could never attain to even one work that I see in my mind's eye, and if I could it would be less than those great masters of old, whose greatest works have not quelled evil or taught good. I could not live for art—it would not be what I am put in the world to do. . . . Two homes have been given unto me and it is to do what I can in them that they are given for brief life.
> (Quoted in Sparrow, *Women Painters of the World*, 1905, p. 13)

One group of nineteenth-century women turned their backs on what Lady Waterford considered her vocation. Forswearing a future home, husband and family, the group of American expatriate sculptors whose 'fair sisterhood' Henry James christened 'The White Marmorean Flock' took up residence in Rome and here they were able to live and work untrammelled by the conventions that ordered the lives of most middle-class women. Because of the lack of sufficient resources in terms of both training and material resources for carving in marble, ambitious American sculptors had gone to Europe since the first quarter of the nineteenth century. However, there were more specific factors affecting these women's choice to live and work in Rome. Hosmer found the attitudes to women in Europe a welcome change from those in America. She wrote from Rome: 'What country is mine for women! Here every woman has a chance if she is bold enough to avail herself of it; and I am proud of every woman who is bold enough.' Hosmer and some of the other women sculptors, avoiding the constraints of marriage and family, lived remarkably free lives for the nineteenth-century woman, walking un-accompanied through the streets of Rome, even at night, eating out and riding

in the countryside without male escort. None the less, even so limited a move towards the kind of independence enjoyed freely by the male artists in the city not only drew censure from respectable matrons in Roman society, but also led the Chief of Police to issue an official warning. However, their independence was partially accepted in so far as they lived such celibate and exemplary lives and did not contravene the established codes of feminine virtue. The English poet, Elizabeth Barrett Browning, a friend of Hosmer's, wrote to reassure a suspicious matron about the sculptor, 'She emancipates the eccentric life of a perfectly "emancipated female" from all shadows of blame by the purity of hers.'

Nathaniel Hawthorne, the American novelist, defender of the old Puritan ethos of New England, examined one of these sculptors' lives at close quarters. Relieved to find her so pure and unsullied by her unconventional existence, he wrote of Louise Lander (1826–1923):

> A young woman living in almost perfect independence, thousands of miles from her New England home, going fearlessly about these mysterious streets by night as well as by day; with no household ties, nor rule nor law but that within her, yet acting with simplicity and quietness and keeping after all within a homely line of right. (Quoted in M. F. Thorp, *The Literary Sculptors*, 1965, p. 91)

These observations served Hawthorne as the basis for the character of a wholly idealized saint-like angel, Hilda, in his novel about the artistic community in Rome, *The Marble Faun* (1860). In his book, however, the woman artist is no longer an independent sculptor, but has become, instead, a copyist of great Italian masterpieces. Hilda's best copy is made from Guido Reni's painting of Beatrice Cenci, a woman suspected of the murder of her tyrannical father. *Beatrice Cenci* was in fact the subject of a famous recent sculpture in 1859 by Harriet Hosmer. The sculpture (fig. 57) is full of tragedy and pathos. There is a weightiness in the forms, immobility, stillness and silence, which contrasts with the way contemporary male artists used the medium of marble to convey energy and movement. The subject of Beatrice Cenci, imprisoned and chained, offered a theme of woman weighed down and imprisoned in sin, a reflection of Judeo-Christian notions of woman's guilt inherited from Eve. Hosmer's sculpture conveys all this in the heavy rhythm of the supine body, the immobile limbs, the passive expression and the way in which the leaden drapery enshrouds part of the body in almost funereal wrappings. But there is a troubling ambiguity for her body is also partially exposed. Yet her purity is reasserted by the rosary she clutches. The complex meanings of the theme are fully realized. Hosmer has used the medium to

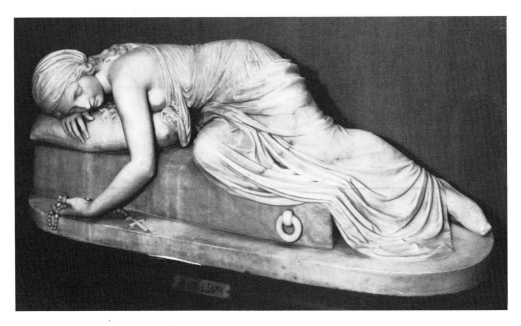

57 Harriet Hosmer, *Beatrice Cenci*, 1857

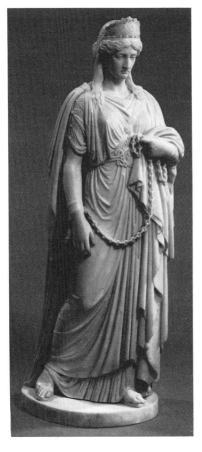

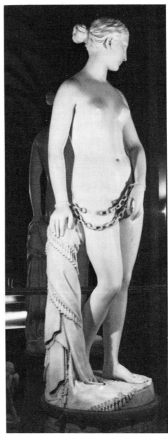

58 (*far left*) Harriet Hosmer, *Zenobia in Chains*, 1859

59 (*left*) Hiram Powers, *Greek Slave*, 1849

convey an acute sense of moral, physical and psychological imprisonment.

Contemporary critics could condone the work of Hosmer and the other American women expatriate sculptors in part because the production of ennobling sculpture was compatible with the role of civilizer and protectress of human values attributed to bourgeois women in the nineteenth century. But at first sight, the making of monumental carved sculpture by women might seem to contradict all we have also said about women's confinement to lesser genres and subjects suitable to production in the home. However, the processes by which sculpture was made in the nineteenth century help to explain the apparent contradiction. Most sculpture, including large pieces in marble, was based on preliminary small-scale modelling in clay. The clay model, embodying the artist's idea, was given over to artisans who made a larger-scale plaster cast and then, by means of a pointing machine, a mechanical device for transferring the model to a large piece of stone, the statue was carved by the highly skilled artisans. The final stage came when the sculptor worked over the marble statue to give it the finishing touches. Modelling in clay fell within the province of activities suitable, according to nineteenth-century writers such as Jackson Jarves (see p. 10), to women's 'fair fingers' and 'lively fancy'. The largest market and source of patronage for sculpture in nineteenth-century America was public statuary for official buildings such as the state capitols. The work of women in this field was subject to restrictions. At times, as trained American sculptors, they were commissioned to make sculptures of famous men for these sites (fig. 7). But strong opposition was expressed to such interventions in this prestigious field on the spurious grounds, for instance, of the impropriety of women modelling men's legs. Hosmer's greatest successes came in the more accepted fields of 'fantasy', her small statue of a chubby *Puck on a Toadstool* of 1856, for instance. Hosmer and the others in the circle also made monumental portraits of famous contemporary women as well as those from history. Her sculpture of the classical figure, *Zenobia in Chains*, 1859 (fig. 58), shows a bold and impressive woman—but under duress, chained, bound and conquered. The subject can be compared to the seventeenth-century tradition of depicting such heroic women as Judith and Portia and shares some of the contradictions of Sirani's depiction of the latter (fig. 17). Zenobia's noble bearing, her queenliness, is signified by the dignity with which she carries her chains, the sign of her captivity and defeat. It is illuminating to contrast Hosmer's *Zenobia* with Hiram Powers's (1805–73) hugely successful sculpture *The Greek Slave*, 1849 (fig. 59). This shows a young, nude, Christian girl offered for sale in a Turkish slave market, sheltering her modesty as best she can with her chained hands. It was read at the time as an anti-slavery statement and an expression of solidarity with the Greek people in their war with the Turks. In attempting to convey the woman's virtue in the face of such

humiliations, Powers used her nakedness to emphasize her vulnerability and powerlessness. This nudity contrasts strongly with the draped bulk of Hosmer's *Zenobia*, from which any sexual suggestiveness is absent. Powers's nude sculpture did not pass without censure, and when it travelled across America on an exhibition tour it had to be defended against accusations of both immodesty and profanity. However, an obliging Reverend Dewey provided an apologia, defending the statue by an assurance that the girl was clothed with the protective covering of Christian virtue. Powers played tantalizingly with youth, beauty and vulnerable availability to convey his notion of Christian virtue. Saleability and sexual possessiveness are bound into his sculpture of a female nude, and the gloss of Dewey or the political meanings read into it cannot obscure or efface these connotations. Hosmer's *Zenobia* manages to convince us of a woman's capacity for stoical strength, a feature only rarely attributed to women in male portrayals of such subjects. Yet here it is undermined by the fact that such courage and fortitude can only be shown in the face of calamity and captivity, a suggestive metaphor for the social bondage in which women lived.

Hosmer was a close friend of Elizabeth Barrett Browning, who lived in Florence. Hosmer chose the name 'Aurora' for the poet-heroine of Barrett Browning's narrative poem *Aurora Leigh*, a major nineteenth-century feminist statement about women and art. In an introduction to the 1978 edition of this work, Cora Kaplan has examined the contradictions and evasions of Barrett Browning's position on women's rights which clarify the position of such women as Hosmer. Kaplan argues that we have to draw a crucial distinction. On the other hand, nineteenth-century bourgeois women were beginning to speak out on their own behalf for their own political causes. In the cultural sphere this included challenging masculine domination in the privileged areas of high culture, such as epic poetry or neo-classical sculpture. On the other hand, the ideological positions of the same women were often less radical than the implications of their activities in these areas. Such a distinction can usefully be applied to the case of Hosmer and her 'sister' sculptors whose determination to participate in this public, monumental professional art was a pronounced refusal to conform to limited notions of women's decorative accomplishments. Yet, the images they made, the subjects they chose and the way they treated them did not present a very profound challenge to dominant ideologies about women. Despite their lives of so-called 'emancipation' from domestic bonds and their choice of heroic women as subject matter, their sculptures not only represent but affirm the bondage and the circumscribed position of woman, either proud and virtuous in humiliation or totally abased and immobilized in Eve's sin.

This community of sculptors was also the subject of short stories seen from

another point of view. In 'Nehemiah P. Hoskins, Artist' (1896), Marie Corelli tells the story of an Italian woman painter whose pictures were sold by male artists as their own work. A brilliant and inevitably 'beautiful' and 'spirituelle' young artist, Giulietta Marchini, recounts how her lover ruined her by stealing her designs. The picture dealer, to whom she tried to sell her own painting, confidently dismisses the incredible notion that it is by her:

> The design of 'I Barberi' is not of a feminine hand. It is purely masculine. . . . No girl of your age was ever capable of designing such a work—look at the anatomy and colouring. It's the man's touch all over—nothing *feminine* about it. (*Cameos*, 1896, p. 51; we are grateful to Susan Hiller for bringing Marie Corelli to our attention)

And later the artist shrugs off the suggestion that she should fight to reinstate her reputation and reclaim a painting of *Daphne* which was then believed to be by an American artist, Hoskins. She provides these pertinent reflections on the relative positions of men and women in the art world:

> 'What is the use of it—to a woman? Celebrity for our sex, as I said before means slander! A man may secure fame through the vilest and most illegitimate means, he may steal other people's brains to make his own career, he may bribe the critics, he may do everything and anything in his power, dishonourably or otherwise—provided he succeeds he is never blamed. But let a woman become famous through unaided exertions of her own hand and brain, she is always suspected of being "helped" by somebody. No I cannot say I care for fame. I painted my picture, or, rather, Mr Hoskins's picture' and she smiled, 'out of a strong sympathy with the legend. The god approaches, and the woman is transformed from a creature of throbbing joys and hopes and passions into the laurel—a tree of bitter taste and scentless flowers.' (p. 54)

The short story is itself as bitter as laurel, although in its own way mythologizes the struggle of the virtuous woman artist unfairly treated in a wicked, prejudiced world. It is a subtle variation of the dominant myth of the artist; she loves her work, shuns notoriety, lives apart from the world and recognizes that the laurel, also the symbol of victory, can only be won through pain and bitterness. She lives the life of, but will never be acknowledged as, an artist. This short story makes an important point; women do great things but the world will not recognize that they do. The theft of Marchini's ideas and designs by Hoskins is symbolic of the way women are deprived of the privileged identity of artist: her work is acclaimed in public, but only when it is assumed

to be by a man. The story illustrates how the sex of the artist determines the way art is seen and that the way art is seen is based on the intersection of two opposing notions, the concept of the artist as male genius and the stereotype of femininity as inherently incapable of genius.

A modern example of 're-attribution' amplifies this point. A *Portrait of Charlotte du Val-d'Ognes* (fig. 60) was purchased in 1917 for $200,000 and bequeathed to the Metropolitan Museum of Art as a work by the neo-classical master Jacques-Louis David (1748–1825). As such it received fulsome praise from international connoisseurs and scholars. In 1948 André Maurois called it 'A perfect picture, unforgettable'. However, in 1951 Charles Sterling published an article in the *Metropolitan Museum of Art Bulletin* tentatively re-attributing the painting to Constance Charpentier (1767–1849). Since then the way the picture is seen has changed dramatically. In 1964, James Laver, for example, wrote: 'Although the painting is extremely attractive as a period piece, there are certain weaknesses of which a painter of David's calibre would not have been guilty' (*Saturday Book*, 1964, p. 19). Sterling's justifications for his re-attribution are entirely spurious, its sentimentality thinly disguising the belief that there is a feminine spirit in art which inevitably is inferior:

> meanwhile the notion that our portrait may have been painted by a woman is, let us confess, an attractive idea. Its poetry is literary rather than plastic, its very evident charms, and its cleverly concealed weaknesses, its ensemble made up from a thousand subtle artifices, all seem to reveal the feminine spirit. (vol. IX, no. 5, p. 132)

Olive (1850) by Dinah M. Craik offers a variant mythology of woman as artist. Olive does become, if briefly, a successful artist. As a woman, she achieves the necessary mythic status of outsider, not because she has a fiercely independent, rebellious spirit, but because she is physically deformed. Her appearance precludes her success as a woman and, realizing she cannot be 'beautiful and beloved', she sets out to create beauty: 'There rose the hope of her Art, under the shadow of which the lonely woman might go down to the grave not unhonoured in her day' (p. 71). Contrary to expectations Olive does get married. Once desired, domesticated and supposedly fulfilled, she abandons her art in favour of more supportive, womanly activities.

The implications of Olive's story, the contradictions between the great artist and the woman, are dramatically documented in the diaries of the painter Marie Bashkirtseff (1859–84) which she kept from the age of five until her early death at twenty-four. They explain her driving need to be an artist, express her acute frustration when her ambition was blocked, and expose all the demands, drawbacks and status that the identity 'artist' had acquired by then. For she

60 Constance Blondelu Charpentier, *Mlle Charlotte du Val-d'Ognes, c.* 1800 Charpentier was a regular exhibitor at the Salons between 1795 and 1819 and the Salon's exhibition catalogues provide a useful list of works by her and indications of her subject matter. Nevertheless, very few of her pictures are identifiable today. Paintings which are firmly attributed to her include a large work, *Melancholy,* of 1801 (Amiens, Musée de Picardie), and a drawing in Dijon. A collection of her works owned by her descendants has recently been discovered but has yet to be published. In 1904 Clara Clement noted two well-known history paintings by Charpentier, *Ulysses Finding Young Astyanax at Hector's Grave* and *Alexander Weeping at the Death of the Wife of Darius,* but these have disappeared.

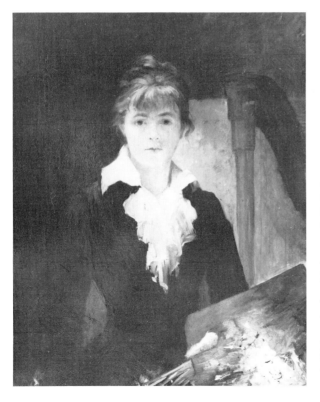

61 Marie Bashkirtseff, *Self-portrait,* n.d. Marie Bashkirtseff was born in Poltava in the Ukraine. Her parents, members of the minor Russian nobility, separated when she was a child and she moved to France with her mother. From roughly the age of five she kept a diary, eighty-four manuscript volumes of which are now in the Bibliothèque Nationale, Paris. Selected extracts, beginning in 1873 when the family lived in Nice and ending with her death from tuberculosis in Paris, have been published. In Paris Bashkirtseff studied at the Académie Julien, exhibiting at the Salon from 1882 to 1884.

not only wanted 'greatness', she wanted it as a woman:

> For when I have the Prix de Rome all the Tabanias, all the Mercuards, all the Larderels [male friends] will lie down on a carpet and I shall walk over them not to crush them—but—it will be they who wish it from the moment when I am what no woman artist has ever yet been. (Quoted in Nochlin and Sutherland Harris, *Women Artists 1550–1950*, 1976, p. 256)

Her background, described with pride in the diary as 'Old provincial Russian nobility...intellectual...brave...cultured...powerful', links her to those noblewomen of a past age whose membership of a cultured élite facilitated their practice as artists. Her self-portrait (fig. 61) recalls those of Anguissola and van Hemessen, for she shows herself with musical as well as painterly attributes. But the vindictive resentment which she confessed to her diary records the difficulties she encountered because she was an aristocrat. By the late nineteenth century a woman of her class was expected to *display* accomplishments, not to pursue a professional career. At thirteen she was disgusted to discover that women were considered incapable of reasoning or understanding. Spurred on, she set out to educate herself, studying Homer, Livy, Dante, Balzac, Sand and Zola. But she commented in her diary: 'I shall not be a poet, a philosopher or a savante. I shall be only a singer or a painter. A vain creature like me must stick to painting, for that is an imperishable work' (*Journals of Marie Bashkirtseff*, M. Blind, trans., 1890). Her ambitions were a result of her desire to escape the expected passivity of a woman's life, yet the way she expressed her determination—in terms of vanity, whereas a man would have regarded it as legitimate ambition—shows how she was undermined from within. She was constantly impeded both by the external and internalized barriers of the social definition of femininity: 'Yes, I with all my impulses, all my immense fever for life, I am always stopped like a horse by the bit. It foams, it rages and rears but is stopped all the same.'

One of the constraints that held her back was profound conflicts between the need for fame to gratify ambition, the need for fame to confirm her as an artist and the belief that fame would bring her love as a woman. But, as Marie Corelli pointed out, fame for a woman was more likely to ensure suspicion, jealousy and infamy, than to win love. And while, for a man, love may be a bonus once success has assured acclaim and confirmation of his ability and social status, for Marie Bashkirtseff it was a central issue, although her motives were confused and contradictory: 'To be celebrated and to be loved, as Balzac said, that is happiness ... yet to be loved is only an accessory or rather the natural result of being celebrated.' She wanted to be great in her own right in order to avoid another 'feminine' trap, the merely vicarious recognition of being beloved by a famous man:

If I were to become a *great* painter, I should have the right before my own consciousness of having feelings and opinions of my own. I might have been happy in being nothing but the beloved of a man who would be my glory . . . but now I must be somebody in my own right.

The choices were stark—independence of mind or complete submission to another, solitary success or supportive subordination. These oppositions were neither necessary nor inevitable. Yet they were disastrously real to nineteenth-century women. The conflicts were internalized by women and conformity to social norms was policed by the censure heaped on any woman who tried to escape.

To satisfy her pride, ambition and need for love, Marie Bashkirtseff had to be great, but there was no longer any model for a female genius. 'The legend of the woman artist,' she wrote, 'a vagabond, a perverted being without industry or talent—repulsive, hungry, beautiful,' no longer existed. To Bashkirtseff, women artists—now so numerous—were simply seen as dull. She reacted to the mediocrity of being merely another woman artist by proclaiming 'there is nothing of the woman about me but the envelope'. She dreamed of confounding 'the idiots who think that my painting is the amusement of a woman of the world' and who, because she was 'so pretty and well dressed', did not believe she painted her own pictures.

She struggled to find ways of breaking through the feminine stereotype of the woman artist and the social stereotype of a woman of her class. But she faced another, perhaps more acute battle of how to reconcile her sense of herself as both an object, a beautiful woman, and as a subject filled with an ambition that by that date could only be described as masculine. While, like the letters of the more famous Van Gogh, Bashkirtseff's diaries constitute a discourse on the modern artist, her introspection and self-analysis is marked by the social construction of the split feminine identity. She watched herself, sometimes as the object, with narcissistic fascination at her own beauty, and at other times as though from a distance: 'I am my own heroine . . . I am so peculiarly constituted that I regard my life as something apart from me and on that life I have fixed all my ambitions and hopes.'

In the last months of her life, suffering from tuberculosis, she struck up a friendship with another young artist, Jules Bastien Lepage, who was also dying. Yet her narcissism and detachment persisted. Four days before the diary ends Bastien Lepage was carried to see her:

I was dressed in a cloud of white lace and plush, all different shades of white; the eyes of Bastien Lepage dilated with delight.
'Oh if only I could paint', he said

And I—
Finis. And so ends the picture of the year.

The diaries are not only a record of her personal struggles and aspirations, but reveal, as no painted self-portrait could even suggest at that date, how, for women artists, nineteenth-century femininity, divided within itself—object of sight and constant surveyor of self, as seen by others' eyes—was in direct opposition to contemporary notions of the artist. In *The Second Sex* (1949), Simone de Beauvoir used Bashkirtseff's diaries extensively in her study of the social construction of femininity in modern times and concluded:

> What woman essentially lacks today for doing great things is forgetfulness of herself, but to forget oneself it is first of all necessary to be firmly assured that now and for all the future, one has found oneself.

This very comment was recorded by a modern American artist, Eva Hesse (1936–70), in her diary in 1964. She too was highly ambitious but had easier access to training, to exhibition and to professional recognition. The thoughts she confided to her diary record, however, that despite the removal of the external constraints a Russian lady encountered in Paris in the late nineteenth century, internal conflicts of identity as woman and artist have persisted. Her analysis is more sophisticated, her perceptions more acute, but the heritage of bourgeois notions of woman is still a powerfully constraining force, lived both in terms of social roles and psychological effects.

Some women have none the less negotiated these social constraints and inner conflicts. There was of course the option of withdrawal from both social life and competition in the public exhibition space and art market. The positions adopted by Gwen John and her brother, Augustus, shed light upon the modified circumstances and artistic practice at the beginning of this century in which that option became a possibility. Gwen John joined her brother Augustus at the Slade School of Art, London, in 1895. They shared an exhibition at the Carfax Gallery in 1903 and Augustus John wrote to Sir John Rothenstein describing the show:

> Gwen has the honours or *should* have—for alas our smug critics don't appear to have noticed the presence in the gallery of two rare blossoms from the most delicate tree. . . . And to think Gwen so rarely brings herself to paint! We others are always in danger of becoming professional and to detect oneself red-handed in the very act of professional industry is a humiliating experience. (Cited in M. Holroyd, *Augustus John*, vol. I, 1973, p. 75)

This statement indicates a shift. Augustus John was ambivalent about the apparent contamination of his 'pure' artistic ideals by the necessity of serving and working for a commercial, professional market. The status of 'professional', which in the nineteenth century had been the ambition of both men and women in art practice, although for women it had been a more acutely important struggle to attain that recognized professional position, was by 1903 more dubious—to be avoided or extremely carefully negotiated.

Gwen John and her brother responded quite differently to the conflicts emerging for the twentieth-century artist. Augustus John refers wryly to the contradiction between the notion of the artist as inspired, free spirit and the career structure dictated by the art market. Gwen John had no sense of being torn between professionalism and geniushood; she simply found the system alien and utterly at odds with the aims she set herself as 'God's little artist'. In 1911 she wrote, 'I paint a good deal, but I don't often get a picture done—that requires for me a very long time of a quiet mind, and never to think of ambition.' Augustus John's flamboyant life-style was dictated by conformity to a notion of the 'Bohemian genius'. Gwen John eschewed such claims for herself, pursuing her work with a dedicated sense of service to a moral ideal of art, reminiscent of the life of a female saint. She struggled for patience and perfection: 'I cannot imagine my vision will have some value in the world— and yet I know it will because I am patient and recueillé [held back] in some degree.' The hard work and patience she imposed upon herself was partly chosen, and partly a necessity if she was to paint. For, as she wrote, she desperately needed calm and desired to 'go and live somewhere where I met nobody I knew till I am so strong that people and things could not affect me beyond reason.' Gwen John went to live in Paris from 1903. The painting *Corner of The Artist's Room* (fig. 62) depicts her sparse room at 87 rue Cherche du Midi in Montparnasse. Both Rodin, whom she met in 1906, and her brother objected to this self-denying standard of living: she selected her homes for her cats' convenience or for the view from the windows, and dismissed her brother's concern for comfort as 'bourgeois'. She painted several versions of the room for she was a perfectionist with a carefully thought-out painting formula: 'I think a painting ought to be done at one sitting or at most two. For this one must paint a lot of canvases.' In this portrait of her chosen working space, everything is assimilated into an image which catches the ambivalence of isolation, loneliness and coldness co-existing with self-containment and peace. It is the artist's room, but the artist is not displayed.

In relative isolation in Paris, painting for a few regular patrons who bought her work, Gwen John practised her art single-mindedly. The fact that such an option to withdraw and work existed does not, however, contradict the continuing potency of social expectations of women and definitions of the

62 Gwen John, *Corner of the Artist's Room*, 1907–9

woman artist. The concept of 'Woman' whose history we have been tracing is not based upon biology or psychology, but is rather a structured social category—a set of roles prescribed for women, ideologically sustained and perpetuated by being presented as descriptions of women. Withdrawal such as John's indicates that it was possible for an individual artist to resist the roles and activities prescribed for her as a woman. But as the case of 'The White Marmorean Flock' demonstrated, non-conformity does not of itself challenge the social structure. John's resistance to the demands of bourgeois femininity, her dedication to her work as an artist, paradoxically evidences the sharpness of the dichotomy, woman/artist.

4
Painted ladies

It thus becomes clear why there is not a female equivalent to the reverential term 'Old Master'. The term artist not only had become equated with masculinity and masculine social roles—the Bohemian, for instance—but notions of greatness—'genius'—too had become the exclusive attribute of the male sex. Concurrently the term woman had become loaded with particular meanings. The phrase 'woman artist' does not describe an artist of the female sex, but a kind of artist that is distinct and clearly different from the great artist. The term 'woman', superficially a label for one of two sexes, becomes synonymous with the social and psychological structures of 'femininity'. The construction of femininity is historical. It is lived by women economically, socially and ideologically. Women occupy a particular position within a patriarchal, bourgeois society, a relation of inequality to its structures of power. Power is not only a matter of coercive forces. It operates through exclusions from access to those institutions and practices through which dominance is exercised. One of these is language, by which we mean not just speech or grammar, but the discursive systems through which the world we live in is represented by and to us.

Full entry into society is marked by access to language, the capacity to use full adult speech and thus to enter into relations with others. We come to know ourselves through being able to use language. But the language of a particular culture prescribes in advance positions from which to speak: language is not a neutral vehicle for expression of pre-existent meanings but a system of signs, a signifying practice by which meaning is produced by the positioning of a speaker and receiver. Furthermore, language embodies symbolically the laws, relations and divisions of a particular culture. Thus, while language is the means by which we speak ourselves and communicate to others, on a deeper level it also controls what can be said, or even thought, and by whom. It is therefore in the field of language that women's struggle must also take place: in

the ways women try to speak themselves and are spoken of, in the ways women represent themselves and are represented by culture.

Representation and the ways in which our views of the world are structured and restricted also occurs in non-linguistic practices. Art is one of the cultural, ideological practices which constitute the discourse of a social system and its mechanisms of power. Power of one group over another is sustained on many levels, economic, political, legal or educational, but these relations of power are reproduced in language and in images which present the world from a certain point of view and represent different positions of and relations to power of both sexes and classes.

From the Renaissance to the mid-nineteenth century the most important and, therefore, influential art form was history painting, that is the painting of historical, mythological or religious subjects based on human figures. For this reason the study of the naked human form was essential training for an artist, and an artist's quality was judged by the criterion of success in history paintings. Women artists were not permitted to study from the nude model. This meant that they could not acquire the necessary tools with which to produce the kinds of painting that alone, according to academic theory, were the test and proof of greatness. Some feminists have pointed to this discrimination as an explanation for what they consider to be the limited success of women artists. However it is dangerous in any way to condone the notion that history painting is the test of artistic greatness; it was so only during the period dominated by academic theory It is also misleading to believe that had women had access to the nude, and therefore the possibility of making history paintings, some would necessarily have been recognized as great artists. For the male establishment not only determined the criterion of greatness but also had control over who had access to the means to achieve it. And at a more important level, a privileged group of men determined and controlled the meanings embodied in the most influential forms of art. The painting of the nude was far more than a mere matter of skill or form; it was a crucial part of an ideology. Control over access to the nude was but an extension of the exercise of power over what meanings were constructed by an art based on the human body. Thus women were not only impeded by exclusion from the nude but were also constrained by the fact that they had no power to determine the language of high art. They were therefore excluded from both the tools and the power to give meanings of their own to themselves and their culture. As we have suggested in discussing the works of Kauffman and Vigée-Lebrun, the problems they encountered were not those of skill or style but of meaning, of what images signified and what could or could not be represented.

Until the late eighteenth century, painting of the nude was based predominantly on the male figure, but after this date the painting of the nude

became increasingly the painting of the female nude. Women continued to be absent from the academies and schools which trained the artists who painted history paintings. But woman was ever more present as the object of that painting, as an image with specific connotations and meanings. The images reproduce on the ideological level of art the relations of power between men and women. Woman is present as an image but with the specific connotations of body and nature, that is passive, available, possessable, powerless. Man is absent from the image but it is his speech, his view, his position of dominance which the images signify. The individual artist does not simply express himself but is rather the privileged user of the language of his culture which pre-exists him as a series of historically reinforced codes, signs and meanings which he manipulates or even transforms but can never exist outside of.

Despite, but also perhaps because of, the loss of conviction in academic theory and the decline of the classical ideal during the nineteenth century, the continuing fascination with the female nude presents this issue more nakedly. In nineteenth-century Salon art the female nude appeared in many guises, as nymph asleep in woodland glades, as Venus raised upon the waves, as shipwrecked and unconscious queen rescued in scanty clothing from the water, as repentant Magdalen careless of dress in her desert retreat, as Flora on her windy way, as courtesan or prostitute dressed for work, as model in the artist's studio (figs 63–69). Despite their manifold disguises and the elevated obscurantism of their classical, historical or literary titles, women's bodies are offered as frankly desirable and overtly sexual. The female figures are frequently asleep, unconscious or unconcerned with mortal things, and such devices allow undisturbed and voyeuristic enjoyment of the female form. Despite variations of style, setting, allegiance or politics, the similarities between these paintings are more striking than the differences. All present woman as an object to a male viewer/possessor outside the painting, a meaning sometimes explicitly enforced by the gaze of a subordinate male onlooker in the painting itself (figs 65, 66, 69).

At first sight such images of female sexual availability might seem surprising in an age which demanded a rigid code of sexual morality for women, placed them in the domestic sphere as keepers of the moral purity and civilized values of society, an image embodied in Coventry Patmore's famous poem 'The Angel in the House' (1856). However, it is important to distinguish clearly between real people and how they are seen through any medium, be it literary or visual, a painting, a novel or a film, between social relations and how they are represented by the mediation of art. It is easy to fall into the trap of seeing art, or images of woman in art, as a mere reflection, good or bad, of the social group, women. Rather we have to recognize in paintings an organization of signs which produce meanings when they are read by a viewer who brings to

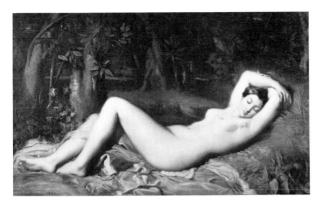

63 Théodore Chassériau, *Sleeping Bather beside a Spring*, 1850

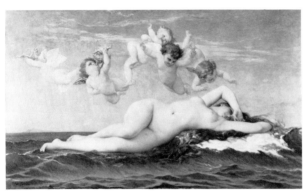

64 Alexandre Cabanel, *The Birth of Venus*, 1863

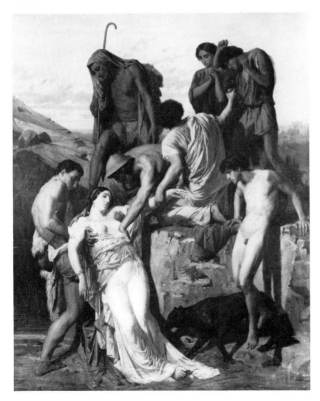

65 William Bouguereau, *Zenobia found on the Banks of the Araxis*, 1850

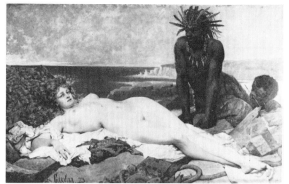

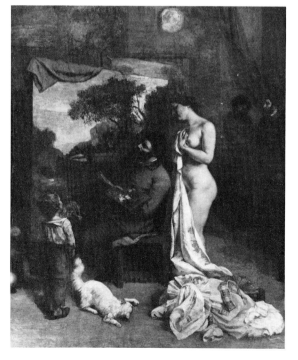

66 (*top left*) Jules-Arsène Garnier, *The Shipwreck Victim*, 1873

67 (*above*) François-Pascal-Simon Gérard, *Flora, c.* 1802

68 (*centre left*) Henri Gervex, *Rolla*, 1878

69 Gustave Courbet, *The Artist's Studio*, 1855 (detail)

the painting both knowledge of the specific signs of a painting—that is, can read lines and colours as denoting certain objects—and familiarity with the signs of the culture or society—that is, can interpret what those objects connote on a symbolic level. Art is not a mirror. It mediates and re-presents social relations in a schema of signs which require a receptive and preconditioned reader in order to be meaningful. And it is at the level of what those signs connote, often unconsciously, that patriarchal ideology is reproduced.

In art the female nude parallels the effects of the feminine stereotype in art historical discourse. Both confirm male dominance. As female nude, woman is body, is nature opposed to male culture, which, in turn, is represented by the very act of transforming nature, that is, the female model or motif, into the ordered forms and colour of a cultural artefact, a *work* of art.

A *Self-portrait* (fig. 70) by the late nineteenth-century German artist Paula Modersohn-Becker (1876–1907) ties together the two threads we have been following, the identity of the artist represented by the self-portrait and the signification of woman represented by the female nude. She exposes the contradictions facing women when they attempt to represent themselves in art and as artists. For not only do women need to be recognized as artists but the very signs and meanings of art in our culture have to be ruptured and transformed because traditional iconography works against women's attempts to represent themselves. Their intentions are undermined by the meanings or connotations that specific iconographies carry.

On Modersohn-Becker's canvas we see a nude female figure against a background of plants, a suggestive, *natural* setting. In her hands and round her head are flowers, whose feminine associations we have discussed. The painting was apparently influenced by the works of Paul Gauguin which Modersohn-Becker had seen in Paris shortly before she began her self-portrait. A certain monumental grandeur and primitive form echoes such Tahitian works by Gauguin of the 1890s as *Tahitian Women with Mango Fruits* (fig. 71), which shows two Oceanic women in an idealized, non-industrialized paradise, one cradling a tray of mango fruits beneath her naked breasts. Linda Nochlin has linked Gauguin's painting with specifically erotic imagery in nineteenth-century painting as well as with popular pornography (L. Nochlin, 'Eroticism and Female Imagery in Nineteenth Century Art', in T. Hess and L. Nochlin (eds), *Woman as Sex Object*, 1972, p. 11). This connection establishes that the association of women with nature, by the juxtaposition of woman with fruit, has at times overt sexual meanings. In the Gauguin painting female breasts nestle amongst fruit, suggesting oral eroticism. Woman and fruit are similarly placed as naturally available for the gratification of men's needs and desires. Certain stylistic comparisons between Gauguin's and Modersohn-Becker's painting are undeniable but the results are rather different.

70 Paula Modersohn-Becker, *Self-portrait*, 1906

71 (*below left*) Paul Gauguin, *Tahitian Women with Mango Fruits*, 1899

72 (*below right*) Paula Modersohn-Becker, *Old Peasant Woman Praying*, c. 1905

In many of her paintings and drawings Modersohn-Becker produced representations of the peasant woman drawn in fact from aged rural paupers living in workhouses in the backwater of Worpswede. Her representations, inflected by her class position and her allegiance to reactionary German ideologies about the Earth, Nature and Natural Woman, were comparable to Gauguin's vision of his Polynesian Eves. Woman was for both unchanging, elemental and natural. But whereas for Gauguin woman was Madonna and Venus, primitive, nourishing and sexual, for Modersohn-Becker woman was the mother, fatalistic and careworn but earthy (fig. 72).

In Modersohn-Becker's self-portrait a series of conflicts is apparent. At one level the painting is an image of fecundity, establishing a parallel between woman and nature. But it is also clear that the painting is intended to be a portrait depicting a self-possessed individual. The assertiveness of the portrait head competes with the imagery of the nude female body surrounded by vegetation. But the portrait connotations are, in fact, seriously undermined by that setting and its associated meanings. However, the title, *Self-portrait*, suggests that the painting was also intended as an image of the artist. Yet all the traditional signs which are usually associated with artists' self-portraits are significantly absent. The painting can be 'read' as an attempt to produce positive and new relationships between creativity and fecundity, between notions of woman and notions of art. But we know that the woman in the painting is an artist only from information provided by the title and, therefore, external to the painting itself. The elements with which Modersohn-Becker worked failed to coalesce.

In striking contrast to the contradictions evident in the bourgeois Modersohn-Becker's attempt to situate herself as artist, the active agent of culture within the codes of representation of the female nude—woman as part of nature—are approached very differently in the work of Suzanne Valadon (1865–1938) (fig. 73). Valadon was working class, daughter of a laundress, one-time trapeze artist and came initially into contact with painting through working as an artist's model. She earned her living 'selling' her body and face to artists for their transformation into their own images of women. In Renoir's *The Bathers* (fig. 74) Valadon was the model for the figure on the right-hand side. In this idyllic vision of modern nymphs bathing, the conception of the female nude—a boneless, well-fed body, a smooth expanse of palpable flesh displayed for the viewer's pleasure—is combined with a whimsical vision of the modern Parisienne, all pouting mouth and retroussé nose. In a *Self-portrait* (fig. 73) by Valadon, painted only shortly before Renoir's composition, a radically different conception of Valadon is displayed. Admittedly it is a portrait, and not a subject picture. The artist depicts herself clothed and it is not a nude. In her concentration upon the face, she underlines the heavy

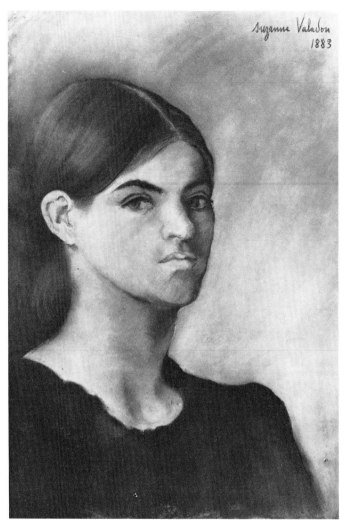

73 Suzanne Valadon, *Self-portrait*, 1883

74 Pierre-Auguste Renoir, *The Bathers*, 1887

75 Suzanne Valadon, *Nu à la Palette*, 1927
Critics of Valadon have marvelled at her treatment of the female nude—how 'unfeminine' she is. Bernard Dorival begins the introduction to the catalogue of the 1967 exhibition of her work at the Musée Nationale d'Art Moderne, Paris by saying that there is really nothing in common between her work and that of 'des dames de la peinture', but concludes that perhaps what he sees as her disdain for logic and indifference to contradictions is the only feminine trait in her art which is 'the most *virile*— and the *greatest*—of all women painters' (our italics). His praise quite simply exposes the modern equation between greatness and masculinity and clearly asserts the by now familiar notion that any woman who achieves greatness has to be an exception to her sex.

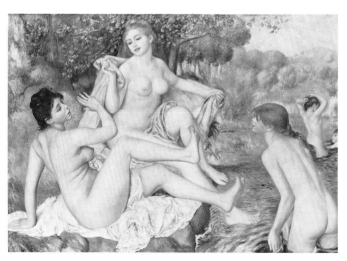

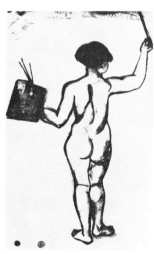

jawline, the dark eyebrows, the indifferent but none the less assertive gaze turned upon herself and thus the spectator. This comparison is not intended to suggest that in the *Self-portrait* we see a truer picture of Valadon. It is as much an image, a constructed representation, as Renoir's. But its choices of emphasis and its effect as an image of a woman dispute those that have operated in Renoir's picture.

The distinctions one can draw between Renoir's work and the way Valadon treated her own and other women's bodies in her frequent portrayals of the female nude depend both upon her background and her different stylistic allegiances. She integrated Degas's attempts to produce a rigorous and realist treatment of the nude engaged in typical, daily activities. She was also interested in the stylistic and coloristic tendencies of the school of Pont Aven with its more schematized delineations. However, just as significant were her experiences as both artist and artist's model. In a *Self-portrait* of herself nude, painted in 1932, Valadon unflinchingly details the process of ageing, setting in tension a fashionable made-up face, short, bobbed hair-cut and jewellery, with her nude torso. Unlike Modersohn-Becker, this painting seeks not to synthesize the nude, the portrait and some ideological conception of woman's place in nature, but rather to play upon the unexpectedness of the juxtaposition of portrait head and portrait nude.

In 1927 Valadon produced some designs for a poster to advertise a benefit dance for the 'L'Aide Amicale des Artistes' in Paris. She chose for her motif a naked woman holding a palette at work upon a canvas (fig. 75). The woman's back is turned to the spectator. She is shown at work, active and absorbed in the activity of painting, contradicting almost everything about the series of academic and realist nudes illustrated above (figs 63–69)—their passivity, their unconsciousness, their bodies blatantly on display. Valadon's drawing also calls into question the role of the nude model as simply bystander to the male artist, object of his work, rather than agent of her own work. It resists certain codes of representation. Yet its effects result from the conventional incongruity, the unexpectedness of 'nu à la palette'—a witty but momentary disruption. Whereas Modersohn-Becker struggled to combine incompatible codes and meanings, Valadon's strategies are those of exposure. But in neither is there the possibility of satisfactory resolution.

A more or less contemporary painting by Henri Matisse, *The Painter and his Model* of 1917 (fig. 76), helps to elaborate what lies behind this. It is also a surprising combination of unexpected elements. Matisse's painting shows us a studio, an artist, male and yet nude, a model female, clothed, and an unfinished canvas. Yet the overall ordering of these elements, the composition itself, produces a structure of dominance. The male artist sits in the foreground, upright, surrounded by rectangles, the chair, the easel and the

canvas on which he works. A form appears on this canvas; shapes and colours echo colours and shapes in the background of the painting to which our gaze is thus drawn. There in a chair the coloured marks are sufficiently delineated to be 'read' as a female model. She is inert and distant from the viewer, a lumpen, shapeless figure, contrasted to the bold vertical in the foreground of an active man at work transforming into *his* own image the raw material which the model offers to *his* gaze, matter into form, nature into culture. He controls the brushes and colours and produces the pictorial image. This is no mirror, the canvas is not a reflection but a space on which, by the mediation of the artist, a transformation is effected into the signs of painting. Skilled in his art and sexually dominant, the artist confidently shows himself at work by painting a picture about painting a picture. He is the maker, the female figure both the object of his gaze and the result of his contemplation.

One device women have used in an attempt to challenge these relations of power is reversal. In *Philip Golub Reclining* (fig. 77) the American painter Sylvia Sleigh shows us a woman at work, painting from a nude man. It is a very different image, or is it? The female figure is upright, a strong vertical in contrast to the lounging horizontal of her male model. But the relative positions of male and female in the space of the painting are not reversed. She is further away from us while he dominates the whole of the foreground. He is not simply a body, a model for the artist to work over, he is Philip Golub whose characterful, highly personalized face stares back at us by the device of the huge mirror in which all save Philip Golub himself, even the artist, is a reflection.

Philip Golub Reclining is also a reference to a tradition—that of the nude, for instance—Velásquez's *Rokeby Venus* (fig. 78). By individualizing and hum-anizing the nude, the artist was attempting to expose and to counter the generalized and objectifying use of the female body in the nude. However, in *The Rokeby Venus*, a woman gazes narcisstically at herself in the mirror, her self-absorption authorizing the spectator's enjoyment of her displayed and shapely form. Yet the mirror is murky, her own face vague, unrecognizable, oblivious to the viewer's voyeurism and imposing no demand for recognition of individual identity. In contrast, Golub's face, well lit and finely detailed, stares back at us with quiet self-possession. He is actively a presence. Despite the metres of sensual flesh, he is a portrait, recognizable and singular. He is not a male odalisque. A man may be placed in a feminine position but will not become feminine. Because of the social power of men in our society no man can ever be reduced to a crumpled heap of male flesh in the dark corner of some woman's studio. The viewer engages with a portrait of a person, not with a generalized male body but with Philip Golub's body specifically.

'When I paint a portrait, and a nude is a portrait to me, I am perhaps more

76 Henri Matisse, *The Painter and his Model*, 1917

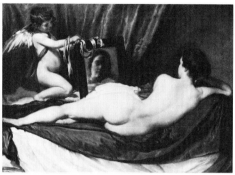

78 Diego Velásquez, *The Toilet of Venus* ('The Rokeby Venus'), *c.* 1650

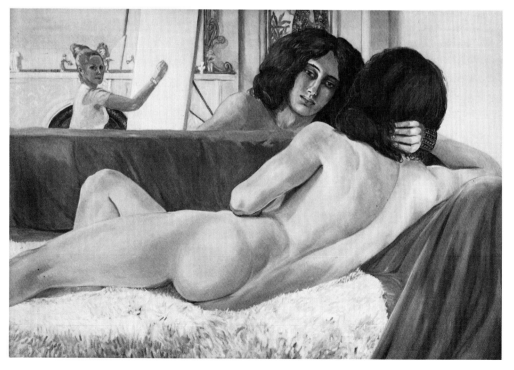

77 Sylvia Sleigh, *Philip Golub Reclining*, 1971

especially aware of the integrity of the flesh than a man would be. I am concerned to discover the psyche of the sitter' (*Feminist Art Journal*, 1972). Thus Sylvia Sleigh describes the intention behind her painting of Philip Golub reclining. She is one of a number of contemporary women to paint naked men in an attempt to comment on the use of the female body in art. On one level they aim to reverse traditional power relations and to show the woman as artistically and sexually potent with the man passive and receptive. But most of these artists would agree that role reversal is not the solution. They are at pains to point out that rather than demanding male and female role reversal they are intending to provide a critique of traditional sexual power relations represented in the female nude. But in the twentieth century a nude, if it is male, is ultimately a portrait only. The traditional form of the nude revolves around the symbolic ordering of sexual difference; these contemporary naked men indicate relaxation, athleticism, familiarity but not sexuality. They belong to a dionysian or apollonian tradition. There is a radical difference between the public art form of the nude reproducing simultaneously male power and male fear of sexual difference and the individual artist's personal encounter with a sitter who has agreed to pose for a portrait without his clothes on. (Such issues raised by paintings of the male nude in art history and current artistic and media forms have been extensively analysed in Margaret Walters, *The Nude Male*, London, 1978.)

The incompleteness of Sleigh's 'reversal', indeed the impossibility of those we have examined, exposes the fundamental asymmetry of power in the structured oppositions of our culture and the effective restraints inscribed into the codes of art itself, within which and against which women artists work. Masculine dominance cannot be displaced merely by reversing traditional motifs and thinking that this automatically produces an alternative imagery.

Nowhere is this clearer than in the use of the female body by feminist artists reacting against the dominance of the male point of view in art. 'Body Art' uses the body of a woman, often the artist's own, in an attempt to liberate it of its meanings exclusively for and made by men, and to reappropriate women's bodies for women. This venture is beset with difficulties, as Lucy Lippard, in an article on 'American and European Women's Body Art', remarked: 'It is a subtle abyss that separates men's use of women for sexual titillation from women's use of women to expose that insult' (*From the Centre*, 1977, p. 125). But woman's body does not just represent sexual titillation for men. At a deeper and unconscious level, the image of the female nude signifies male fear of sexual difference. In European art the signal omission from the depiction of the female nude is exactly the sign of her femaleness, her difference. Female genitals are almost never exposed. The positive assertion of female genitals in so-called vaginal imagery represents for many feminists, therefore, a rejection

of male views of woman's body and an assertion of female sexuality. It attacks the idea of women's genitals as mysterious, hidden and threatening.

Suzanne Santoro is an American artist living in Rome. During the 1960s she worked as a sculptor, primarily with rope and sheet metal. Her work changed under the impact of the Women's Liberation Movement. *Towards New Expression* (1974) was her response as an artist to the issues raised by Italian feminists and relates to women taking control of their own bodies. The sparse, carefully produced volume was published by a women's liberation group, Rivolta Feminile. It opens with photographs of female nudes from art history, decisively demonstrating how women's genitals in art have been 'annulled, smoothed down and in the end idealized'. The photographs (figs 79 and 80) illustrate a flower and a clitoris and belong to the subsequent section of the book which explores the structure of female genitals. Santoro's accompanying text states that she placed photographs of the Antique Greek figures, the flowers and the conch shell near the clitoris as a 'means of understanding the structure of the female genitals. It is also an invitation for the sexual self-expression that has been denied women till now, and it does not intend to attribute specific qualities to one sex or another.' Demystification leading to self-knowledge and sexual self-expression is, Santoro believes, a vital prerequisite for artistic activity. The book demands that women assert themselves, define themselves: 'We can no longer see ourselves as if we live in a dream or as an imitation of something that just does not reflect the reality of our lives.' As the title suggests, the book constitutes a search for ways to analyse and express female experience.

However, such images are dangerously open to misunderstanding. They do not alter radically the traditional identification of women with their biology nor challenge the association of women with nature. In some ways they merely perpetuate the exclusively sexual identity of women, not only as body but explicitly as cunt.

A more metaphorical exploration of woman's body in art is the work of Judy Chicago (b. 1939), an American feminist. She explores female sexuality in explicit images of women's sexual and bodily functions, such as menstruation in an installation called *Menstruation Bathroom*, for a project for a collective teaching programme *Womanhouse* (1971) in Los Angeles, and with a print depicting a woman removing a used tampon, *Red Flag*. Such work challenges long-standing taboos surrounding these areas of female experience. At other times she uses less explicit imagery, for instance in *Female Rejection Drawing* (fig. 81), in which fleshy forms radiate around a central core. This drawing of 1974 marks the culmination of the efforts of Judy Chicago to bridge the gap between, in her words, 'my real concern as a woman and the forms that the professional art community allowed a "serious" artist to use'. In the mid-1960s

79/80 Suzanne Santoro, two double pages from *Towards New Expression*, 1974

81 Judy Chicago, *The Rejection Quintet: Female Rejection Drawing*, 1974

82 *Penthouse*, vol. 12, no. 3, July 1977

she had exhibited large minimalist sculpture, concealing the emotional content of her art and working with formal rather than symbolic issues. By 1973 she had evolved 'clear abstract images of my feelings as a woman' (*Through the Flower*, 1975). *Female Rejection Drawing* is less abstract than other works of that date which share the same optical colour mixture and rippled format, reminiscent of the style practised in Los Angeles in the 1960s. Chicago explained the image to Lucy Lippard: 'I couldn't express my own sexuality by objectifying it onto a projected image of a man, but only by inventing an image that embodied it. That is basically a feminist posture, and I don't think it was possible before the development of abstract form' (*From the Centre*, 1976). *Female Rejection Drawing* clearly refers to the form of the female genitals but Chicago insists that she uses flower and genital forms metaphorically to symbolize, for example, the duality of strength and vulnerability or of power and receptivity. The drawing is one of a series dealing with rejection. Below the image Chicago writes of her rejection as a woman artist. She nearly always accompanies her images with a text making explicit the feelings that prompted the art work, partly because she wants to make her work accessible to those who do not 'read' abstract form and partly in response to the stress the Women's Liberation Movement was then placing on the direct expression of the individual woman's experience.

But what is the effect of these attempts to validate female experience, to reappropriate and valourize women's sexuality? Women, feminist or otherwise, may well feel affirmed by such work, recognizing the way it confronts their oppression by exposing hitherto hidden, repressed or censored aspects of their lives. But because meanings in art depend on how they are seen and from which ideological position they are received, such images have a very limited effectivity. They are easily retrieved and co-opted (fig. 82) by a male culture because they do not rupture radically meanings and connotations of woman in art as body, as sexual, as nature, as object for male possession.

But what determines the connotations of woman as body, as sexual, as nature? What places woman as the antithesis of mind, culture and masculine plenitude and power? At what level do we have to place our analysis? What kind of work begins to rupture these ideologies?

In an article on the contemporary pop artist Allen Jones, 'You Don't Know What's Happening, Do You Mr Jones?' (*Spare Rib*, 1973), Laura Mulvey argues that the insights provided by psychoanalytic theories enable us to begin to understand why women appear as they do in Allen Jones's work and, by extension, in art in general. She does not use psychoanalytic theory to analyse the artist or to make psycho-biographical readings of his images, but rather to understand the unconscious structures and fantasies of the patriarchal order which appear in representations such as these.

Allen Jones's pictorial language is the language of the fetishist: the female body is requisitioned to be re-created in the image of man. The power of man is signified by his privileged access to the phallus, not the real penis, but the primary signifier in the patriarchal symbolic order. (It would be impossible to give a full account of this process here, but reference can be made to the following studies of the psychoanalytic theory and its role in representation; see L. Mulvey, 'Visual Pleasure and Narrative Cinema', *Screen*, 1975; J. Lacan, *Écrits* (English translation, 1977).) The threat of loss, signified by the phallus, the threat of castration, as Freud argued, occurs at the moment of a child's discovery of difference, the mother's lack of phallus which in fantasy not only presents the possibility of castration but comes to represent castration and its attendant fears, as well as imaginary fears of generalized loss and absence. To disguise his potential loss and hide from the acceptance of the knowledge of, or, in psychoanalytic terms, to disavow sexual difference is the work of fetishism. As Laura Mulvey explains:

> To understand the paradoxes of fetishism, it is essential to go back to Freud. Fetishism, Freud first pointed out, involves displacing the sight of woman's imaginary castration onto a variety of reassuring but often surprising objects—shoes, corsets, rubber goods, belts, knickers, etc.— which serve as signs for the lost penis but have not direct connection with it. For the fetishist, the sign itself is the subject of his fantasy—whether actual fetish objects or else pictures or descriptions of them—and in every case it is the sign of the phallus. It is man's narcissistic fear of losing his own phallus, his most precious possession, which causes shock at the sight of the female genitals and the fetishistic attempt to disguise or divert attention from them.
>
> A world which revolves on a phallic axis constructs its fears and fantasies in its own phallic image. In the drama of the male castration complex, as Freud discovered, women are no more than puppets; their significance lies purely in their lack of penis and their star turn is to symbolize the castration which men fear. Women may seem to be the subject of an endless parade of pornographic fantasies, jokes, daydreams etc., but fundamentally most male fantasy is a closed loop dialogue with itself, as Freud conveys so well in the quotation about Medusa's head. Far from being a woman, the Medusa is the sign of a male castration anxiety. Freud's analysis of the male unconscious is crucial for any understanding of the myriad ways in which the female form has been used as a mould into which meanings have been poured by a male-dominated culture. (*Spare Rib*, no. 8, 1973, pp. 15–16)

Within male-dominated culture, its language and its codes of representation,

it is thus not possible to produce in any simple way an alternative, positive management of the image of woman. The image of woman is the spectacle on to which men project their own narcissistic fantasies:

> Most people think of fetishism as the private taste of an odd minority, nurtured in secret. By revealing the way in which fetishistic images pervade not just specialized publications, but *the whole mass media*, Allen Jones throws a new light on woman as spectacle. The message of fetishism concerns not woman, but the narcissistic wound she represents for man. Women are constantly confronted with their own image in one form or another, but what they see bears little relation or relevance to their own unconscious fantasies, their own hidden fears and desires. They are being turned all the time into objects of display, to be looked at and gazed at and stared at by men. Yet, in a real sense, women are not there at all. The parade has nothing to do with woman, everything to do with man. The true exhibit is always the phallus. Women are simply the scenery on to which men project their narcissistic fantasies. (p. 30)

Mulvey's analysis of Allen Jones is relevant here for two reasons. It directly confronts the unconscious levels on which patriarchal ideology operates in bourgeois society. It shows us what fears in fact lie behind men's supposedly unproblematic enjoyment of the sight of woman's body. Second, it indicates that psychoanalytic theory, precisely because it concerns the structures and workings of the unconscious, is both relevant to feminists and a necessary addition to the more common sociological or purely art historical approaches to the issues of art and sexual politics.

We can draw a number of important conclusions. Women's sense of self, their subjectivity, is not to be understood as a matter of social conditioning, for it is determined by the structures of the unconscious. These are based on the impact of sexual difference, the meanings attributed to sexual difference in our culture, and the way in which the lack of the phallus is represented to women. In a patriarchal culture, femininity is not an alternative to masculinity but its negative. Masculinity and femininity are culturally determined positions. Sexual identity is not a given from birth but we are placed as masculine or feminine by the culture into which we are introduced when we learn to speak and recognize ourselves as 'he' or 'she', as son or daughter. Thus language is symbolic of the patriarchal culture in which the phallus is its signifier of power. Both in fantasy and language, woman as woman is not present, except as the cipher of male dominance, the scene of male fantasy. Therefore, within the present organisation of sexual difference which underpins patriarchal culture, there is no possibility of simply conjuring up and asserting a positive

and alternative set of meanings for women. The work to be done is that of de-construction. The 'otherness' of woman as negative of man and the repression of woman in our culture is not without radical possibilities for challenging the oppressiveness of patriarchal systems for both men and women. In art practice, women can engage in work to expose these ideological constructions by questioning the traditional institutions of artist and art, by analysing the meanings which representations of woman signify and by alerting the spectator to the ideological *work* of art, the effects of artistic practices and representations.

5
Back to the twentieth century: femininity and feminism

Throughout this book we have been mapping the positions of women in art by analysing the structures which determine and sustain the differences of power and privilege for men and women in art. These structures not only include conditions of production but, as importantly, conditions of reception. Our point of departure was the need to understand and explain contradictions. The contradictions exist between, on the one hand, current art history's silence on or stereotyping of women's art past and present and, on the other, the vast number of women artists who practise. This situation illustrates a particular brand of twentieth-century patriarchal attitude. Equal opportunities are apparently available but they are effectively contradicted by disguised but profound levels of constraint, containment and oppression.

Any female art student finds herself in an historically determined situation within which the operation of ideology is deeply rooted but frustratingly elusive. The individual female artist alone in her studio or in a traditional art school can achieve only a partial breakthrough. Besides, the situation demands a great deal more than token acceptance of a few women by an establishment which upholds not only the traditional views and limited definitions of art but which also embodies those very values for which the containment and repression of women is structurally necessary.

In 'The Women Artists' Movement—What Next', a thoughtful essay on the situation of current American feminist artists, whose consistent campaigning has raised the proportions of women exhibited in major national institutions, Lucy Lippard has rightly questioned the value of the single-minded pursuit of limited recognition by the establishment. The higher quotas are still quotas. They may become merely new barriers to further change:

> The great danger of the current situation in America . . . is that the barrier will be accepted, that women artists will be content with a 'piece' of the

pie, so long dominated by men, satisfied with the new found luxury of greater representation in museums and galleries (though not yet in teaching jobs and art history books) rather than continuing to explore the alternatives. These alternatives will, hopefully, change more than mere percentages, more than the superficial aspect of the way art is seen, bought, sold and used in our culture. (L. Lippard, *From the Centre*, 1976, p. 14)

Lippard anticipates that if art by women is absorbed into the establishment in this partial way we shall find ourselves within a decade right back where we started, with a few more women's names known in the art world, but with the same system intact and a whole new group of women wondering why they are still left out. Her timely doubts about the direction of the women artists' fight for recognition echo our questions about the feminist art historians' strategies with regard to the women artists of the past.

Lippard's comments raise a pertinent question. Should women artists' energies be directed towards gaining access to the art establishment, demanding full and equal participation in its evident benefits, exhibition, critical recognition, status—a living? Or, instead, should their efforts be channelled into their independent and alternative systems of galleries, exhibitions, educational programmes? These are not in fact oppositions, but differing strategies. Tactically women's collective efforts to provide their own supportive networks are immensely important and they have effectively opened up new spaces and extended the possibilities of work for many women. However there is a real danger of remaining on the margins, occupying the separate sphere established for women's practice in the nineteenth century, at best annexed to mainstream cultural production.

Both interventions in the existing establishment and alternative institutions to those which dominate artistic practice are necessary. They are however but one aspect of the problem. In discussing women artists' relations to eighteenth-century art institutions such as the academies we noted the existence of women's studios and alternative networks. Equally there was evidence of tokenist policies of limited and belated admission of some women to these official bodies. But women's exclusion from the academies did not only mean reduced access to exhibition, professional status and recognition. It signified their exclusion from power to participate in and determine differently the production of the languages of art, the meanings, ideologies and views of the world and social relations of the dominant culture. Women artists did of course produce their own variant or different meanings through their work, challenge or disrupt the ways women were represented. But such interventions as have been made could be dismissed, ignored, re-defined and eventually obliterated

because the power to determine what is 'high', 'great' or 'historically significant' art remained in the hands of male-dominated institutions. In the later nineteenth century we pointed to the special significance for women of the conjuncture in avant-garde practices, when institutional *and* representational practices were jointly questioned and restructured. Avant-garde practices in the twentieth century have themselves presented challenges to traditional notions of art, the artist and codes of representation, though in many cases their impact has been safely absorbed and diverted to become the new establishment. Admittedly, women's participation in these avant-garde practices is still conditioned by their position as women. This is obvious in the way men within such movements view their female colleagues and how critics respond in stereotypical ways to the work women produce. However some of these movements in twentieth-century art have a particular relevance for feminist theory and practice.

In the previous section we discussed the difficulties and pitfalls for women artists who have had to work within codes of representation dominated and controlled by men. Modernistic movements within the twentieth century, for instance, abstraction, 'conceptual art', 'assemblage of found objects', have broken with figurative representation and traditional fine art media. There has been some challenge to the Romantic notion of the artist both by those who stress the impersonality of the work of art or see the individual as mere medium and by those who make use of chance, automatism and encourage spectator involvement. The classical separation of artist, product (the expression of artist) and public has been undermined, while the activity of art itself, the processes of making, the manner in which meanings are produced in a process that includes spectator or receiver as much as maker have all been examined.

But despite new signifying practices and the different relation of the spectator to the work of art, the critic has assumed an unprecedented importance, reconsidering and assessing the significance of the art produced while elaborating the theories and premises upon which modern art is based. The critic of modern art is a central element in twentieth-century art practice, one who conditions the reception of works of art. It is through the discourse of critics, however, that ideology operates to protect the dominant system and stamp the work that women produce, even within radical art practices, with its stereotypes and values.

Our purpose in this book has not been to ascertain a female, feminine or even feminist essence in art or to expose a long-hidden, alternative female culture, gratifying as that might be to our sense of self. It plainly cannot exist isolated like some deep frozen essence in the freezer of male culture. Rather we are concerned to discover the relationships between women artists and the institutions of art and ideology throughout historical shifts and changes.

The heterogeneous activities of women in the twentieth century convincingly dismiss any notion of a homogeneous woman's art. Instead we are confronted with the very many different ways women have intervened in avant-garde practice. But it is those practices or movements which have, however obliquely, touched on the issues of sexual difference that we will consider.

In order to bring out those points that relate specifically to a feminist analysis, we will look in detail at a few works by individual women within selected modernist movements. These works and artists are not special examples whose reputations we wish to establish. We have chosen already well-known artists precisely because their works have already been discussed extensively by critics and this enables us to set their work in the context of its reception by critics.

There are many reasons to take a look at one of the most important twentieth-century movements, Surrealism, the most obvious being that a large number of women became involved; some of the better known are Dorothea Tanning (b. 1910), Meret Oppenheim (b. 1913), Leonor Fini (b. 19–), Remedios Varo (1913–63), Leonora Carrington (b. 1917) and Toyen (b. 1902). Their contribution to Surrealism has, however, been masked by male attitudes. Fellow Surrealists or modern historians either ignore them altogether, or, like Marcel Jean who, in *History of Surrealist Painting* (1960), chivalrously discusses Carrington for her Surrealist cooking, notes the Surrealist women's eccentric fashion sense, delights in Oppenheim's charming Surrealist jewellery or appraises Leonor Fini for her elegant, chic style and dab hand at furniture decoration.

But Surrealism has importance for our purposes beyond the fact of the presence of women in the movement. Surrealist manifestos were produced in the wake of the First World War and movements in art such as Dadaism, which reacted against the bourgeoisie and the system that had taken Europe into war. The Surrealists declared their opposition to prevailing notions of art and the perverted values of their society, its repressions, its notion of common sense and rational order. In the 1930s some members of the movement explicitly allied themselves to revolutionary political movements. Others were particularly interested in promoting quite new definitions of art and a different role for the artist. Lucy Lippard described one of their aims in her introduction to *Surrealists on Art* (1970):

> Surrealism intended to initiate a new humanism, in which talent did not exist, in which there were no artists and non-artists, but a broad new consciousness that would sweep the old concept of art along with it. (p. 4)

Their interest in psychoanalysis, whether they fully understood it or merely

found it useful, represented a desire to attack the symbolic order of their culture, to liberate fantasy, repressed or censored material, to enlarge their experience and their concept of mankind. What they reacted against was defined by André Breton as all that was masculine and what they sought was symbolized by all that was attributed to femininity:

> The time should come to assert the ideas of woman at the expense of those of man the bankruptcy of which is today so tumultuously complete. Specifically it rests with artists, even if it is only in protest against this scandalous state of affairs, to ensure the supreme victory of all which derives from a feminine system in the world in opposition to the masculine system, to base the foundations exclusively on the faculties of women, to exalt, or better still, to appropriate and make jealously one's own all which distinguishes woman from man with regard to modes of appreciation and volition. . . . Yes it is always the lost woman who sings in man's imagination but who—after what trials for them both!—should be also woman regained. And first she must regain herself, learn to know herself, through those hells which, without his more than doubtful aid, man's attitude in general sets up around her. (André Breton, *Arcane 17*, 1945, p. 89)

Although the Surrealists identified masculinity and patriarchy as the repressive order, they intended to subvert it by appropriating the feminine. That which was defined as 'other' was to be taken over by men to fulfil their desire for their total humanity; women it is presumed could not conversely desire to appropriate all that was disparaged as masculine to complete themselves.

Many of the Surrealist notions of the feminine and their fascination with Woman are no more than idealist or essentialist notions of the difference between the sexes and ultimately work to endorse traditional definitions of Woman as Nature, Woman as silent enigma, Woman as Sphinx, Woman as child. None the less they were directly concerned, however mystifyingly, with altering existing definitions of sexual difference. Their notion of the primary androgyne, a composite of masculine and feminine, can be read not just for its overt humanist content but as an unconscious desire to revert to that state which Freud perceived in the pre-oedipal child (the 'little man'), namely the bisexuality, the not yet fixed gender identity, of the human infant, prior to its positioning in patriarchal culture as definitively masculine or feminine subjects.

The implications of this attempt to break open the order of our culture, the pursuit of an androgynous ideal or the exploration of fantasy, castration

anxiety and sexual difference by so many Surrealist male artists was crucial for women of that circle. The cult of the feminine as opposed to the celebration of machismo sexuality in art, the notion of artist as medium rather than domineering, ordering force, the search for hidden, mysterious meanings by a variety of techniques all opened the way for women's participation in the movement.

Leonor Fini (b. 19–) arrived in Paris in the 1930s and although she was never a member of the group, she took part in Surrealist exhibitions and became friendly with Max Ernst, Paul Eluard and Leonora Carrington. Her work is decidedly about Woman, in many mythic guises, as alchemist, goddess, priestess, seamstress, spinner and sphinx, often with her own features. Invocations of old myths and female archetypes from pagan religions celebrate woman as creator, as powerful. But none the less they fall back into traditional definitions of woman, silent or silenced, mysterious, chthonic, enigmatic. Yet the way in which Fini combines her images of woman with her own image, woman as alchemist with woman as artist in the rituals of art, can be seen as an attempt to appropriate to woman exactly the divine force—access to another level of experience— that has been the sacred and exclusive attribute of 'the great male artist'.

In her repeated use of the sphinx, for example, *The Little Guardian Sphinx* of 1948, originally in Egyptian culture a male creature but in Greek mythology a symbol of woman, half-human and half-beast, Fini offers an image of woman as seen by patriarchal society, mythological, intermediate between spheres of nature and humanity, brooding, mysterious and eternally silent. The sphinx exerts an endless fascination, a symbol of an unknown; as Laura Mulvey and Peter Wollen suggested in their film *Riddles of the Sphinx* (1977), it is the symbol of the feminine as the unconscious.

Later works by Fini in the 1960s address the issues of sexual difference more directly, with cooler colours, a more stark, linear style, clinical at times, the protagonists always silent. In *Capital Punishment* (1969) she deals with castration. A female figure kneels beside a block. Behind her stands a young girl, unseeing, her eyes covered by a large sunhat, in her hand a kitchen knife. Both look at a seated figure whose legs are open and whose pubic hair is marked by a bright red stain. The painting has suggested to some a reference to castration, especially because of the goose held by the girl under the menace of her knife. Of her *Fait Accompli (The Deed Accomplished)* of 1967 Fini has written:

In a café full of girls the outline of a man is drawn on the ground in the same way that the police mark the position of a dead body. . . . It is in this outline that the witch revels against all the social opacity of men. That is

to say; the deceit, the conventionality, the sordidness—this is everything which the girls cannot tolerate. (C. Jelenski, *Leonor Fini*, 1968, pp. 14–15)

By exposing the terrible cost to women of the patriarchal system, Fini desires to eradicate sex distinctions. But she uses sex distinction in her own work; she employs reversals. Her paintings are often based on series of oppositions: verticals and horizontals, sleep and consciousness, black and white. In *Chthonian Deity Watching a Young Man Asleep* of 1947 (fig. 83) she took up a theme popular in rococo and Romantic art and epitomized by *The Sleep of Endymion* (1791) (fig. 84) by Girodet (1767–1824). The sensuality of the sleeping boy gently caressed by the embrace of the light of the moon goddess Selene in Girodet's work is replaced by a more sinister Goya-esque atmosphere. An angular young man lies asleep, legs sprawled, his genitals protected and disguised by a soft drapery, typical of the traditional effacement of female sexuality in images of the female nude. The shadows of his imminent beard place him on the verge of manhood. He is watched by a black sphinx, adorned with Minoan jewels and ostrich plumes. The gaze of the sphinx is not subordinated to the viewer's gaze but dominates; her awareness and upright alertness signifies power over the supine male. Although many of its possible meanings are obscured by arcane references and private symbolism, it actively refers to and works over traditional representations. Once again woman's menace to the male order is represented through mythological figures, taking up perhaps Freud's insights in his reading of myths and legends such as the story of Medusa's head and, of course, in the drama of Oedipus. By structural use of verticals and horizontals, by use of colour, the black sphinx contrasting with the pale male, the power of woman, the watcher, but also the fantastic creature, is represented. She also sets up oppositions between aspects of femininity, as in *The White Train* of 1966 (fig. 85), which Linda Nochlin has pointed out is a reworking of a Victorian painting, *The Travelling Companions* of 1859 by Augustus Egg (1816–63) (fig. 86). At one level Fini appears to be exposing what lies beneath the surface of Old Master paintings, the sexuality of women hidden beneath layers of Victorian drapery; but at the same time she uses the sleeping/waking dichotomy, though to different effect.

In Egg's painting two passive, identical young women are travelling in a carriage. One reads and the other sleeps, with her bodice just perceptibly unbuttoned, while their silk petticoats billow in vaguely suggestive shapes. Fini makes the repressed Victorian sexuality overt. She uses the train imagery in several paintings, and twins, or doubles, appear again and again in her work. In *The White Train* they seem to be reflecting the Surrealists' concern with the resolution of opposites, conscious and unconscious, sleeping and waking, life and death, socially admissible and inadmissible behaviour, masculine and

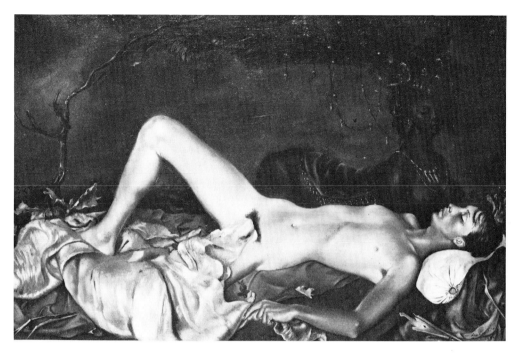

83 Leonor Fini, *Chthonian Deity watching a Young Man Asleep*, 1947

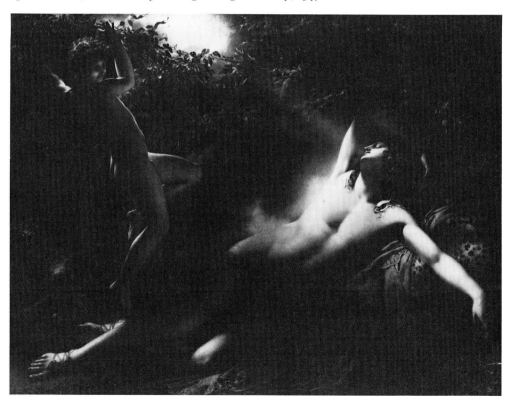

84 Anne-Louis Girodet de Roucy-Trioson, *Sleep of Endymion*, 1791

85 Leonor Fini, *The White Train*, 1966

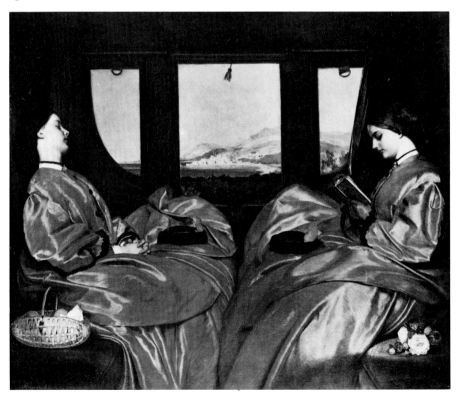

86 Augustus Egg, *The Travelling Companions*, 1859

feminine. Fini once said, 'I am in favour of a world where the sexes are not differentiated, or little differentiated.' The male Surrealists tended to seek androgyny by appropriating what they saw as the feminine; Fini, on the other hand, appears to be demanding a fuller 'humanity' for women, not necessarily based only on the acquisition of supposedly 'masculine' qualities. She challenges Egg's one-dimensional view of women by differentiating the travelling companions. Describing the painting she said one woman was 'like a beautiful cow, very white and somnolent, while the other much more alive, much more alert, pulls the curtain. She doesn't know what she will do next, whether she will kill the other or make love to her' (Jelenski, 1968, p. 37).

Fini's images are strange and difficult to understand because of the mixture of esoteric symbolism and clearly delineated representational forms. But her work betrays certain important tendencies predicated on but differing in effect from the tenets of Surrealism. Behind the valorization of women as alchemist or priestess lie other levels of meaning which are revealed in her chosen forms and images and through references to mythology or which are embedded in the structural oppositions of the compositions. These works deal with woman and the structure of sexual difference but inevitably woman is seen as enigmatic, ambiguous. These are not, therefore, simply 'positive' images celebrating women's power or an alternative female culture but pointers to the unknown quantity that is woman, distantly present in our culture through myths, fantasies, a menace of the repressed. What is present in Fini's work, however, is the discourse of the female artist, working over traditional representations, shifting their meanings, exposing the fears, the limiting divisions of masculinity and femininity.

To shift meanings and to break open common sense were two of the goals of Surrealism, especially apparent in those activities that displaced the traditional notions of the artist and the art object, offering a larger space to the spectator. Certain works known as 'surrealist objects' abandoned conventional media, oil and canvas, and reworked objects from the environment. Meret Oppenheim's (b. 1913) famous *Déjeuner en fourrure* (*Fur Tea Cup*) of 1936 (fig. 87) brings together two banal forms, a cup and saucer and pieces of fur. But their juxtaposition gives rise to powerful effects that cannot be related individually to any one of the component elements. There is the shock of the unexpected, the dislocation of elements from their roles in daily life, the transformation of objects by being placed in an unusual context, not only a teacup and piece of fur in an art exhibition, but fur in the kitchen, luxury on the surface of the commonplace. The juxtaposition is full of condensed meanings, but to take the Freudian terminology further, it suggests another aspect of unconscious processes, displacement. Has not some of the shock of the object a vague, discomforting sexual undertone? With whom are fur coats and

tea cups associated? And in a larger, symbolic sense, vessels, nourishment and hair introduce another level of female sexual reference. One can ultimately only ask questions because the use of juxtaposition and found objects in this way liberates many meanings. Displaced and condensed, intimations of female sexual difference occur in the signifying practice, the materials and methods used and the space opened up to the spectator to bring his/her readings to the object have all been brought together by Oppenheim.

Oppenheim not only exploited the possibilities of strange juxtapositions of objects in her search to produce novel experiences of and through art, she organized events, for instance *The Banquet* in 1959 in which she disturbingly played upon notions of woman as nourishment by placing a nude woman as the centre-piece of the banquet. Oppenheim's conception of novel definitions of men and women's roles was both in line with general Surrealist theories and distinct. She shared the tendency to assume that there was an 'essence' of woman beneath or beyond the socially ordained roles and current definitions, and like other women in the movement she drew upon fertility archetypes and mythologies.

However, whereas Breton in *Arcane 17* discussed the value of femininity in terms of men appropriating the special qualities associated with women, Oppenheim demands that women reclaim their 'masculinity'. The following comment was written in 1975 and, judging from the notions of projected and introjected masculinity and femininity, bears the stamp of Jungian thought (Oppenheim entered Jungian analysis in 1944):

> I believe that men, since creating patriarchy, that is since the devaluation of the female, projected the femininity inherent in themselves, which is regarded as being inferior, onto woman. This means for the women that they have to live their own femininity plus the femininity projected onto them by the males. They are therefore females squared. They are not allowed to live their masculinity. The same applies vice versa for the male.
> (Cited in *Künstlerinnen International 1877–1977*, p. 78)

Women have participated in many of the twentieth-century movements, but Surrealism, not only as a movement but as an approach which has continued to exert influence on other avant-garde practices, is particularly relevant to feminist studies because it was a conscious attempt to fight repression by introducing fantasy and the dream into the discourse of art. But many Surrealists remained within a figurative style of representation which only partially broke with traditional meanings and connotations. Certain forms of abstraction—for instance American Abstract Expression in the 1940s and 1950s—which were touched by Surrealist practices and concerns with

unconscious processes, rather than with their styles of representation, offered a different kind of space and potential for women's intervention and transformation of art language.

Unlike pre-modernist art in which how a thing was painted was subordinate to what was represented, in Abstract Expressionism the act of painting itself was emphasized, and through its use of gesture, abstract form, colour and line, new meanings could be produced.

Despite new possibilities of meaning, the artist in Abstract Expressionism remained extremely important because the activity of painting, the materials and their effects, the gestures an artist made, became the subject of the work itself. So rather than displacing the artist, Abstract Expressionism supremely celebrated the gestures and creativity of the maker and what one sees on an Abstract Expressionist canvas are the traces of the artist's activity.

The situation of women artists in the Abstract Expressionist group and subsequent developments in American painting in the 1950s therefore contained certain basic contradictions. While the signifying practices opened up possibilities, particularly relevant to women, for producing new meanings, the even more mythic status of the artist within this practice brought into headlong collision, on the field of critics' discourse on women artists, notions of 'the great artist' and the stereotypes of femininity. The work of Helen Frankenthaler (b. 1928), who bridged Abstract Expressionist and colourfield painting, and her reception by the critics superbly illustrates the dialectic between the singular and distinctive way one woman worked within this avant-garde and the critical misrecognition of her work by stereotypical responses. For how could a woman be acclaimed as an 'action painter' and achieve the semi-divine heights of the creator? Instead not only have the critics avoided considering her in terms relevant to the movement of which she was a part, they have often fallen back into reading her work through traditional conventions of representational art.

Helen Frankenthaler (b. 1928) graduated in 1950 from a privileged art education. From school, college and visits to museums in New York, Frankenthaler had gained a thorough knowledge of recent developments in modern art and became involved with the debates in current American painting. In 1951 she was introduced by the critic Clement Greenberg to the work of Jackson Pollock—notably his drip paintings in which Pollock had abandoned easel painting in favour of a method of placing his canvases on the floor and moving around all four sides, dripping and splashing dense webs of paint direct from a stick onto this vast surface (fig. 88). After seeing these paintings and having firmly grasped the arguments propounded by Clement Greenberg about the development of modernism and the investigation of formal problems in painting, Frankenthaler developed her own novel

technique—stain-and-soak—which was to have important repercussions for the development of colourfield painting. The significance of her move— pouring paint onto unprimed cotton duck laid on the floor—(fig. 89) was that it enabled Frankenthaler to assert the notion of the flatness and two-dimensionality of the surface of a painting, and thus deny the *illusion* of three-dimensional space. At the same time, the floating colour, saturated into and therefore literally part of its canvas support, creates a sense of ambiguous space through depth of colour, the different forces of colours receding or coming forward. The paintings both conform to and undercut the notion of flatness in a way that brings the maximum number of ambiguities into play. Ambiguity was a theme Frankenthaler consciously pursued, producing in 1957 a large canvas, subsequently given the title of a leading critical study on the uses of ambiguity in creative literature, *Seven Types of Ambiguity* by William Empson.

Her thorough understanding of the premises of modern formalist art with this innovation won her recognition, albeit only unequivocally in 1969, and only after two men, Kenneth Noland and Morris Louis, had acknowledged their debt to her in their own, later and different use of this procedure. In the introduction to a major retrospective exhibition of her work at the Whitney Museum of American Art in 1969, E. C. Goosen gave her the final art historical accolade: 'Recent American painting would have been notably different without her presence and the absence of her work would deprive us of any number of major paintings on which the premises of contemporary art rely' (p. 8). She has been recognized in one sense, but in the end few critics or even enthusiastic admirers have been able to come to terms fully with her work. When confronted with the serious discussion her work demanded, critical discourse resorted all the more revealingly to the feminine stereotypes and separate categories. Superficial changes of terminology and greater academic sophistication say little different from what George Moore wrote of Berthe Morisot, for, in the same catalogue, Goosen commented:

> No matter how abstract her paintings, yet they never quite lose that hereditary connection with the world of nature and its manifestations. This is in direct contrast with that kind of art which is fed only by other art and derives itself from current aesthetic theory. (p. 13)

Frankenthaler is thus associated with nature and distinguished from intellect and theory, a notion both contradicted by the artist herself and by the facts of her class, background, education, involvement with key theories of the period and obvious grasp of their implications.

The feminine stereotype persists. The author of the substantial monograph on Frankenthaler, Barbara Rose, says 'She is essentially an intuitive and

87 Meret Oppenheim, *Déjeuner en fourrure*, 1936

Born in Berlin, Oppenheim went to Paris in 1932 and studied at the Académie de Grande Chaumière. She met members of the Surrealist group and exhibited with them in the 1933 Salon des Surindépendants. Due to financial difficulties she turned to fashion design, making a fur-coated metal bracelet for Schiaparelli which was to inspire *Déjeuner en fourrure*. Pursuing the Surrealist commitment to broadening the definition of art, she continued to create clothes and jewellery even after the general acclaim that greeted the fur teacup when it was exhibited in 1936. Thirty-six years later she made the tea-cup into a series. Annoyed at having been asked 'to do it again' (*Art and Artists*, 1976), she made it into a multiple souvenir piece using frames found at an Italian tourist shop, thus satirizing her legend and the past.

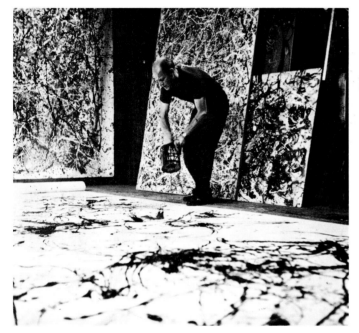

88 Jackson Pollock at work, 1951

89 Helen Frankenthaler at work

90 Helen Frankenthaler, *The Maud*, 1963

natural painter not an intellectual one' or 'There is no doubt that the bursting, flowing, expanding, unfolding, flowering image is her own.' The present participles and the organic metaphors echo the well-known feminine stereotypes, which are reinforced by attempts to place Frankenthaler in a broader art-historical or cultural tradition. Rose significantly chooses the eighteenth-century *fête galante*, the rococo art of Watteau and early tapestry cartoons of Goya as precedents for Frankenthaler's 'lyrical' and 'pastoral' tone, and Dore Ashton compares the artist to the lyric poet whom she defines as self-absorbed, emotional and spontaneous.

The critics' discourse on Frankenthaler not only oozes notions of femininity from every pore, but thus effectively removes her from her precise historical context. Her art becomes timeless as nature, inexplicably reverting to the eighteenth century even in the midst of the important upsurge in national American art in the 1950s. Frankenthaler is contained and categorized, but the critics' language does tell us something about what can and cannot be said about women in art, even in the 1950s.

The inappropriate metaphors, the disconcerting shifts to irrelevant historical references and literary analogies, the search for a point of departure, all these devices circle around something that cannot be said, something inadmissible. No one can say simply, here is an artist, a woman, who is working in a particular movement and shares its premises but produces something different because she is breaking new ground and saying new things within it. Instead they find themselves only suggesting that here is art that is inevitably, timelessly and quintessentially feminine.

Frankenthaler's paintings must, however, be discussed in the specific context of practices of American art in the 1950s. She was impressed by Jackson Pollock's 'drip paintings' for three specific reasons. 'Pollock opened up what one's own inventiveness could depart from.' His vocabulary opened up new possibilities for painting. Second, Frankenthaler was impressed by the surreal elements in Pollock, the implicit levels of association: 'By Pollock I was touched by the surrealist, by surrealist I mean associative quality. It's what comes through in association after your eye has experienced the surface as a great picture. It's incidental but enriching' (*Art Forum*, 1965). Frankenthaler furthermore recognized that Pollock's paintings gave rise to many levels of meaning, because of his use of Surrealist notions of randomness and automatic methods of working.

Based on a thorough understanding of the potential of Pollock's methods and supported by her extensive grounding in the history of modern art, Frankenthaler has consistently pursued the implications of 'stain-and-soak' abstraction which sometimes gave rise to recognizable *Gestalt*s, schema which more directly suggests known shapes, but later become completely abstract,

paint-filled, richly coloured and deeply saturated. A painting of 1963, *The Maud* (fig. 90), provides useful insights into her working methods and their effects, into how paint comes to suggest meanings. It is a large canvas, roughly eight by seven feet, with contrasting areas of thinned, floating paint in abstract shapes and a darker frame, more rugged and sharp-edged. There is a kind of density of space and confusion of depth which is produced entirely by the manner in which the canvas was painted. Unprimed canvas was laid on the floor and pigment was poured onto the material, which was then turned over so that the new top surface bore the chance imprint of the wood grain of the floorboards. This gave incidental texture and the slight suggestion of a grid to the colour which is now literally behind the surface but floating through. Then the darker areas were soaked onto this 'turned-over' side of the canvas and the more sombre tone suggests recession and depth, though because it does not bear the mark of the wood grain the layer is clearly on top of the previously painted reversed surface. Thus, subtle ambiguities of depth and space occur because of the levels of the paint and the incidental features that occurred in the painting process. Many things are suggested by the mood of the muted colours, the intimacy of an interior space framed by menacing jagged areas, the forms of paler, more mobile paint, the title, but these are just possibilities, spaces for the viewer's response that are left open after the artist has moved the paint over canvas and chosen to stop at a certain point.

Such a painting is unlike a work by Pollock, less linear, more saturated with colour, more fluid and less busy. But there are more profound differences. The critics have seen the differences purely in terms of stereotyped readings of the end results, Frankenthaler's paintings are seen as images of nature. They superimpose on an observed difference of 'style' conventional notions of essential femininity or woman's art. But, in contradiction to the premises of Abstract Expressionism, they look at the finished products, *the paintings*, not at how she does them.

The spectator's response to paintings produced by these different procedures and ways of using materials will be conditioned by subjective reactions to certain forms, colours and associations which in turn will be determined by cultural attitudes and socially induced expectations. None the less the various readings of Frankenthaler's and Pollock's paintings depend on the distinctive way in which these painters have acted on canvas. Moreover, Frankenthaler's art is as different from that of Pollock as it is distinct from that of other women who worked in this movement, Grace Hartigan (b. 1922) or Lee Krasner (b. 1908) for instance. The paintings conform to no stereotype, they are not symbolic representations of woman, but the discourse of one woman, illustrating some of the possibilities for women involved with such practices which break open new ground, however momentarily, to produce new

meanings, new effects and statements of their own. Moreover this study of the critical reception of Frankenthaler's work clearly reveals that the language of modern critics continues to reproduce the feminine stereotype, yet again displacing women from their place in the history of art.

Avant-gardism has become an institution in modern art. Each successive stylistic change is overtaken by public acceptance at shorter and shorter intervals. New tendencies and movements occur in an accelerated sequence, even overlapping in time.

A return to figuration in art was made in the New York School in the early 1960s when artists drew upon new materials and motifs—'found' objects from the world of consumer commodities, and 'found' images from the advertisements and other media that celebrated and promoted the rapid expansion of the American economy and American nationalism. Marisol Escobar (b. 1930), Venezuelan by birth but resident in America, who is known professionally as Marisol, was part of the 'beat generation' in New York in the late 1950s and became associated with the development of Pop Art. Cindy Nemser introduces her interview with the artist in *Art Talk* (1976) with this summary of Marisol's position and the legend that grew up around her: 'She became famous in the sixties for her brilliant satiric collaged sculpture, her own personal beauty, and her long mysterious silences' (p. 179).

Marisol's work takes the form of large, free-standing figures, individuals and groups, made of wood and metal, with drawn, cast or painted faces, hands, feet, and often real objects used as accoutrements, clothes, handbags, tables, etc. Though she shared some of the concerns of male pop artists for new media and forms, she did not use them to celebrate American consumer society as they did, but instead subjected contemporary political and artistic circles to searing commentary. For instance in a 1967 assemblage, *LBJ Himself* (New York, Museum of Modern Art), a huge, *machismo* figure of the American president dwarfs three little dolls, his wife and two daughters, who perch in the palm of his outsize hand. In *Babies*, a series dating from 1962–3, huge, angry babies become monstrous and gross. *Baby Girl* (Buffalo, Albright-Knox Art Gallery) holds a diminutive doll which has the features of Marisol. Of the piece, the artist has said, 'For me that meant America. This huge baby monster is taking over. I even had the flags here—stripes. And people think it is a child' (*Art Talk*, 1976, p. 188)

Her large, carved, collaged, assembled sculptures also incorporate and transform elements that intrigued Marisol in non-European art, American Indian, Mexican, pre-Columbian and folk art. This has sometimes led to her work being dismissed as decorative or as craft. Marisol herself responds with an articulate criticism of the narrow definitions of art that result from western artistic imperialism in which western art is placed in a privileged position and

the art of other cultures is dismissed, treated not by art history but by ethnography or anthropology.

Marisol often makes female figures, and the features on their masks are her own. This she explains is not a result of narcissism but of her late working hours when the only model she can call upon is herself. However in *The Dinner Date* (fig. 91) one can easily see how suggestive and complex such repetition of the same face can be: a woman seen in different guises, from different angles, a woman's face as a mask, a dressing like the other coverings or garments. Moreover, it raises the issue of the varieties of women's self-identities in contrast to the way women are encouraged to conform to a homogeneous mould, a fashionable mask, an 'in' face by media fashion and make-up advertisements. Marisol's sculptures also play on levels of illusion and reality in art, assembled collages of objects, fragments of the body, carved wood forehead and torso, painted arm, real boots, dislocated plaster hand holding a real fork, painted heads, but faces made from masks taken from life, wooden sculptures seated on real wooden chairs and at a real table, preparing to dine on a painted TV dinner. The illusions that we come to accept in art are examined, while the setting of two figures with the same features at a table together suggests that in some ways, we never meet anyone else but project onto others a facet of ourselves.

Marisol's work was at first critically acclaimed, but little has been written about her work. Her personal reputation, however, as a legendary beauty and the myth of her sphinx-like silences have grown conversely. The mystique of her beauty and her supposed silences are a throw-back to, or rather an up-dated version of, the eighteenth-century stereotype of the woman artist, acceptable only as a beautiful object, who does not speak, but is to be looked at. Marisol sees very clearly what this treatment of a woman means. In her interview, Nemser asked,

> But you have this mystique that people talk about—this mystique of silence. People say, 'Marisol never talks'. *Marisol*: Well I think that's a way to wipe me out. They used to say that I am mysterious and like a madonna, and that I don't say anything. I was thinking about it the other day, it's a way to wipe you out . . . I'm a very good artist, but I have to seem like a spook and not really like a person . . . it seems to me that in the sixties the men did not feel threatened by me. They thought I was cute and spooky, but they didn't take my art seriously. Now they take my art seriously, but they don't like me so much. (*Art Talk*, 1976, p. 182)

The career of Eva Hesse (1936–70) traversed a decade of intensified change and she participated in the reaction against Abstract Expressionism and in the

91 Marisol Escobar, *The Dinner Date*, 1963

92 Eva Hesse, *Hang Up*, 1966

greater varieties of possible positions artists explored in New York during the 1960s. Because of her early death and her intriguing personal diaries, a myth has also grown up around Hesse. She does not have to be 'wiped out' or silenced, she has become a nostalgic legend. The real significance of her work has been assessed in a recent book by the feminist critic Lucy Lippard and her work has had an impact in many art schools and student studios. There has also been a tendency to romanticize her art and to speak of it in purely formalist terms, appropriating it as kind of sublime, spiritual abstraction.

Her life story does provide some good material for a Van Gogh-type legend. Born in Nazi Germany in 1936 she was soon separated from her family until they all made a successful escape to America in 1939. Many of her relatives disappeared during the war. In America, her parents separated, and first her mother and then her father died. In 1966 she separated from her husband and in 1969 she collapsed with a brain tumour. One year later she died. It would be easy to sentimentalize or romanticize such tragic events. But it is clear from her diaries that these extreme experiences were worked over by her acute and consistent self-analysis and transformed into her experimental and brilliant sculpture. Chronologically and stylistically her work belongs to the minimalist and post-minimalist aesthetic of the late 1960s in New York, and her work combined rigorous formal reduction, erotic wit and wilful iconoclasm. In her sculpture she drew upon the mechanistic erotica of Marcel Duchamp, the 'combine' materials of Robert Rauschenberg, the humour and absurdity of Claes Oldenberg and the incongruities and sexual content of the Surrealist heritage. Formal contradictions and a daring sense of the absurd based on these various modernist tendencies worked to open up new spaces for Hesse, to find a way of speaking as a woman.

Art making was for her a life-long process of exploration of art and self which took place not only in the objects she made but in her writings which subjected the notion of the artist and art to intense investigation. Her notes and diaries are an integral part of her work. Her diaries however show that, for her, formal concerns were a means to break with art conventions and preconceptions and find something completely new. The artist told Cindy Nemser, in an interview:

> I am interested in solving an unknown factor of art, an unknown factor of life. It can't be divorced as an idea or composition or form. I don't believe art can be based on that. . . . In fact my idea now is to counteract everything I've ever learnt or ever been taught about those things—to find something inevitable that is my life, my thought, my feelings. ('Interview with Eva Hesse', *Art Forum*, no. 9, 1970, p. 59)

Within patriarchal culture, woman is a social construct, as Simone de Beauvoir

wrote in *The Second Sex* (1949): 'One is not born but becomes a woman . . . it is civilisation as a whole that produces this creature . . . described as feminine.' Women are deprived of self-determination and self-knowledge at profound levels while they are barraged with others' definitions and imposed identities, roles and meanings. Hesse's search through art to go beyond, or, in her own words, 'to extend my art into something that doesn't yet exist', 'to fall off the edge', to break out of conventions and preconceptions was coupled with her intense self-analysis which explored the contradictions of the social construct that is femininity and the lived experience of women in our culture.

Reading Simone de Beauvoir had made her aware of the conflicting identities of women. Like Marie Bashkirtseff, she wanted to be great and to find herself. She saw in the practice of art a means to push through the contradictions and limitations and discover a new language infused with her own meanings. In 1964 she explained the dialectics of her intentions in art and the discoveries that came about through work, the processes of making: 'It [art] is an idea, a point of view, the work is quite secondary. However, it is true that with the making you do see things which you would not otherwise.' Her commitment to being an artist and to being a great one was constantly distracted by what was expected of her as a woman. In January 1964 she wrote: 'I cannot be so many things. I cannot be something for everyone. . . . Woman, beautiful, artist, wife, housekeeper, cook, saleslady, all these things. I cannot even be myself or know what I am' (L. Lippard, *Eva Hesse*, 1976, p. 24). Her search for self-knowledge included a close involvement with psychoanalysis which provided her with the theoretical framework to understand the structures of the unconscious. In one diary she made this statement

Conflicting Forces Inside Eva
Mother Force: unstable, creative, asexual, threatening my
stability, sadistic, aggressive.
Father Force: good little girl, obedient, neat, clean,
organised, masochistic.

In this Freudian division, one can read the split between the conscious and unconscious. She also seems to be seeing that division as masculine and feminine—between the symbolic order represented by the father in a patriarchal social structure and that which is repressed, which she referred to as the 'mother force', with all the ambivalence of a female child's identification with and reaction against the mother. However both these forces co-exist within her. In these notes Hesse tried to consider the issues of sexual difference and female subjectivity, however, in a way limited by her classical Freudian perspective.

In her sculptures, made in a decade of intense upheaval and crisis in American art, she produced ambiguous images, erotic, absurd, full of conflict and discomfort. A sculpture of 1966, *Hang Up* (fig. 92), was one of her most important breakthroughs using unlikely oppositions and conjunctions, strange combinations of material—found objects, exaggerations and absurdity. Her interest in this concept of absurdity was derived from existentialist theories:

> It was the most important early statement I made. It was the first time my idea of absurdity or extreme feeling came through. It was a huge piece, six by seven feet. The construction was really very naive. . . . It is a frame, ostensibly, and it sits on the wall with a very thin, strong, but easily bent rod that comes out of it. The frame is all cord and rope. It's all tied up like a hospital bandage—as if someone broke an arm. The whole thing is absolutely rigid, neat cord around the entire thing. . . . It is extreme and that is why I like it and don't like it. It's so absurd to have that long thin metal rod coming out of that structure. And it comes out a lot, about ten or eleven feet, and what is it coming out of? It is coming out of this frame—something and yet nothing and—oh! more absurdity—it is very, very finely done. The colors on the frame are very carefully gradated from light to dark—the whole thing is ludicrous. . . . It has a kind of depth I don't always achieve and that is the kind of depth or soul or absurdity of life or meaning or feeling or intellect that I want to get. (*Art Forum*, 9, 1970, p. 60)

What does this mean, this notion of the depth she felt she had achieved by absurdity and nothingness? *Hang Up* shows us an empty frame, obsessively bandaged and carefully painted, and a metal rod that describes a curve of empty space and casts a few shadows on the wall and floor. What is significant is that Hesse refused to put woman or even herself on view. The frame in *Hang Up* is left empty. She defined the space but not an image. Unlike Frankenthaler, whose presence is emphatic in her work, Hesse left only an indirect trace of the maker. She walked a tightrope, in her own words, between something, an object, a painting or a sculpture, materials, a shape, and nothing, no obvious connotations. In a way, reminiscent of Fini, she poses woman as hidden, unknown presence. But she did not rely on myths or legends, but approached it entirely abstractly. Woman is absent as an image, but present as the maker. The contradictions Hesse perceived for herself as an artist and a woman are not resolved; she treats only the absurdity of such extremes.

In neither her written nor sculpted work is there any notion of a female essence, no identifiable essence of any sort. Her work is a kind of verbal and visual discourse. It can be read as a kind of mapping of the position from which

a woman as artist and as individual makes art and expands the possibilities of what can be made or said. Her aim was not to produce alternative, positive meanings but to break up received meanings in order to speak herself, to produce new spaces, different ones with multiple possibilities.

Critics have admired her work though they were often puzzled and disturbed by its eroticism, its presence, even though it used such unusual means. However, some enthusiastic critics have labelled her work as 'sublime', a usefully non-specific term which avoids confronting what her work is, while throwing an emotional veil of mystery and spirituality over it. Frankenthaler, Marisol and Hesse have been retrieved for the stereotypes. Heterogeneous art made by women becomes homogeneous 'women's art', and, though in terms less overtly complacent than the Victorians, is prevented from threatening the dominance and privilege of 'male art'. However, Frankenthaler, Marisol and Hesse did not aim expressly to challenge the modernist institutions of vanguard art and artist. They worked within them, intervening, producing differentiated meanings by means of that intervention. We can recognize in their activities within the modernist avant-garde radical implications in their practices. However such consciousness of their position as women as did inform their practice was individualistic, without a political understanding of that position.

In the 1970s, however, the emergence of the women's movement has had a radical impact on women artists. A variety of feminist strategies have emerged. Women have challenged the unequal representation of women artists in exhibitions, criticism, teaching and state patronage. Others have established their own organizations, such as the Women's Workshop of the Artist's Union and the Women's Arts Alliance in London, to challenge, in different ways, the dominant notions of the artist and definitions of art. They have sought to extend the distribution of their work and to discover new and broader publics.

In terms of practice there has been diversity. There is no more a homogeneous category of feminist art than there was a single category of women's art. Feminist practices have produced a plurality of aesthetic and political positions, a multiplicity of styles, media and subjects. Feminists have been involved in film-making, TV, performance art, video, as much as in the traditional areas of fine art, painting, sculpture, assemblage and photography. All feminist art is however informed by a political consciousness of the differential position of women in our society, aiming to combat all forms of women's oppression.

One of the most immediate effects of feminist intervention in art has been to draw attention to the way in which cultural production and representations in art, as much as in the media, film and TV, are themselves ideological and political. Art is neither pure nor neutral. It is, as we have shown, an ideological practice, secured with power structures—institutions which work to exclude

certain artists and art forms, or to produce representations favourable to the existing social system while dismissing or distorting others which challenge it. Feminist artists have explored the definitions of art, artist and woman which sustain these power systems, questioning the dismissal of women's art as merely dextrous and decorative and the representations in art of women as nature, identified exclusively with femininity and domesticity.

In working over and against them women artists have resisted these imposed definitions. They speak about hidden aspects of women's lives and their experiences as women from their own point of view. In the face of trivialization it has been important to validate women's domestic labour, private and taboo areas of female sexuality and the craft traditions. These areas are important for women's sense of themselves and their past. Work within them is nevertheless open to misinterpretation and can run the risk of appearing merely to reconfirm traditional associations of women with the body, the home and the needle. However these strategies are only one aspect of feminist art. Other work documents those areas of women's life and labour—in factories and the office for instance—that are unacknowledged and repressed in prevalent representations of woman as home-maker and sexual object. Women have also produced art work analysing the economic and social structure of the sexual division of labour inside and outside the home which produce these ideologies of women's domestic femininity, 'natural' proclivites and duties.

These varying positions and emphases are closely interrelated within the complex map of feminist art practice. Many artists work simultaneously or at different times with all of these levels, intercutting consciousness-raising approaches with analysis and historical documentation.

There are thus a variety of feminisms within contemporary art practice and the issues they confront are complex, interdependent and diversely treated. An exhibition held in 1978 in London, The Hayward Annual II, organized by the Arts Council, provides an opportunity for examining the impact of feminism in relation to our overall analysis of women, art and ideology.

The Hayward Annual was instituted in 1977 by the British Arts Council to provide an annual survey of current British art selected by a panel of artists and critics. After many years of campaigning by women both within and outside the women's movement for the inclusion of more women artists in such official exhibitions, the Arts Council was persuaded to invite five women to select the work for the second annual in 1978—hereafter referred to as HA II. The five selectors, Gillian Wise Ciobaratu, Rita Donagh, Tess Jaray, Liliane Lijn and Kim Lim, organized an exhibition which was not an all-women show so that it could neither be complacently dismissed as just a women's show nor be taken as in any way a comprehensive survey of work by contemporary British women artists. Only 16 of the 23 artists were women. This ratio of 16 women to 7 men is

not simply a reversal of the dismally small percentages of women exhibited in state-sponsored shows (none in the *New Art* exhibition in 1972, 4 in a show with 36 men titled *Condition of Sculpture* (1975), 16 women as against 106 men in *British Painting Today* in 1975, 1 in the preceding Hayward Annual out of a total of 32 men). Men constituted at least one third of the exhibition. It was a fairly mixed show.

The selection process and the resulting show exposed a variety of positions held by those who arranged and participated in the event. Some were feminists, others did not identify themselves with the women's movement, others resisted any notion that being a woman affected their life or art. There were in addition those who did not participate at all. Their form of art and its audiences was incompatible politically with exhibiting in such a space as the Arts Council's gallery within an establishment art show amongst work which largely conformed to traditional definitions of fine art, or to current mainstream art movements.

The exhibition was seen by some as merely a *strategic* event to demonstrate women's position as a disadvantaged group and to claim equal rights to access to the benefits of the art establishment. For others it was an opportunity to place the work produced by women in the context of the contemporary art practices from which it arose. Women's art could thus be seen as not necessarily different from that of their male colleagues except in so far as difference of perspective, aim or effect was the stated intention of the works. There was in addition a possibility which was not in fact pursued but in some ways ensued. The exhibition could have been a more overtly political event, exhibiting work which engaged with the debates within feminist theory and feminist art practice, indicating that there is an important difference between work produced by artists who are women and work produced by feminists.

Responses in the press were unexpected. In the *Sunday Times* (13 August 1978) Suzanne Hodgart introduced the forthcoming exhibition with the revealing phrases:

Male artists are likely to be on the defensive when this year's Hayward Annual opens next week. The show was proposed and organised by a group of five women artists. They have chosen 23 artists *only seven of whom are men*. (our italics)

Why would such an exhibition inspire defensiveness from men? What threat would it pose? Why does Hodgart stress the *only* seven men as opposed to the novelty of a show exhibiting work predominantly by women artists? However, in subsequent reviews, the presence of seven men did not prevent the show from being treated as exclusively and stereotypically a 'women's art event'.

Titles of the press reviews framed it only as 'The Girls's Own Annual' (William Feaver). All the familiar notions of women's art and women artists were reasserted with coy belittlement and complacent superiority—'The Female Twist', 'Wayward Gallery', 'Ladies First', 'Distaff Side', 'Ladies Night at the Hayward'. In the *Guardian* Michael McNay sounded a note of relief with his 'No Deadlier than the Male'. Yet threat was none the less registered in the repeated way women were insistently labelled as everything but adult women—girls, liberated ladies, wayward and distaff.

Most critics went on however to endorse the exhibition. Edward Lucie Smith (*Evening Standard*, 24 August 1978) wrote: 'What a pleasure it is to be able to give a warm welcome to a survey show of contemporary British Art. . . . The result is the most stimulating art event I've seen in ages.' In *Arts Review* (1 September 1978) Frances Spalding gave a more indirect welcome: 'If it were possible to divorce the show from the political issue it arouses—the role of women artists in Britain today—it would still rate as one of the most exciting exhibitions of modern art for some time.' A reviewer in the *Christian Science Monitor* (2 October 1978) declared himself grateful that 'vague intuitions were not thick on the ground' and called it 'one of the most stimulating exhibitions of a collective kind seen in Britain for sometime'. His expectations, and more explicitly his relief that women's art did not conform to his preconceptions was more blatantly expressed by John Russell Taylor of the *Times*: 'There is a very consistent level of achievement in this show, with no signs of lame ducks who might have got in just because it is ladies' night' (24 August 1978).

Strikingly the more recurrent terms of *praise* bestowed upon work in the exhibition—as often on art by men as by women—were those traditionally used to *disparage* art. Terms usually employed to dismiss work by women as not great art but merely evidence of feminine sensibility—'lyrically fine constructions', 'delicacy', 'refinement', 'exquisite', 'decorative', 'painstaking'—were applied approvingly to Farrer, Jaray, Leapman, Blow. Ironically critics even took particular pleasure in the layout of the show which provided separate, studio-like spaces for each contributor. Michael Shepherd commented: 'I'd like to think this is because the home-maker aspect in woman understands the relations between space and substance and takes the visitors into account.' The constituent elements of the feminine stereotype return in all their diverse forms: woman as domestic, refiner, decorative and careful. But paradoxically they have become the very grounds for validating the work in the exhibition.

This was not however the case across the board. In the first place this occurred only in discussion of formal aspects of the work by women and men in the show who conformed unproblematically to mainstream modern art styles and concerns. Hostility, significantly expressed in similar terms, was reserved

for work exhibited by feminists, who, in form and content, challenged prevailing concepts of women and their relationship to art. The overtly hostile reactions to the feminist work in the exhibition took one of two forms. Since the art had political motives and resonances, it was not art; or it belonged elsewhere, in the home, the maternity hospital, but not in the art gallery. Much of this kind of attack is contradictory in terms of the traditional definitions of men's 'high' art as intellectually challenging while women's is merely tasteful and manually dextrous. Women's art is feminine because it has so little intellectual content and tends to be decorative. Yet the work by feminists that demanded mental effort ceased to be art, and became instead art politics, which have no place because art should be a purely visual experience. In the *Times Literary Supplement* (27 August 1978) Tim Hilton attacked the 'intrusion' into art of what he took to be politics: 'In many respects one is encouraged to read this exhibition rather than experience it visually', was Hilton's complaint. The feminist art works, defined as art politics, were twice asserted in his essay to be the weakest part of the show, weak in this instance being no quality judgment but an ideological difference of opinion over what art can and cannot be or should and should not treat. When women's art therefore fails to conform with stereotypical expectations and to remain quietly in the sphere carved out for it by man, it is dismissed as simply not art. The organizers are accused by Hilton of having 'occasionally allowed militant feminism to triumph over artistic taste'. To complete the assault, the slur of a 'Salon de Refusées'* was cast over the entire show, the selection

> has clearly been made with much kindness, and they have gone out looking for art. At the same time, felled by their own penchant for the minor, they have necessarily excluded women whose work is of high quality and who belong by nature and inspiration to the fine art traditions. To have shown Katherine Gili and Jennifer Durrant, for instance, would not only have shamed every other contributor; it would also have destroyed its unspoken rationale, that second rate art deserves as much showing as first rate.

Kenneth Robinson, author of a review in *Punch* (6 September 1978) entitled 'Wayward Gallery' began 'I didn't like the idea of all those liberated women artists at London's Hayward Gallery', and he singled out Mary Kelly's work:

What this tedious woman had done is to cover several walls with framed

* In 1863 there was an outcry in Paris amongst artists against the number of artists rejected by the Salon Jury. An alternative Salon des Refusées—the refused—was set up, so that there could be no doubt how bad the rejected pictures were.

statements of thoughts about a growing child, and the child's first precious questions about its parents' bodies. The questions reminded me of those horribly true stories that appear every week in women's magazines. Still I don't want to knock something that could brighten the waiting rooms of Queen Charlotte's [a maternity hospital in West London] or the foyers of Mothercare. I just didn't expect to find it at the Hayward.

The favourable responses to an intervention by women in the arenas of high culture were not in fact unexpected nor inexplicable. The critics subsumed the show into the established category of the feminine in art—a strategy for differentiating and separating women's art in such a way that it can be endorsed and simultaneously affirm masculine dominance. The exhibition, despite its male participants, was praised as visually rather than intellectually interesting, designed with domestic and decorative sensibility, pleasant and undemanding. So long as this category of difference could be reasserted, the show as a whole presented few problems and questioned no assumptions. Even the hostile reviews were not in fact in fundamental disagreement with the favourable. Admittedly they were more prejudiced and overtly dismissive of what they took to be the feminine. For them the art was feminine and therefore bad rather than good and feminine.

Cutting across almost all the reviews, however, was consistently adverse criticism of most of the artists whose work was overtly feminist. Susan Hiller's investigation of how the art of other cultures is perceived and categorized in her piece about the pottery of Pueblo women, *Fragments*, was treated as if it belonged in the domain of anthropology. Her own practice as an artist in reconsidering the fragmented histories of women's art work in other cultures in the past in order to question cultural assumptions and hierarchies was ignored, overlaid by the critics' cultural and ideological assumptions about the pottery that was her subject matter.

Why was it that the feminist contribution to this exhibition necessitated such special treatment? What was it about Mary Kelly's work in particular that had to be distinguished so adamantly from the feminine and denied its status as art?

Mary Kelly (b. 1941), an artist who works in Britain, has been fully involved with the women's movement, and her work engages both theoretically and in practice with political struggle. In an interview with Rozsika Parker, Kelly has said, 'My involvement with the Women's Movement has determined my practice as an artist.'

The first examples of Kelly's involvement with feminism in art practice was her participation in the making of the film by the Berwick Street Film Collective, *Nightcleaners* (1975), a film about the campaign for unionization of women industrial cleaners, in which the film-makers were actively involved.

In 1975 she worked collectively with two women, Kay Hunt and Margaret Harrison, on an exhibition called *Women and Work*, which they described as:

> a document on the division of labour in a specific industry, showing the changes of the labour process and the constitution of the labour force during the implementation of the Equal Pay Act. At the same time we were discovering how the division of labour in industry was underpinned by the division of labour in the home and that the central issue for women was, in fact, reproduction. (Interview with Mary Kelly by Rozsika Parker, 'What is Feminist Art', *Towards Another Picture*, 1977)

The exhibition was composed of objects and written, photographed and filmed records, graphs, health reports and copies of government legislation. The aim was not to 'paint a picture' of the division of labour in industry, but to organize diverse materials so that the viewer, in reading and looking, would come to understand the workings of the sexual division of labour under capitalism in the early 1970s. Her subsequent project, *Post Partum Document* of 1976 (figs 93–97) brought together the new understanding in the women's movement of the sexual division of labour in the home and her own experience of childcare in order to investigate the ramifications for women's struggle of reproduction and childcare.

Mary Kelly is an example of a feminist artist who has taken up the issues of radical practice in art, challenging conventional notions of the art object. Laura Mulvey explains this clearly in a review of Kelly's *Post Partum Document* exhibition held in 1976 at the ICA, London.

> This exhibition comes within radical art practice which refuses to see art objects as purely objects in themselves but rather takes an exhibition as the space to give documentation the force of argument. It deprives the object of any market value and its meanings only truly emerge if the work put in by the artist is complemented by work put in by the spectator in reading the documentation and understanding the theories. (*Spare Rib*, 53, 1976, p. 40)

Moreover, Kelly's work brings together in the art gallery those historically separated roles, artist and mother, but it also unites the public and the private, the domestic and professional, whose categorical separation has structurally defined what is and what is not called art.

Kelly's work confronts one of the myths of the patriarchy, woman as nature and nurture, as mother because of her 'natural' capacity to bear children, which is often used to discount women's creativity. She does this, however, by

refusing to put the mother on view, precluding the notion of woman as object and spectacle. Instead she uses notes, diaries and objects which bear the traces of the relationship of mother and child. Kelly is emphatically not concerned to document child development in the pre-oedipal phase but to show the reciprocal process for both mother and child of socialization in the first few years of life. It is not only the child whose future personality is formed then, but also the mother's; her 'feminine' psychology is sealed in this division of labour through reproduction and childcare.

For example, in the section of *Post Partum Document*, 'Weaning from the Breast' (figs 94, 95), Kelly records the weaning process and exposes the significance of its attendant emotions and anxieties by documenting and commenting on the child's digestive and excretal functions through the traces of its health or ill-health revealed in the stains on a series of nappy liners. 'The normal faeces is not only an index of the infant's health but also within the patriarchy it is appropriated as proof of the female's natural capacity for maternity and childcare.' Mounted nappy liners are accompanied by clinical feeding charts. The process of weaning a child from the sterilized breast milk and moving it on to solid foods is physiologically very complex and, indeed, in medical text books, the development of a child's digestive system is still little understood. However, within patriarchal ideologies of motherhood, the mother is expected to know all about weaning through 'instinct' alone. The doubts and worries ('What have I done wrong?') understandably experienced if a child is ill or 'not normal', are thus the effect and symptoms of the workings of that ideology. Kelly exposes this process by juxtaposing the nappies, the evidence with which the mother judges her child and herself, with the medical knowledge typified by the clinically presented feeding charts. The mother is expected to know all instinctively. The mother is thus judged and formed through her child. By analysing the impact of motherhood and childcare on herself from personal, psychoanalytical and political perspectives, Kelly radically undercuts the notion of 'naturalness' and 'instinct' and brings into view the workings of ideology in the family.

Her chosen format for presentation of this work is related to radical practices of the British avant-garde in the 1970s. However, the impact of her work has not been confined to the art establishment, it achieved public notoriety in the pages of the popular press. The press reaction may well indicate public misunderstanding of avant-garde art practice. But its particular strategies with Kelly's work, humour and ridicule, reflect a need to defend art and society against the radical critiques of its myths and institutions. The defence against this feminist work was not merely to stereotype the work but to deny that it is art at all. Responding to the section in her exhibition on feeding and faeces, a press cartoon showed a harrassed *father* standing over his naughty young son,

Mary Kelly's *Post-Partum Document* developed out of and is addressed to current debates within both the women's movement and current art practice. Since the publication in 1974 of Juliet Mitchell's *Psychoanalysis and Feminism* there has been considerable interest in the implications of concepts of modern psychoanalysis for theories of ideology. It has been argued that we are not born with a human essence or pre-given sexuality, but that our identity or 'subjectivity' as male or female members of our society is constructed, produced in the interrelating processes by which the human infant, physiologically and psychologically unformed at birth, acquires language, a sense of self and a sexual position as feminine or masculine. The two most important areas of this work concern the split in the human subject between conscious and unconscious and the function of language as a symbolic system of cultural meanings which structure our experience and determine what we can and cannot say. A number of contemporary artists have also become interested in these issues, attempting to understand the implications of the role of the unconscious, sexual difference and the systems of meaning in language and representation in order to produce work that does not merely re-assert the dominant ideologies of our society.

The form of Kelly's *Document* deliberately avoids traditional pictorial representations of mother and child with their cluster of pre-determined meanings. Moreover her own words in diaries, recorded conversations and statements are presented in such a way as to prevent their being regarded sentimentally only as the personal autobiographical confessions of a mother. The scripto-visual format of her work in its six parts with its accompanying footnotes and amplifications results from the necessity of finding new ways to represent the social and political significance of the intersubjective relations between a mother and a child during the first few years. Kelly has collected and ordered material from the first six years of her son's life around the specific and ideologically significant moments through which the child achieves its separate identity and the mother adjusts to the 'loss' of her child.

The *Document* begins with the initial separations that take place during *Weaning from the Breast* (figs 93 and 96). The second part, entitled *Weaning from the Holophrase* (fig. 94), concerns the period of the child's first utterances. Single sounds which do not constitute patterned or syntactical speech are heard by the mother as meaningful, as a holophrase, that is a conceptually complete sentence. The mother and child are thus linked in a particular relationship; it is through her filling out his sounds with meaning that he appears to communicate, so that although his early sounds initiate the movement towards his independence as a speaker, the mother is still a crucial intermediary.

The third part, *Weaning from the Dyad* (fig. 95) traces the crucial developments that occur when the dyad, mother and child, is broken first by the intervention of the father, not only by his actual presence but in so far as the mother refers to him in her speech, and then by the child's going to nursery school. The section takes the form of pages of the child's increasingly circular drawings, his representations of himself, overprinted excerpts of recorded conversations between mother and child in which his use of the pronoun 'I' begins to occur, a sign of his growing use of language and separation as he learns to represent himself and thereby distinguish himself from his mother. Beside these conversations are extracts from the mother's diaries which record her responses to the situation, and, finally, a later reconsideration by the mother of her adjustment to and understanding of the significance of these events.

A fourth section, *On Femininity*, addresses the mother's thoughts and fantasies, focusing on objects such as a cast of the child's fist and a part of his comforter, which acquire the status of fetishes or substitutes for the child. The mother's narcissistic pleasure in the baby's body as part of herself has to be relinquished at this stage because of the child's maturing and in response to the patriarchal prohibition on incest. These sign-objects or fetishes are compensations for and attempts to overcome the loss by the child of the mother's body and by the mother of the child's body, the loss that is the law of our culture and the predicate of sexual difference. In the choice of objects and presentation in this section and the following one Kelly is also making a statement about the role of fetishism in art itself.

The fifth section, *On the Order of Things*, is more complex because it documents the period of the child's curiosity about bodies and anatomical differences in his attempt to find out the answers to both 'what am I?' and 'who am I?' This reciprocally re-activates in the mother at the unconscious level fantasies of her own childhood and passage through the Oedipal moment to a feminine position in language and culture, a position of 'lack' which is partially obscured, at least in fantasy, by the experience of child-bearing. In the child's learning to take his gendered position on an axis of sexual difference and in the mother's struggle to represent female sexuality, the mother's 'negative' place as feminine is sealed once again in the same process by which her son comes to adopt a masculine

93 *Post-Partum Document: Documentation I: Analysed Faecal Stains and Feeding Charts* (28 units, 71.1 by 35.6 cm each). The feeding and changing process was recorded at hourly intervals over a period of three months in 1974. The code refers to the 'normality' of faeces.

94 *Post-Partum Document: Documentation II: Analysed Utterances and Related Speech Events* (23 units, 58.4 by 25.4 cm each). The transition from single-word utterances to pattered speech was recorded in daily twelve-minute sessions over a period of five months in 1975. The gloss refers to the mother's interpretation of the child's words and the index card gives the context in which they were used.

95 *Post-Partum Document: Documentation III: Analysed Markings and Diary-Perspective Schema* (10 units, 35.6 by 71.1 cm each). The diary conversations were recorded at weekly intervals during the child's first three months in nursery school in 1975. Each conversation was played back later the same day and again the following week with the mother's notations being superimposed over the child's markings within a 'revised' traditional perspective schema.

position and acknowledge 'the patriarchal order of things'.

The sixth part completes the process of separation and positioning with the full entry of her child into language, signified by his learning to write his own name. Representation, language and sexual position are thus perceived as intimately interrelated and mutually determining in the very process of the construction of the sexed, speaking human subject. Kelly's work is an attempt to find a way to expose these processes and their significance for both women and art. She has constructed the

96 Post-Partum Document: Documentation I: Analysed Faecal Stains and Feeding Charts, detail. 'In the early post-partum period, what the mother wants the child to be is, primarily, "healthy". The normal faeces is not only an index of the infant's health, but also, within the patriarchy, it is appropriated as proof of the female's natural capacity for maternity and childcare. . . . The child is the mother's symptom in so far as she is judged through him' (Mary Kelly, *Footnotes and Bibliography, Post-Partum Document*, 1976).

97 *Post-Partum Document: Experimentum Mentis I–III* (3 units, 71.1 by 35.6 cm each). The diagrams were used to construct a second, more theoretical and specifically psychoanalytic reading of *Documentation I–III* (see Jacques Lacan's Schema R in Anthony Wilden, *The Language of the Self*, Baltimore, 1968, p. 294). Events in the child's life such as eating solid food, learning to speak and entering a nursery underline crucial moments of the 'separation' for the mother, that is *Weaning from the Breast*, *Weaning from the Holophrase* and *Weaning from the Dyad*, 'In the *Post-Partum Document* I am trying to show the reciprocity of the process of socialisation in the first few years of life. It is not only the infant whose future personality is formed at this crucial moment but also the mother whose "feminine" psychology is sealed by the sexual division of labour in childcare' (Mary Kelly, *Introduction to the Post-Partum Document*, 1973).

document in order to show what lies behind the sexual division of labour in childcare, what is ideological in the notion of natural maternal instinct, what is repressed and almost unrepresentable in patriarchal language, female subjectivity. In making the mother-child relation the subject of her art work, she is addressing some of the most politically important and fundamental issues of women, art and ideology.

saying to distant mother, 'Young Henry's just done another work of art on the carpet.' In attempting to ridicule and dismiss her work, the cartoon significantly reasserts all the conventional notions of the art object and creativity, attributed here, of course, to a small *male*.

Conclusion

In *Old Mistresses: Women, Art and Ideology* we have argued that women's art has occupied a strategic though contradictory position in the history of art, always present, always diverse, but represented in art history as always absent or forever the same. A closer analysis of the implications of the ways in which art by women has been discussed and repeatedly belittled suggested an important link between the representation of women's art and the creation of the dominant assumptions about art and the artist.

We have to reject the simple notions that women's art has been ignored, neglected or mistreated by art history, and seriously question the belief that women need to struggle to gain entry into and recognition from the existing male-dominated field of art. Far from failing to measure up to supposedly 'objective' standards of achievement in art, so unproblematically attained by men by virtue of their sex, we discover that art by women has been made to play a major role in the creation and reproduction of those very standards. This represents a fundamental re-reading of the history of women artists and the historical significance of women's art. The focus shifts from the peripheries to the centre—that centre is the historical development of the definitions of art and identities of the artist as the exclusive prerogatives of masculinity.

We can now recognize the reasons for and political importance of the persistent feminine stereotype within the structure of art history's ideological practices. In this stereotype women are presented negatively, as lacking creativity, with nothing significant to contribute, and as having had no influence on the course of art. Paradoxically, to negate them women have to be acknowledged; they are mentioned in order to be categorized, set apart and marginalized. We have focused therefore on art history, its words, its categories, its values, its discourses as ideology. By breaking open the feminine stereotype within art history to expose it not as the product of female gender but of the masculine discourses of art history, we have shown it to be one of the

major elements in the construction of the hegemony of men in cultural practice, in art.

Trying to establish the relationship between women's history in art and the history of ideologies in art has led us to question some of the current interpretations of women's art history. Both nineteenth- and twentieth-century women writers claim that women artists have made a slow but steady progress into art from the few individual celebrities like Anguissola in the sixteenth century to the more numerous but not yet fully integrated professionals of more recent times. We have observed, however, a more varying history in which at different periods the factors of sex, class and dominant forces in art, together with the changing identity of the artist, have produced distinct and differing possibilities for women's practice. Women artists have negotiated their situations within these changing circumstances to produce art which at times conforms to and at other times is in conflict with current ideologies in art making. However in the last two centuries, with the consolidation of bourgeois society and its rigid enforcement of women's economic and social position, manifested in the elaboration of women's 'natural femininity' and divinely ordained domesticity, women artists have been subjected to a more complex process of constraints. The antithesis of artist and 'Woman' have become more profound and entrenched.

Our book is not a conclusive nor an exhaustive study of this history. There are many gaps and generalizations. We have tried to construct a conceptual framework for the analysis of women, art and ideology. We attempt to provide ways of connecting the specific histories of women throughout the history of art with the ideologies and structures that have shaped both their practice and its place in art historical accounts of the art of the past. This helps us understand some of the paradoxes and contradictions in the present situation of women and art, for instance the growing numbers of women artists, and the disproportionately few who are ever fully recognized; the 50 per cent female intake into art schools, and the absence of women in major teaching posts in art education; the language of the critics with the redeployment of the feminine stereotype in almost every reference to a woman artist published in the art press. Women's practice in art has never been absolutely forbidden, discouraged or refused, but rather contained and limited to its function as the means by which masculinity gains and sustains its supremacy in the important sphere of cultural production.

The mapping out of a new framework and our revisions are relevant to both feminist historians and artists. We must understand the historical process and practices that have determined the current situation of women artists if we are to confront the role of cultural production and representations in the systems of sexual domination and power.

NOTES TO THE REVISED EDITION

1. Page 14

Boccacio's essay exhibits the twin tendencies that recur in discussions on women and art well into the nineteenth century, namely, acknowledgement accompanied by segregration – what ultimately produces the feminine stereotype. In providing feminist accounts of the history of art we have to ensure that we do not reproduce this falsely imposed separateness. We have, in addition, to resist the temptation to chart a history of women in art in terms of exceptional celebrities or of heroines overcoming internal or social barriers. To see women artists and their work in a genuinely historical perspective, we must attend to the varied patterns of women's participation in prevailing modes of artistic production. While our work must be informed by a broad sense of discontinuity and rupture in the history of art as much as in the history of the societies art serves, we must also be sensitive to the specificity of art making. Women's art must be approached, therefore, with a full understanding of the effects of such factors as sex and class but also with attention to individual artists negotiations of questions of style, imagery, media and patronage.

2. Page 28

These novel features of artistic production in the eighteenth century challenge the view of history as a linear progression towards the present. History is discontinuous and development is uneven. What occurred in the history of art as well as on the social and political landscape of the eighteenth century was of decisive importance to women. The period culminating in the Revolutionary era of the late eighteenth century marks an historic defeat for women. Yet historical events do not offer themselves in simple positive and negative forms. No obvious pattern emerges of discrimination on the part of the academy or of progress by women towards overcoming it. Rather the history of women and art in the eighteenth century is one of resistance to constraint and more significantly negotiation of the limits set upon their artistic activity. We have to examine different facets of women's negotiation of their situation at this historical moment by considering their explorations of media and genre, their relation to the competition for professional status in the academies, and equally importantly that contractual bond which placed women artists in the centre of the historical stage – patronage.

Select bibliography and further reading

There is a vast literature on women and art and on individual women artists which has already been bibliographically listed in Krasilovsky (1972), Bachmann and Piland (1978), Nochlin and Sutherland Harris (1976), Petersen and Wilson (1976), Vogel (1973) (see below, chapter 1 for full references). We have therefore listed only the most important sources and added further reading following the major chapter divisions of the book.

Chapter 1 Critical stereotypes: the essential feminine or how essential is femininity?

D. BACHMANN and S. PILAND (eds), *Women Artists: An Historical, Contemporary and Feminist Bibliography* (New Jersey and London, 1978).

E. BAKER and T. HESS (eds), *Art and Sexual Politics* (New York, 1971, 1973).

A. CALLEN *et al.*, 'A Beginning Time: Three Women Artists Look at Experience of Art College', *Spare Rib*, 44, 1976.

B. A. CARROLL (ed.), *Liberating Women's History* (Chicago and London, 1976).

E. CLAYTON, *English Female Artists* (London, 1876).

C. E. CLEMENT, *Women in the Fine Arts from the Seventh Century to the Twentieth* (Boston, 1904; new edn New York, 1974).

L. DAVIDOFF, *The Best Circles: Society, Etiquette and the Season* (London, 1973).

L. DOUMATO, 'The Literature of Women in Art', *Oxford Art Journal*, vol. 3, no. 1, 1980.

E. ELLET, *Women Artists in All Ages and Countries* (New York, 1859).

M. ELLMANN, *Thinking About Women* (London, 1968; reissued 1980).

S. FIRESTONE, *The Dialectic of Sex* (New York, 1970).

A. GABHART and E. BROUN *Old Mistresses* (Walters Art Gallery, Baltimore, 1972); see also *Bulletin of the Walters Art Gallery*, vol. 24, no. 1, 1972.

V. GORNICK and B. MORAN, *Women in Sexist Society: Studies in Power and Powerlessness* (New York, 1971).

G. GREER, *The Obstacle Race: The Fortunes of Women Painters and their Work* (New York and London, 1979).

E. Honig Fine, *Women and Art: A History of Women Painters and Sculptors from the Renaissance to the Twentieth Century* (New Jersey and London, 1978).

A. Krasilovsky, 'Feminism in the Arts—an Interim Bibliography', *Art Forum*, vol. 10, no. 10, June 1972.

S. Lipshitz (ed.), *Tearing the Veil* (London, 1978).

D. Miner, *Anastaise and Her Sisters: Women Artists of the Middle Ages* (Baltimore, 1974).

G. Moore, *Modern Art* (London, 1890).

A. Mongan, *The Pastels and Drawings of Berthe Morisot* (New York, 1960).

D. Munault, *Woman as Heroine: Seventeenth Century Italian Representations of Women*, Worcester Art Museum (Worcester, 1972).

C. Nemser, 'Stereotypes and Women Artists', *Feminist Art Journal*, April 1972.

L. Nochlin, 'Why Have There Been No Great Women Artists?' in Baker and Hess (1973) and Gornick and Moran (1971).

L. Nochlin and A. Sutherland Harris, *Women Artists: 1550–1950* (Los Angeles, 1976)

G. Orenstein, 'Review Essay: Art History', *Signs*, vol. I, no. 2, 1976.

K. Petersen and J. J. Wilson, *Women Artists: Recognition and Reappraisal from the Middle Ages to the Twentieth Century* (New York, 1976; London, 1978).

G. Pollock, 'Underground Women: Art by Women in the Basement of the National Gallery', *Spare Rib*, no. 21, 1974.

G. Pollock, *Mary Cassatt* (London and New York, 1980).

L. Ragg, *Women Artists in Bologna* (London, 1907).

D. Rouart (ed.), *The Correspondence of Berthe Morisot* (New York, 1957).

T. Schwartz, 'They Built Women a Bad Art History', *Feminist Art Journal*, Fall 1973.

W. Sparrow, *Women Painters of the World* (London, 1905).

E. Tufts, *Our Hidden Heritage: Five Centuries of Women Artists* (London, 1974).

O. Uzanne, *The Modern Parisienne* (New York and London, English edn, 1912).

M. Vachon, *La Femme dans l'art* (Paris, 1893).

M. Vicinus, *Suffer and Be Still: Women in the Victorian Age* (Indiana, 1972).

L. Vogel, 'Fine Arts and Feminism: The Awakening Consciousness', *Feminist Studies*, vol. 2, 1972.

L. Vogel, 'Women, Art and Feminism', *Female Studies*, vol. 7, 1973.

J. Wayne, R. Braeutigam, B. Fiske (eds), *Sex Differentials in Art Exhibition Reviews: A Statistical Study* (Los Angeles, 1972).

A.-M. Weyl Carr, 'Women Artists in the Middle Ages', *Feminist Art Journal*, vol. 5, no. 1, Spring 1976.

V. Woolf, *A Room of One's Own* (London, 1928).

V. Woolf, *Three Guineas* (London, 1936).

V. Woolf, *Women and Writing* (ed. M. Barrett, London, 1979).

Chapter 2 Crafty women and the hierarchy of the arts

M. Alford, *Needlework as Art* (London, 1886).

A. Callen, *The Angel in the Studio: Women in the Arts and Crafts Movement* (London, 1979).

A. G. I. Christie, *English Medieval Embroidery* (London, 1938).

A. CLARK, *Working Life of Women in the Seventeenth Century* (London, new edn, 1968).

R. FINLAY, *Old Patchwork Quilts and the Women Who Made Them* (Philadelphia, 1929).

M. H. GRANT, *Flower Painting Through Four Centuries* (London, 1952).

J. HOLSTEIN, *The Pieced Quilt: An American Design Tradition* (New York, 1973).

M. JOURDAIN, *History of English Secular Embroidery* (London, 1910).

M. H. KAHLENBERG and A. BERLANT, *The Navajo Blanket* (Los Angeles, 1972).

A. F. KENDRICK, *English Needlework* (London, 1967).

D. KING, *Samplers* (London, 1960).

M. LAMB, *Miscellaneous Prose 1798–1834* (London, 1903).

L. LAMPHERE, 'Strategies, Cooperation and Conflict among Women in Domestic Groups' in Rosaldo and Lamphere (1974).

M. LEVEY, *Rococo to Revolution* (London, 1966).

P. MAINARDI, 'Quilts—the Great American Art', *Feminist Art Journal*, Winter 1973.

W. MORRIS, *Selected Writings and Designs* (ed. A. Briggs, London, 1962).

S. B. ORTNER, 'Is Female to Male as Nature is to Culture?' in Rosaldo and Lamphere (1974).

R. PARKER, 'The Word for Embroidery was WORK', *Spare Rib*, no. 37, 1975.

I. PINCHBECK, *Women Workers and the Industrial Revolution* (new edn, London, 1969).

G. POLLOCK, 'A Tale of Old and New: Patchwork Quilts', *Spare Rib*, no. 26, 1975.

E. POWER, *Medieval Women* (Cambridge, 1975).

M. Z. ROSALDO and L. LAMPHERE, *Women, Culture and Society* (Stanford, 1974).

S. ROWBOTHAM, *Women, Resistance and Revolution* (London, 1972).

S. ROWBOTHAM, *Hidden from History* (London, 1973).

C. L. SAFFORD and R. BISHOP, *America's Quilts and Coverlets* (New York, 1972; London, 1974).

E. A. STANDEN, *Working for Love and Working for Money: Some Notes on Embroiderers and Embroideries of the Past* (New York, 1966).

R. M. UNDERHILL, *The Navajos* (Norman, Oklahoma, 1956).

H. WALPOLE, *Anecdotes of Painting in England 1760–1795* (New Haven, 1937).

VISCOUNTESS WILTON, *The Art of Needlework* (London, 1840).

Chapter 3 'God's little artist'

E. BARRETT BROWNING, *Aurora Leigh* (1856) (introduced by C. Kaplan, London, 1978).

M. BASHKIRTSEFF, *The Journals of Marie Bashkirtseff* (ed. and trans. by M. Blind, London, 1890).

M. CORELLI, *Cameos* (London, 1896).

D. M. CRAIK, *Olive* (London, 1850).

C. DUNCAN, 'Happy Mothers and Other New Ideas in French Art', *Art Bulletin*, vol. 56, no. 101, 1973.

C. DUNCAN, 'Virility and Male Domination in Early Twentieth Century Vanguard Art', *Art Forum*, vol. 12, no. 4, 1974.

N. HAWTHORNE, *The Marble Faun* (1860).

W. GERDTS, *The White Marmorean Flock: Nineteenth Century Women Neoclassic Sculptors* (Poughkeepsie, New York, 1972).

R. PARKER, 'Portrait of the Artist as a Young Woman', *Spare Rib*, no. 34, 1975.

E. S. PHELPS, *The Story of Avis* (1877).

G. POLLOCK, 'Artists, Media, Mythologies: Genius, Madness and Art History', *Screen*, vol. 21, no. 3, 1980.

M. SHRODER, *Icarus—The Image of the Artist in French Romanticism* (Cambridge, Mass., 1961).

C. STERLING, 'A Fine "David" Reattributed', *Bulletin of the Metropolitan Museum of Art*, vol. 9, 1951.

M. F. THORP, *The Literary Sculptors* (Durham, North Carolina, 1965).

J. WAYNE, 'The Male Artist as Stereotypical Female', *Art Journal*, vol. 32, 1973.

R. WILLIAMS, *Culture and Society 1790–1950* (London, 1958).

R. WILLIAMS, *Keywords* (Glasgow, 1976).

R. and M. WITTKOWER, *Born Under Saturn* (London, 1963).

Chapter 4 Painted ladies

S. DE BEAUVOIR, *The Second Sex* (Paris, 1949).

R. BROOKS, 'Woman Visible, Women Invisible', *Studio International*, vol. 193, no. 987, 1977.

J. CHICAGO, *Through the Flower* (New York, 1975).

R. COWARD, 'Re-reading Freud: The Making of the Feminine', *Spare Rib*, no. 70, 1978.

R. COWARD and J. ELLIS, *Language and Materialism* (London, 1977).

E. COWIE, 'Women, Representation and the Image', *Screen Education*, no. 23, 1977.

E. COWIE, 'Woman as Sign', *M/F*, no. 1, 1978.

C. KAPLAN, 'Language and Gender', in *Papers on Patriarchy* (London, 1976).

C. KAPLAN, *Salt and Bitter and Good* (London, 1973).

J. LACAN, *Écrits* (trans. London, 1977).

J. MITCHELL, *Psychoanalysis and Feminism* (London, 1974).

L. MULVEY, 'You Don't Know What's Happening, Do You Mr Jones?', *Spare Rib*, no. 8, 1973.

L. MULVEY, 'Visual Pleasure and the Narrative Cinema', *Screen*, vol. 16, no. 3, 1975.

L. NOCHLIN and T. HESS, *Woman as Sex Object* (New York, 1972).

R. PARKER, 'Censored: Feminist Art that the Arts Council is Trying to Hide', *Spare Rib*, no. 54, 1977.

R. PARKER, 'Images of Men: Invalided Men in Women's Art and Literature', *Spare Rib*, no. 99, 1980.

G. POLLOCK, 'What's Wrong with "Images of Women"?', *Screen Education*, no. 24, 1977.

A. SAUZEAU BOETTI, 'Negative Capability as Practice in Women's Art', *Studio International*, vol. 191, no. 979, 1976.

L. TICKNER, 'The Body Politic: Female Sexuality and Women Artists Since 1970', *Art History*, vol. I, no. 2, 1978.

L. TICKNER, *Women's Images of Men* (London, 1980).

M. WALTERS, 'Playmales', *Spare Rib*, no. 33, 1974.

M. WALTERS, *The Nude Male* (London, 1978).

Chapter 5 Back to the twentieth century: femininity and feminism

J. BARRY and S. FLITTERMAN, 'Textual Strategies: The Politics of Art Making', *Screen*, vol. 21, no. 2, 1980.

BERLIN, *Kunstlerinnen International 1877–1977*, Berlin, Schloss Charlottenburg.

J. CHICAGO and M. SCHAPIRO, 'A Feminist Art Program', *Art Journal*, vol. 31, no. 1, 1971.

J. CLARKE *et al.*, 'Women and Representation: a Discussion with Laura Mulvey', *Wedge*, no. 2, 1978.

T. DAVIES and P. GOODALL, 'Personally and Politically: Feminist Art Practice', *Feminist Review*, no. 1, 1979.

C. ELWES, R. GARRARD and S. NAIRNE, *About Time: Video, Performance and Installation by 21 Women Artists* (London, Institute of Contemporary Arts, 1980).

THE HAGUE, *Feministiche Kunst Internationaal* (The Hague, Gemeente Museum, 1979).

M. HARRISON, 'Notes on Feminist Art in Britain 1970–1977', *Studio International*, vol. 193, no. 987, 1977.

M. KELLY, 'Notes on Reading the Post Partum Document', *Control Magazine*, no. 10, 1977.

L. LIPPARD, *Surrealists on Art* (New York, 1970).

L. LIPPARD, *Eva Hesse* (New York, 1976).

L. LIPPARD, *From the Centre* (New York, 1976).

L. LIPPARD, 'Anatomy of an Annual' in London, Arts Council, *Hayward Annual '78* (London, 1978).

L. LIPPARD, *Issue: Social Strategies by Women Artists* (Exhibition and Catalogue, London, Institute of Contemporary Arts, 1980).

LONDON, *Hayward Annual '78* (London, Hayward Gallery, 1978).

L. MULVEY, 'The Post Partum Document by Mary Kelly', *Spare Rib*, no. 55, 1976 (see also 56 and 57 for debate).

C. NEMSER, *Art Talk* (New York, 1976).

G. ORENSTEIN, 'Women of Surrealism', *Feminist Art Journal*, Spring 1973.

R. PARKER, 'Women Artists Take Action', *Spare Rib*, no. 13, 1973.

R. PARKER, 'Art of course has no Sex; but artists do', *Spare Rib*, no. 25, 1974.

R. PARKER, 'Portrait of the Artist as a Housewife', *Spare Rib*, no. 60, 1977.

R. PARKER, 'Feministo', *Studio International*, vol. 193, no. 987, 1977.

R. PARKER, 'Interview with Mary Kelly', partly published in *Towards Another Picture* (eds A. Brighton and L. Morris, Nottingham, 1977).

R. PARKER, 'The Story of Art Groups', *Spare Rib*, no. 95, 1980.

R. PARKER, 'About Time: Video, Performance and Installation by 21 Women Artists', *Spare Rib*, no. 102, 1981.

R. PARKER, 'Feminist Art Practice Represented in "About Time", "Women's Images of Men" and "Issue"', *Art Monthly*, no. 43, February 1981.

G. POLLOCK, 'Feminism, Femininity and the Hayward Annual II', *Feminist Review*, no. 2, 1979.

G. POLLOCK, 'Issue', *Spare Rib*, no. 103, 1981.

M. SCHAPIRO, 'Education of Women as Artists', *Art Journal*, vol. 31, no. 3, 1972.

WOMEN ARTISTS COLLECTIVE, 'Women's Art 1877–1977', *Spare Rib*, no. 59, 1977.

Index